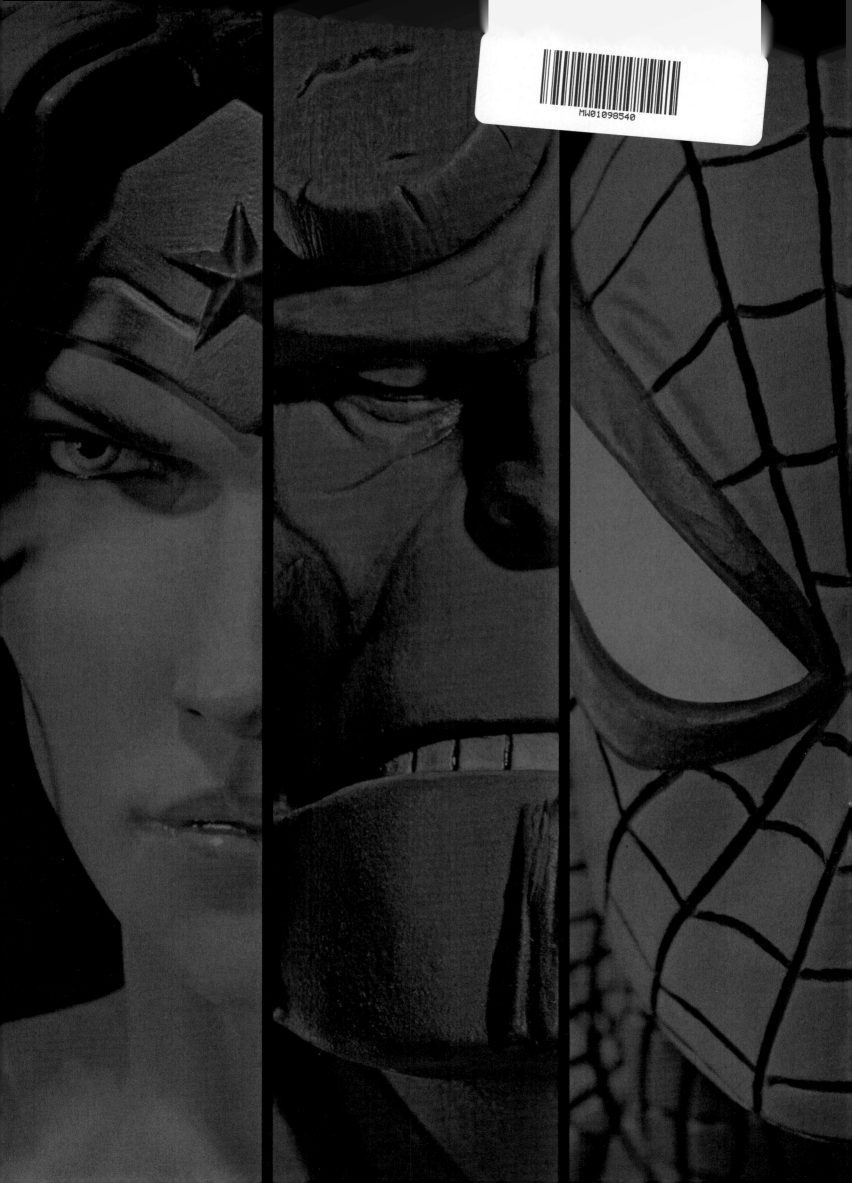

SIDESHOW COLLECTIBLES PRESENTS

# CAPTURING ARCHETYPES
## —— VOLUME 2 ——

### A GALLERY OF HEROES AND VILLAINS
### FROM BATMAN TO VADER

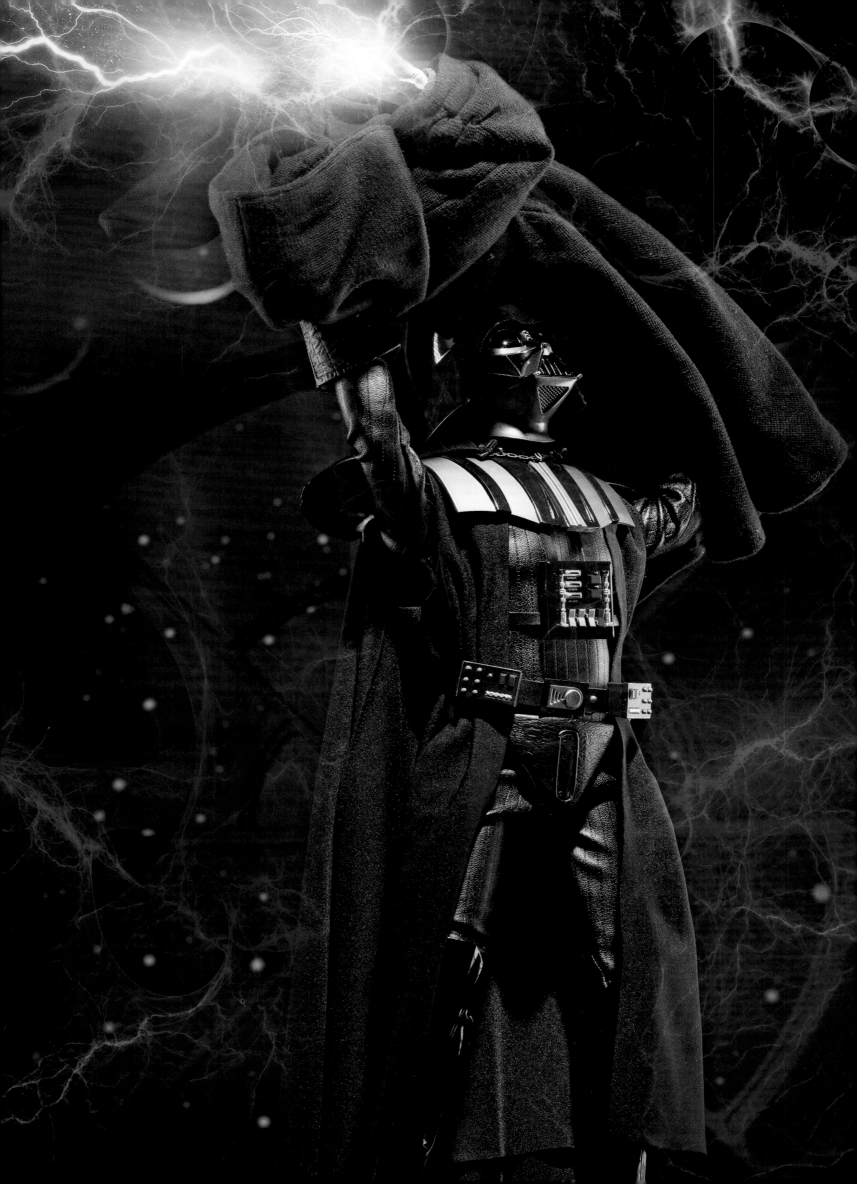

SIDESHOW COLLECTIBLES PRESENTS

# CAPTURING ARCHETYPES
## VOLUME 2

### A GALLERY OF HEROES AND VILLAINS
### FROM BATMAN TO VADER

FOREWORD BY
DREW STRUZAN

INTRODUCTION BY
GREG ANZALONE

INSIGHT EDITIONS

San Rafael, California

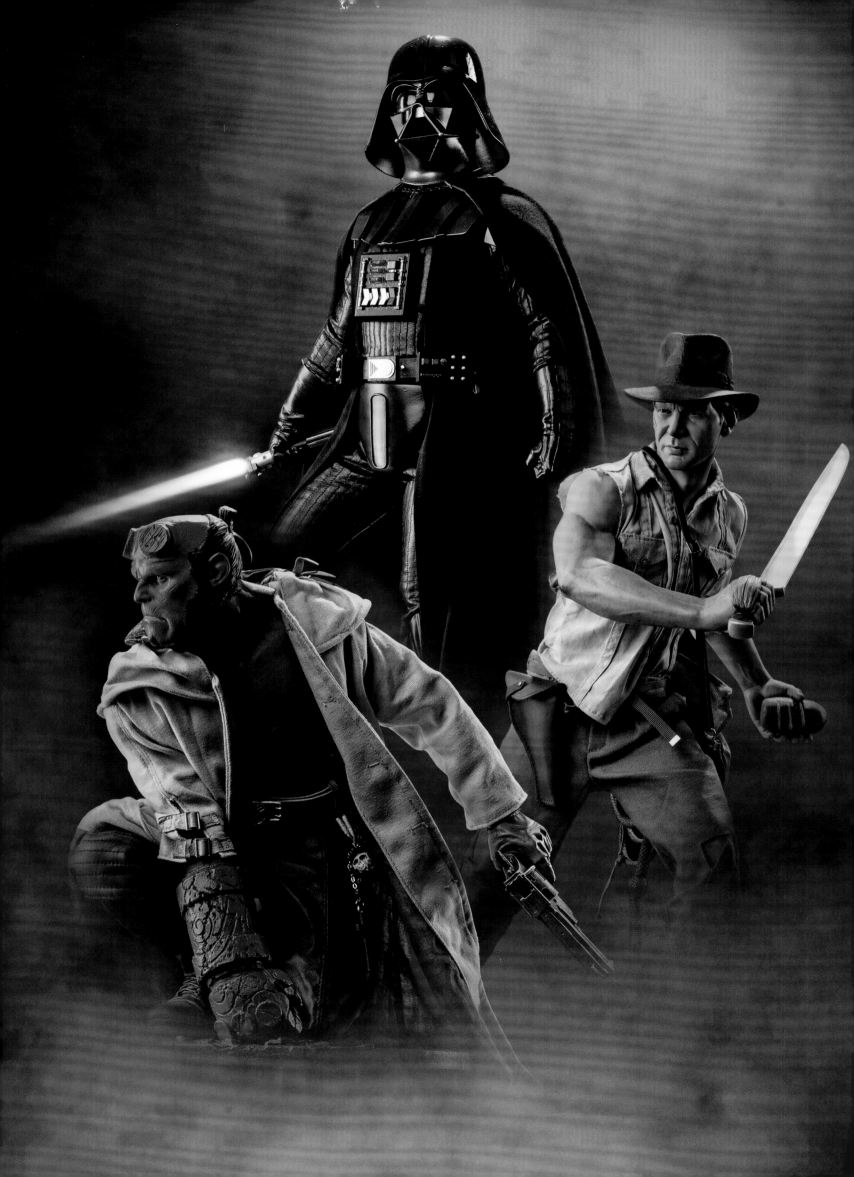

# FOREWORD

BY DREW STRUZAN

Who are we, beyond beings that struggle for survival? Why are we; what are we? And how are we going to get to wherever it is we are going? These questions have been pondered by the humanities for ages. We have an advantage in art. It gives us a universal language. And in the modern era, technology unites us all. We are no longer bound by borders. We have become one and, in the process, we share a culture filled with the archetypes of our time.

We work to survive, but there is more to humanity than survival. Our culture is not the record of wars, politics, and governments. It is the art that survives, a reflection of what makes us human. What we leave behind is what recommends us to future generations. Let us put our best foot forward in this new world of mankind. This is what art is intended to do.

I believe that art does just that. Art should feed our hearts and our spirits. It should inspire us to create works that honor our humanity. It should reflect the things that make us worthy of the gift of life . . . our best qualities; our dreams, hopes, and prayers. That's what I like to paint. I reach for the archetype that inspires us, that catches us when we fall, that keeps us working our humanity.

When I paint, I willfully make a powerful and beautiful image. I want you to know who the people are that I'm painting. I want you to desire to step into their world. I put emotion in my paintings. I want you to see where my brush has been and to love the energy of a splash or a scratch. It is a primal joy that I wish to transfer to you.

I work with an artistic language, a visual language, a beautiful and powerful language of heart, emotion, and spirit. The creators at Sideshow Collectibles do the same thing. They show us at our best, at our most agonized, at our most victorious. As artists, we pull the essence of the archetype out of the character and capture it

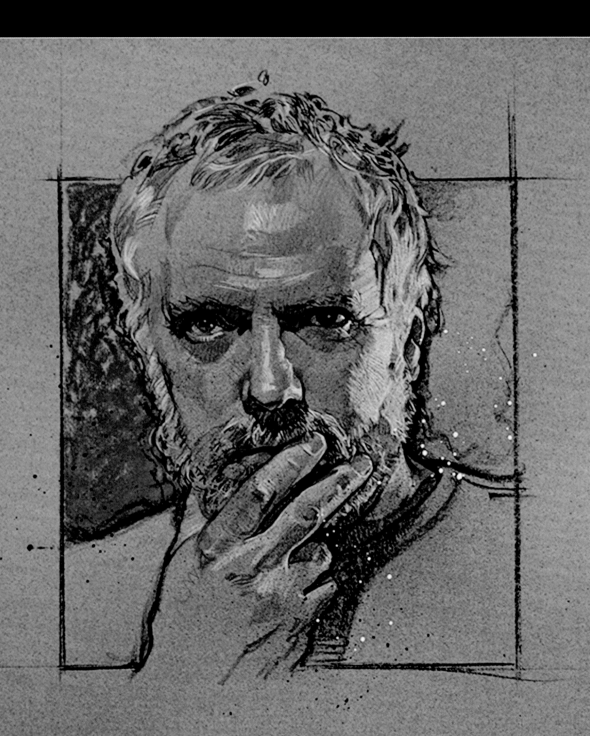

I drove out to their offices and found that they had expanded since the last time I had visited. They had grown immensely, and I was impressed by the spirit, the creative presence of the place. Over lunch, I listened to their story, their vision, what it is they see as their mission. Everything I would like to believe about Sideshow was reaffirmed. It's about art—a conclave where people believe there is such a thing as art, and that alone is unusual in this world. It's a very rare thing.

You walk through the front door, and you know you're in a different world; you know that right off. It's like you're in somebody's heart when you're there. It says, "We love something, we're impassioned by something, and we want to inspire others." It is the epitome of all the wonderful worlds that live in a creative's mind and experiences. I could feel the spirit. I would like people to believe that they should live in this world. I don't know how to say that in such a way that would make everyone want to be there.

Sideshow gets it right. Art must speak to us here and now! By delving into character, they touch the essence of archetypal events, figures, and motifs that blend to give us meaning in our lives. An image, a word, a story . . . all these things come to us through time and are born of our time. They represent our accomplishments, our heroes, our dreams. They give us hope, love, beauty, and inspiration.

Sitting on the shelves around my studio are sculptures of Indy, Luke, Hellboy, Frankenstein, and Wonder Woman—my inspiration to glorious values. This grand spirit of love and hope inspires me and motivates the artists at Sideshow. The sculptures fill my room, the air, and my spirit, just as they did when I visited their home at Sideshow. This book is a glimpse of the art I saw that day . . . simply *art*. May this art inspire you to reach for your best qualities, for this is the culture we leave behind. May we epitomize the best traits of our humanity, as exemplified in our heroes and archetypes, and allow them to remind us of who we are and what we can be. We all have the freedom to choose our spirits. Choose to be heroes, the best we can be.

We are all living this together: Me, Sideshow, and You.

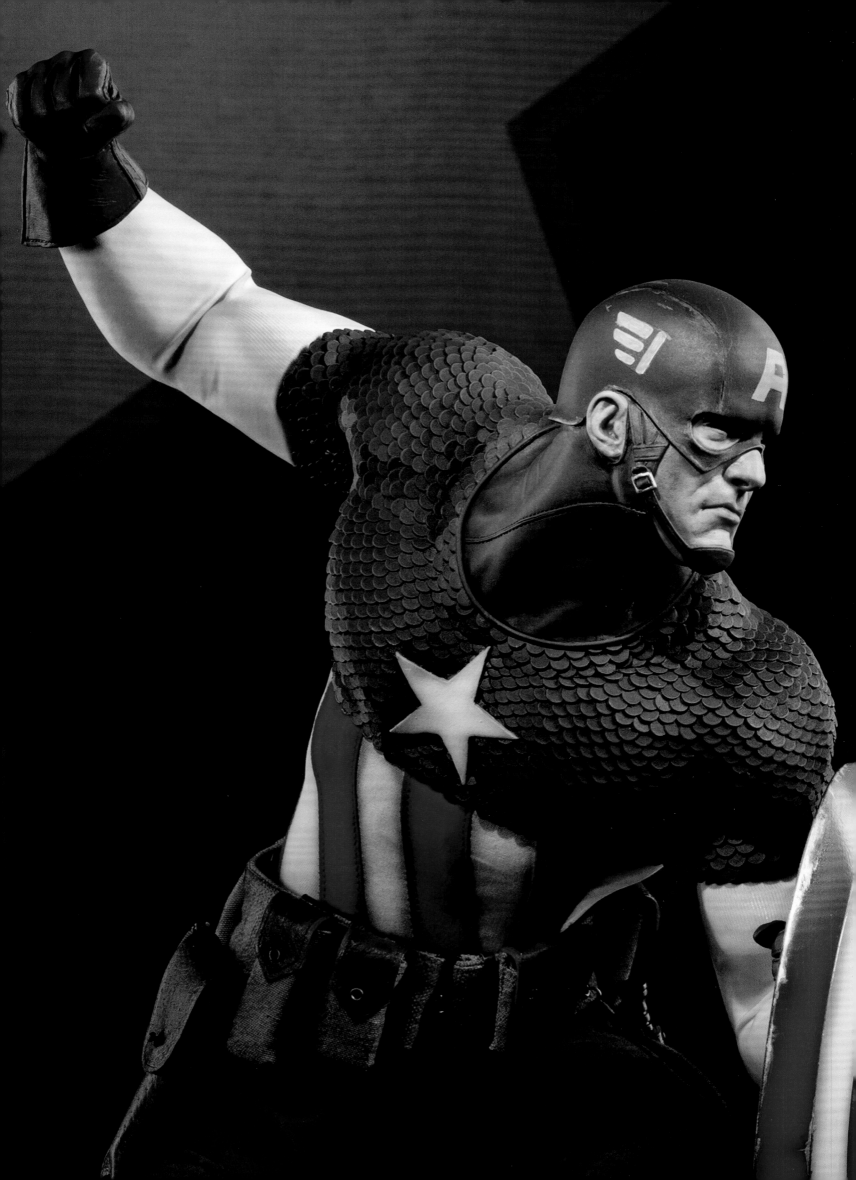

# INTRODUCTION

BY GREG ANZALONE
CEO AND PRESIDENT, SIDESHOW COLLECTIBLES

We've been on a very unusual business and artistic expedition for the past twenty-plus years. We've been journeying to multiple universes, like some kind of unbridled time traveler, into and out of enough alternate realities to qualify for immediate entry into a sealed institution.

The truth is that we've been invited to journey forth by some of the most creative minds of our popular culture. The men and women who have created the worlds, the characters, the creatures, and the stories of these alternate universes have been our guides, and they've taken us to places of which we could not have dreamed.

But we're not just along for the ride. We have a purpose. I think of us at Sideshow as modern nomads on an artistic adventure. We don't own the geography that we cover, but we tread lightly as we know the value of the place and all that exists there. We reverently chart out the connective routes and call out the landmarks. We are navigators who take all those who care to journey with us to places that are familiar and foreign, cautionary and satisfying, illuminating and mysterious.

We go from comic book to film to television show to video game with great willingness and genuine devotion. We are somewhat like those adventurers who journey off to experience something new and to access something real within themselves. Our pop culture takes us to places without borders, often to lands that were previously uncharted, places with unfamiliar laws and customs. And like the most earnest of explorers, we test ourselves through these travels. We test our resolve, abilities, patience, stamina, and of course, sanity.

But who doesn't want to be on this kind of journey? The excitement is real because we are not simply spectators of our pop culture. At Sideshow we're engaged at an unusual level. Our artistic endeavors are never like that of a child's walk through the zoo: detached, shielded, and protected. We purposely immerse ourselves in the lands where we travel and in the lives of the characters we get to know in ways that are more akin to that of their creators.

Over the years and because of these travels, we now serve as goodwill ambassadors for pop culture. We strive to better define these pop culture characters

hoping to explain them to a world that may misunderstand, misinterpret, and too easily dismiss them as failures, frauds, or freaks. Now, how many of us can relate to that?

Allow me to suggest that some all too easily disparage the brilliance of those fertile minds that give us the classic monsters, the superheroes, the warriors, villains, and magical creatures of sci-fi and fantasy. But we hold forth that these characters and their stories shape us and are the cultural landmarks that guide our development individually as artists and collectively as a business. Ours is a world that needs heroes, real and imagined, and a group like Sideshow that is willing to highlight their presence.

The artists and business people at Sideshow are innocent in their pursuit of what is meaningful around us, what has value in the faces and the actions of our superheroes and villains alike. We do not act as the judge or sit on any jury that condemns our pop culture. We pass no judgment and likewise accept no blame. We ask for no acceptance and make no excuses for our artistic endeavors.

At Sideshow we believe we perform a necessary task with a devotion reserved for more obvious, more accepted professions. We willingly reflect our recognition back onto our subjects and the creators who gave birth to these monsters and saints. What's especially meaningful to us is when those creators ask for us to be involved, give us a nod of approval, and acknowledge our passion for the accurate representation of their work.

One aspect of our contribution that propels us is whether anyone is moved to own what we make. To know that we are re-crafting characters of pop culture that will sit on the altar of someone's personal space is an honored role for us and moves us forward with renewed energy and purpose.

In the very personal search for meaning in the convoluted reality of this world we have many willing guides from our pop culture. Sideshow's mission has been to call them out, to announce them in a figural format, and to replicate them in a pristine and dynamic way that allows collectors to enjoy a personal accessibility, a real connection that orientates and inspires their inner lives.

It's been a remarkably rewarding journey for all of us at Sideshow, and this book—and series—is a way for us to celebrate our work along the way.

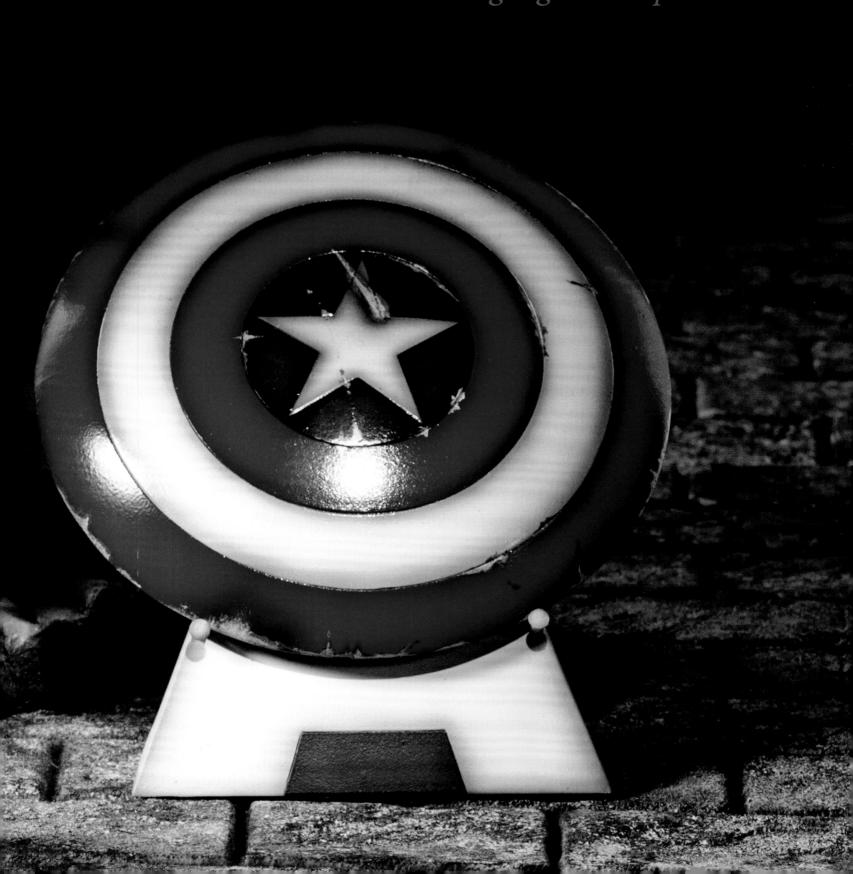

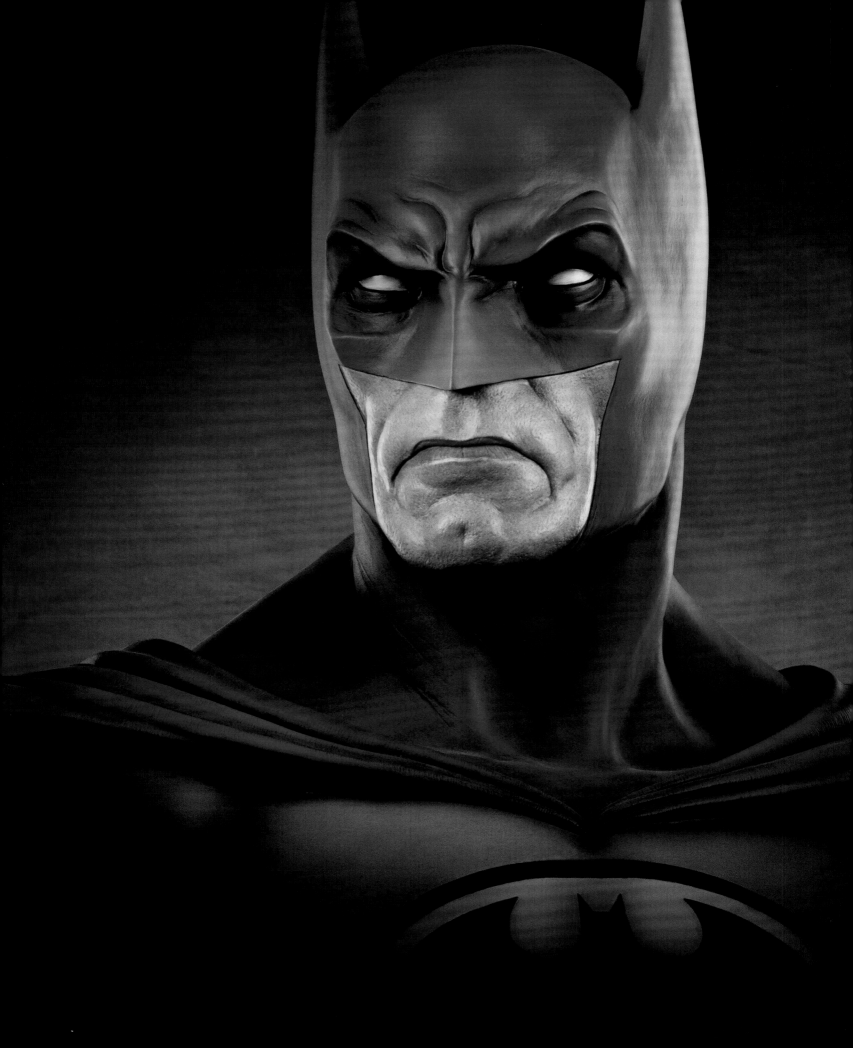

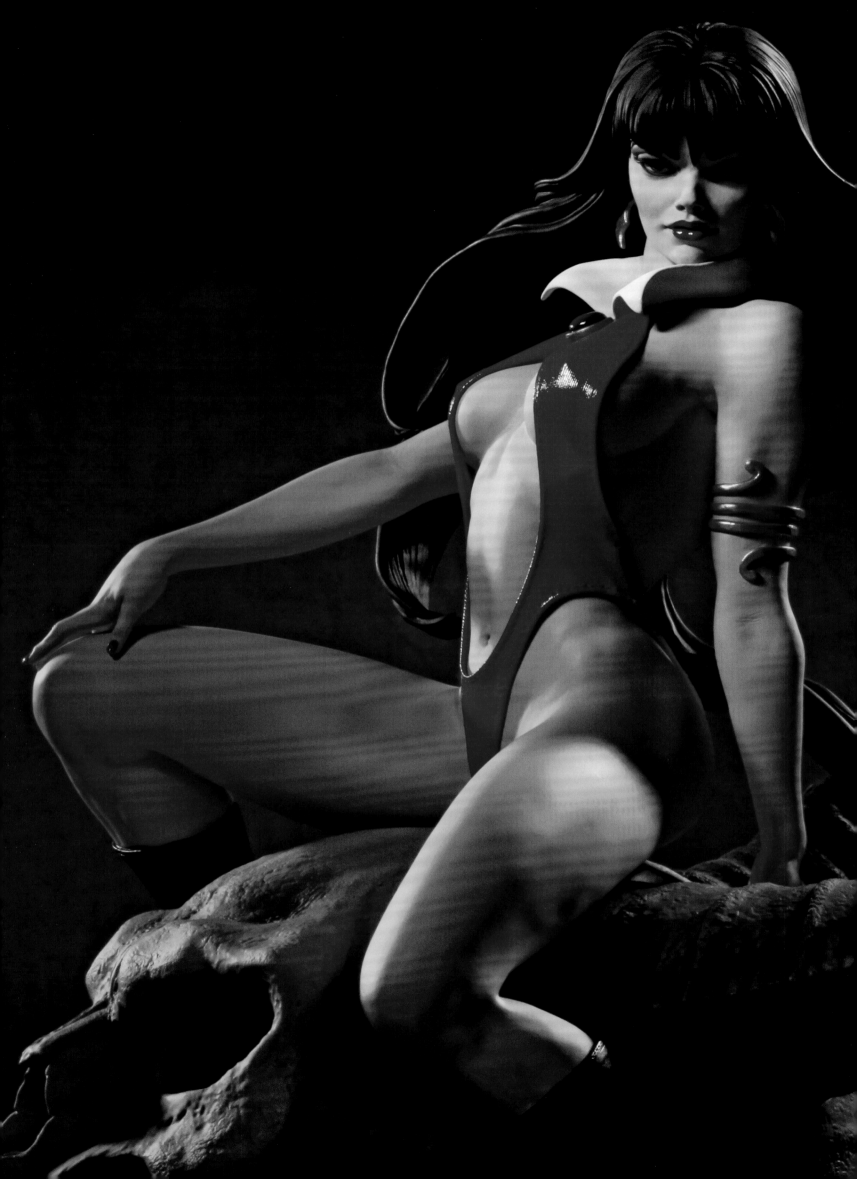

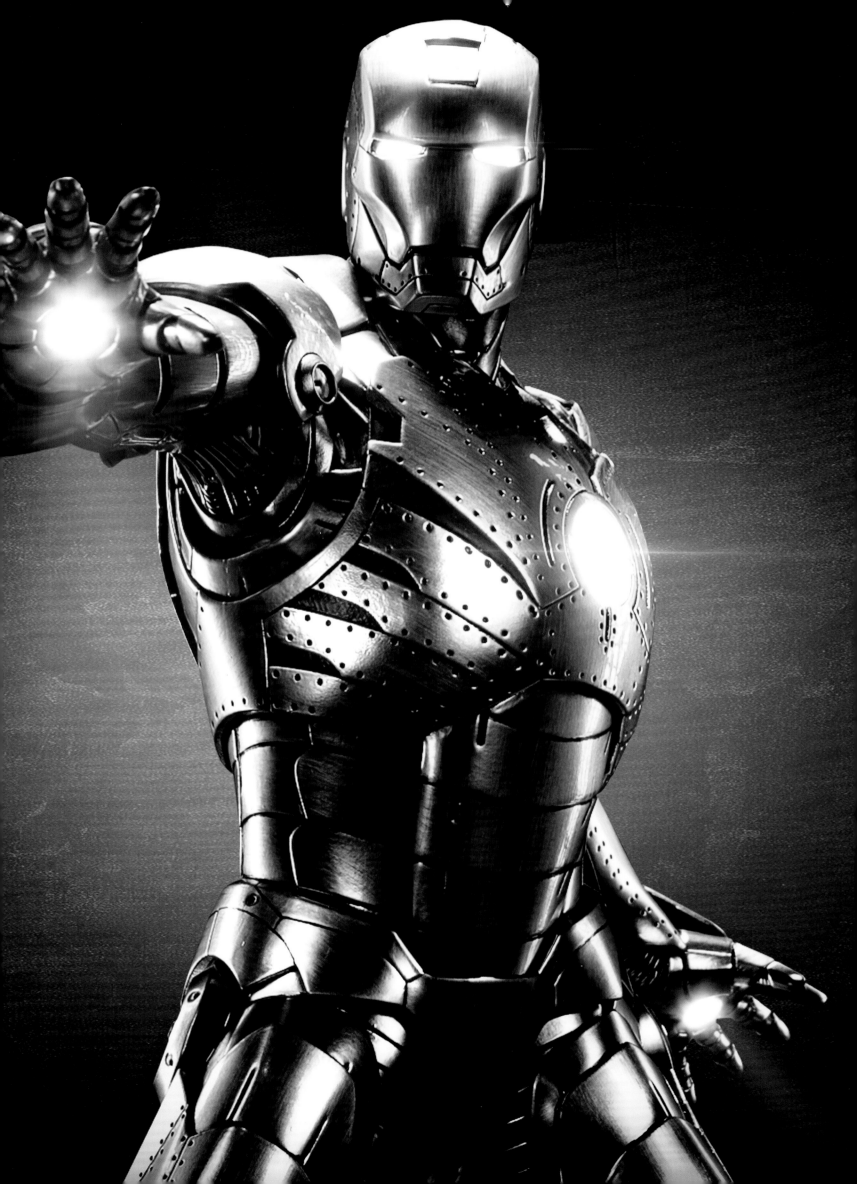

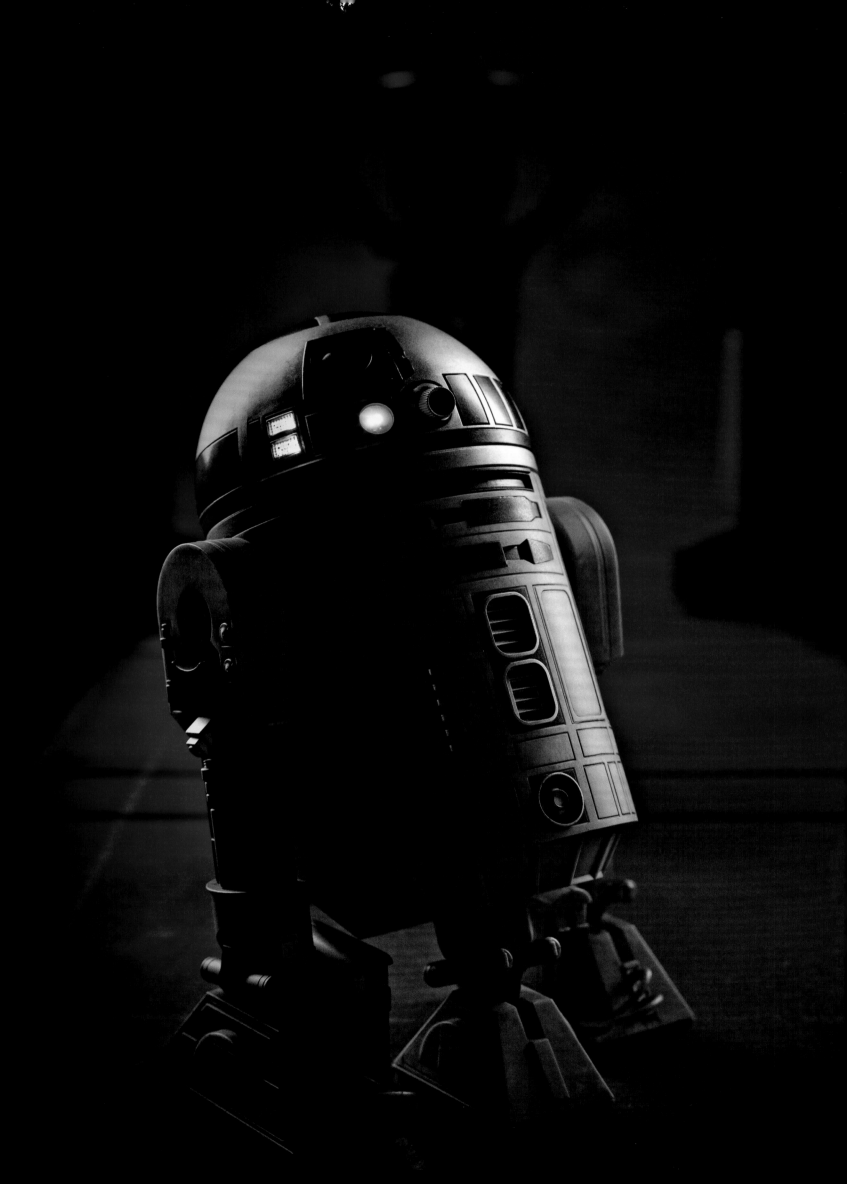

*" You're a feisty little one, but you'll soon learn some respect. I have need for you on the master's sail barge. And I think you'll fill in nicely. "*

—*EV-9D9 to R2-D2,* Star Wars: Episode VI: Return of the Jedi

R2-D2 is the ultimate example of comic relief without a voice. He is only able to communicate with a thousand bleeps and whistles. However, he is still able to emote beautifully even though he's basically a trashcan with a mouth that makes noise. Before R2-D2, robots were just actors in clunky metal suits. But in Star Wars, he is the unsung hero of the entire epic—the holder of all the holograms."

—Anthony Mestas, Paint Department Manager

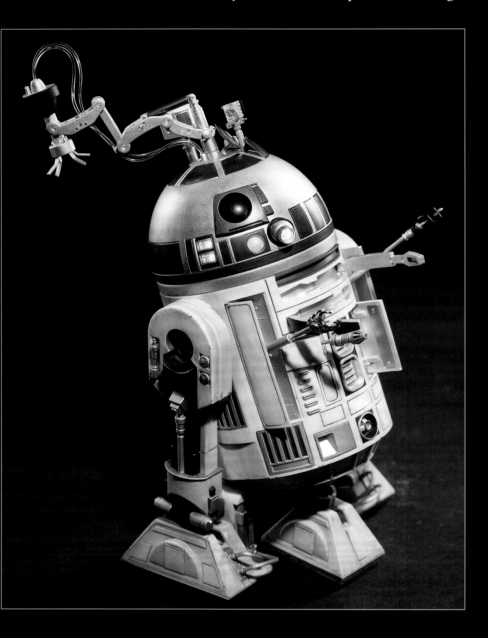

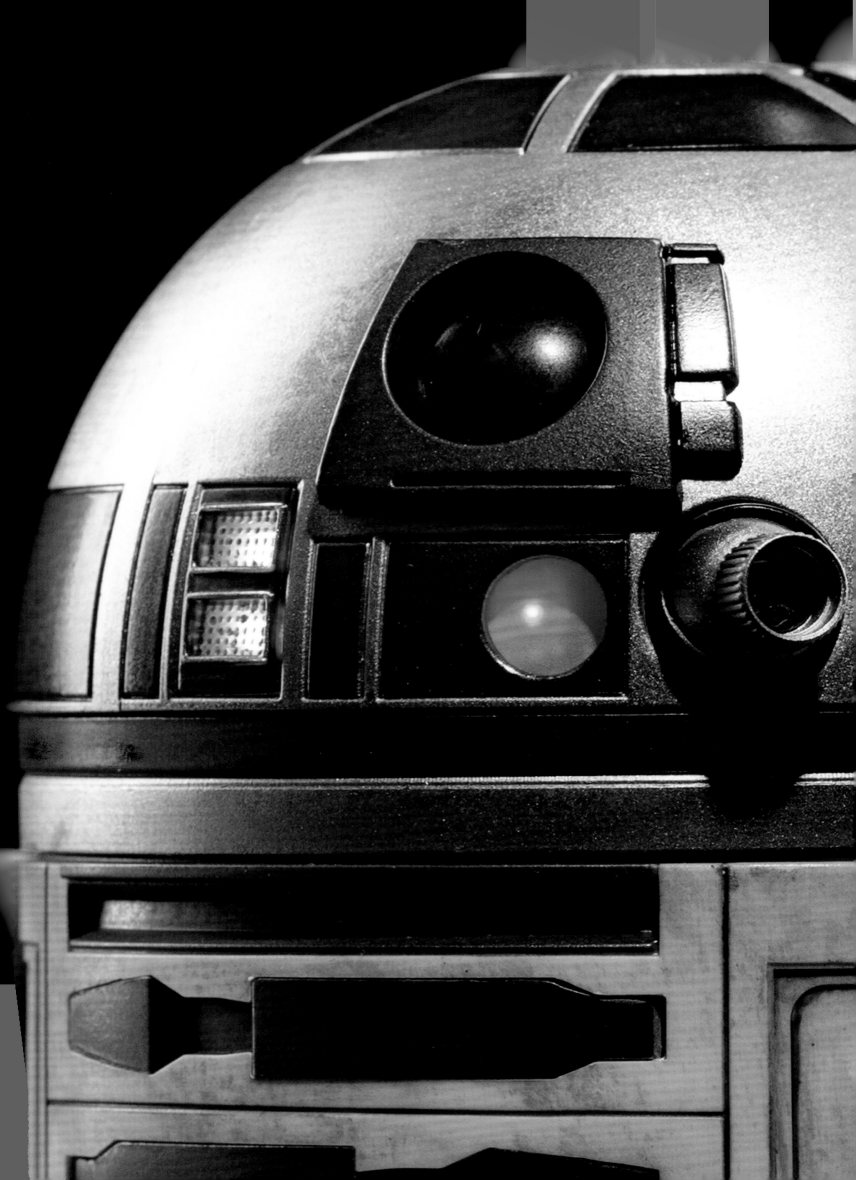

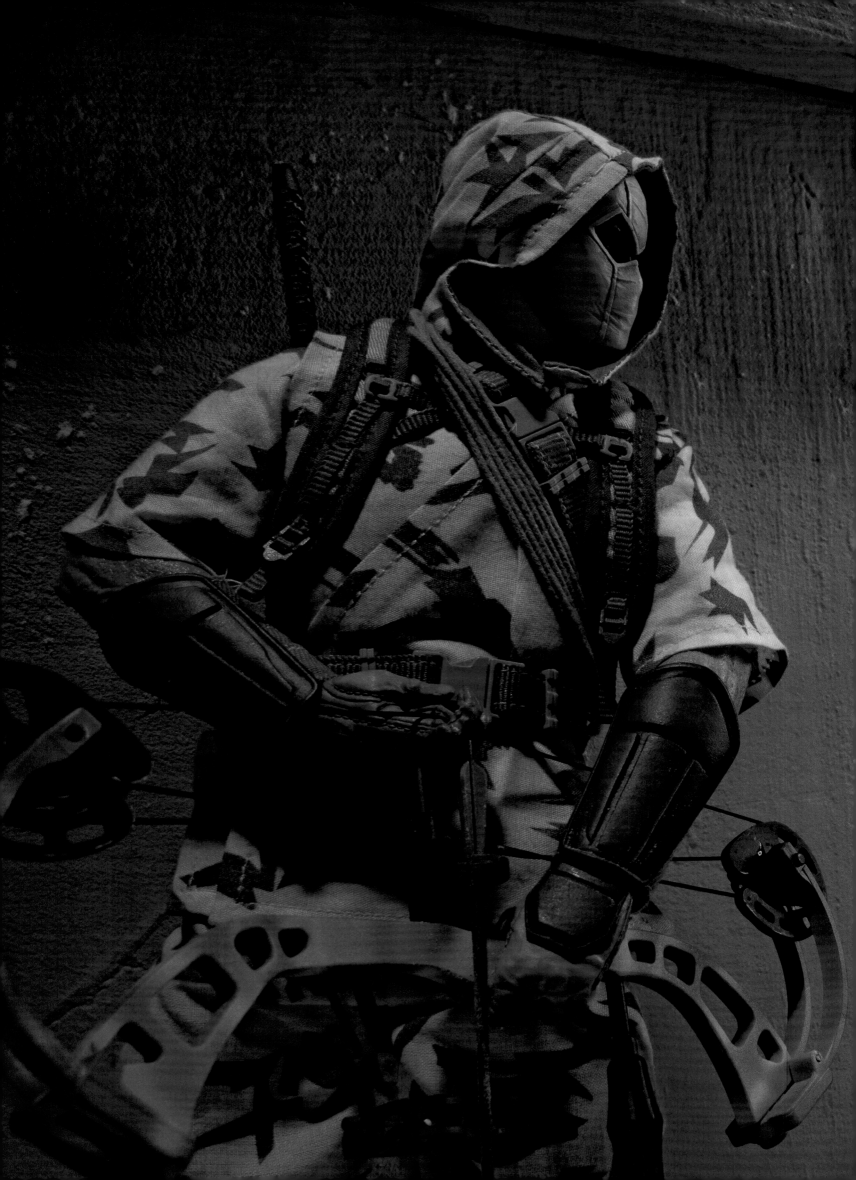

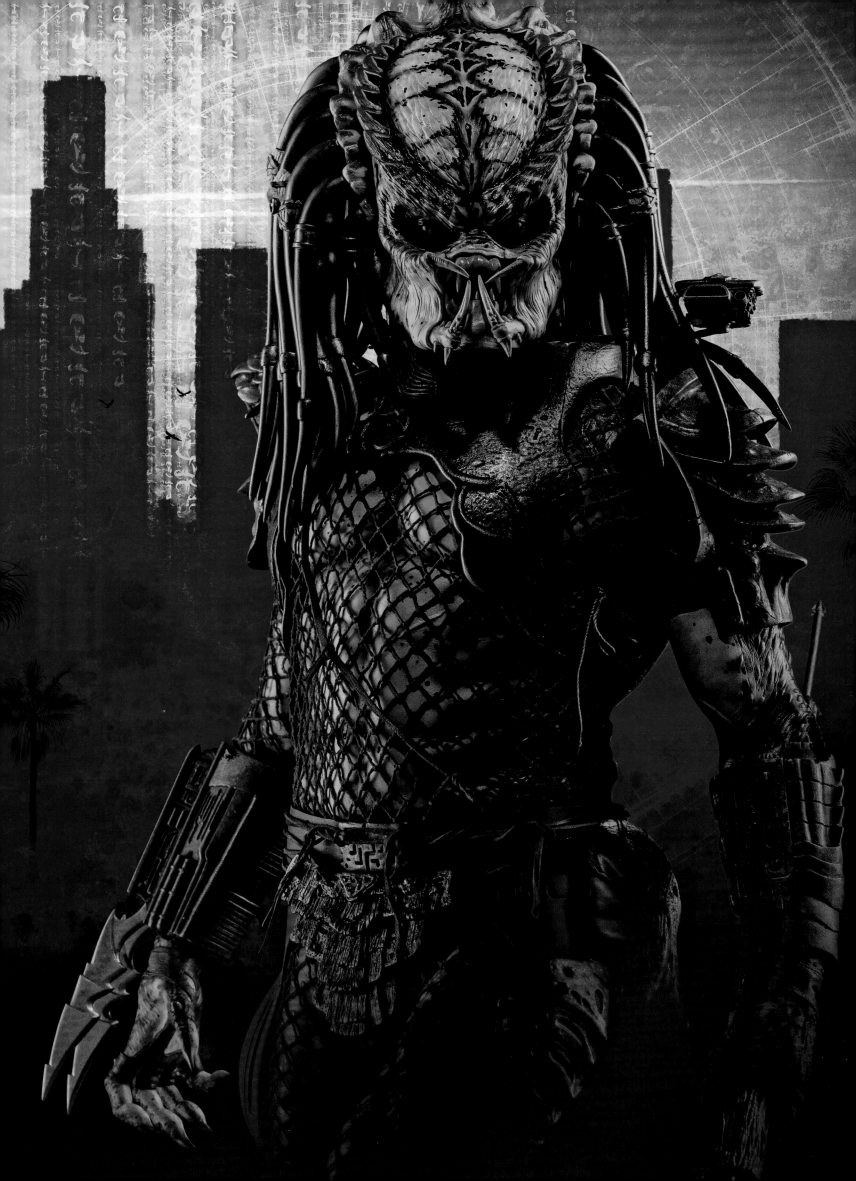

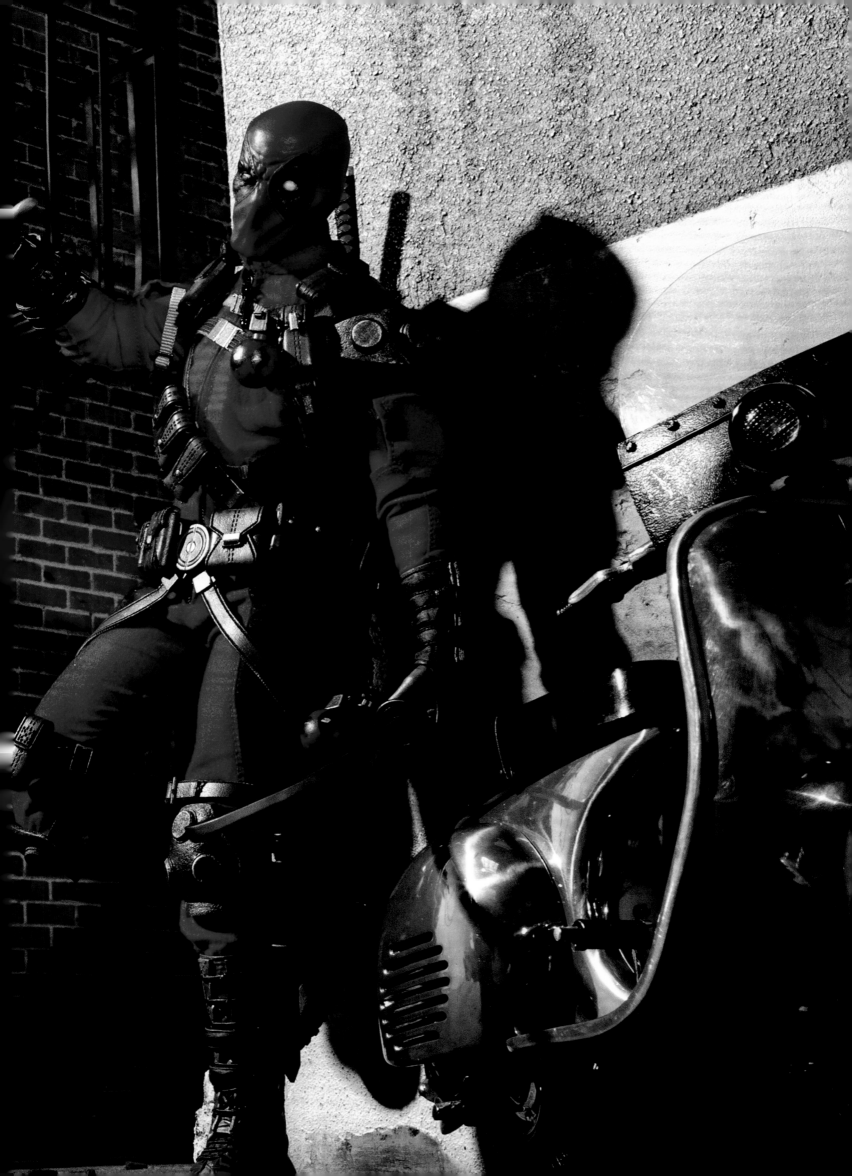

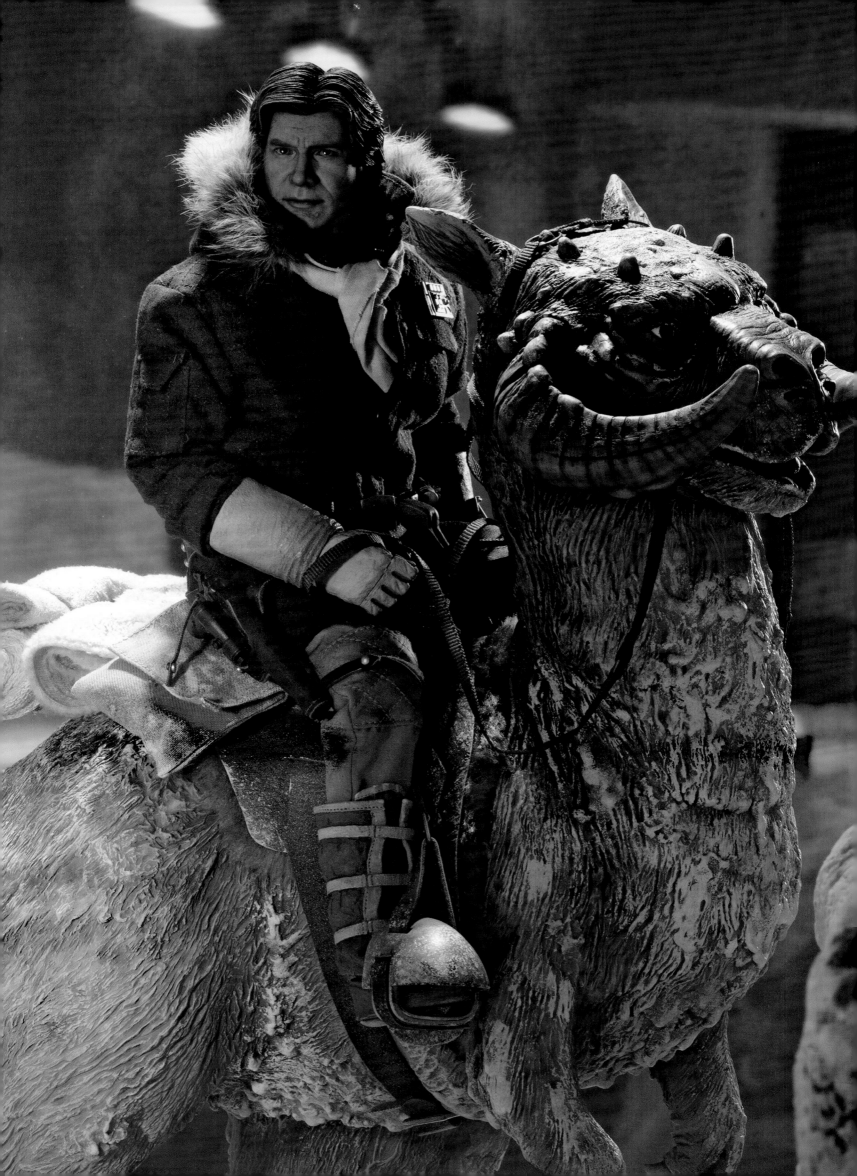

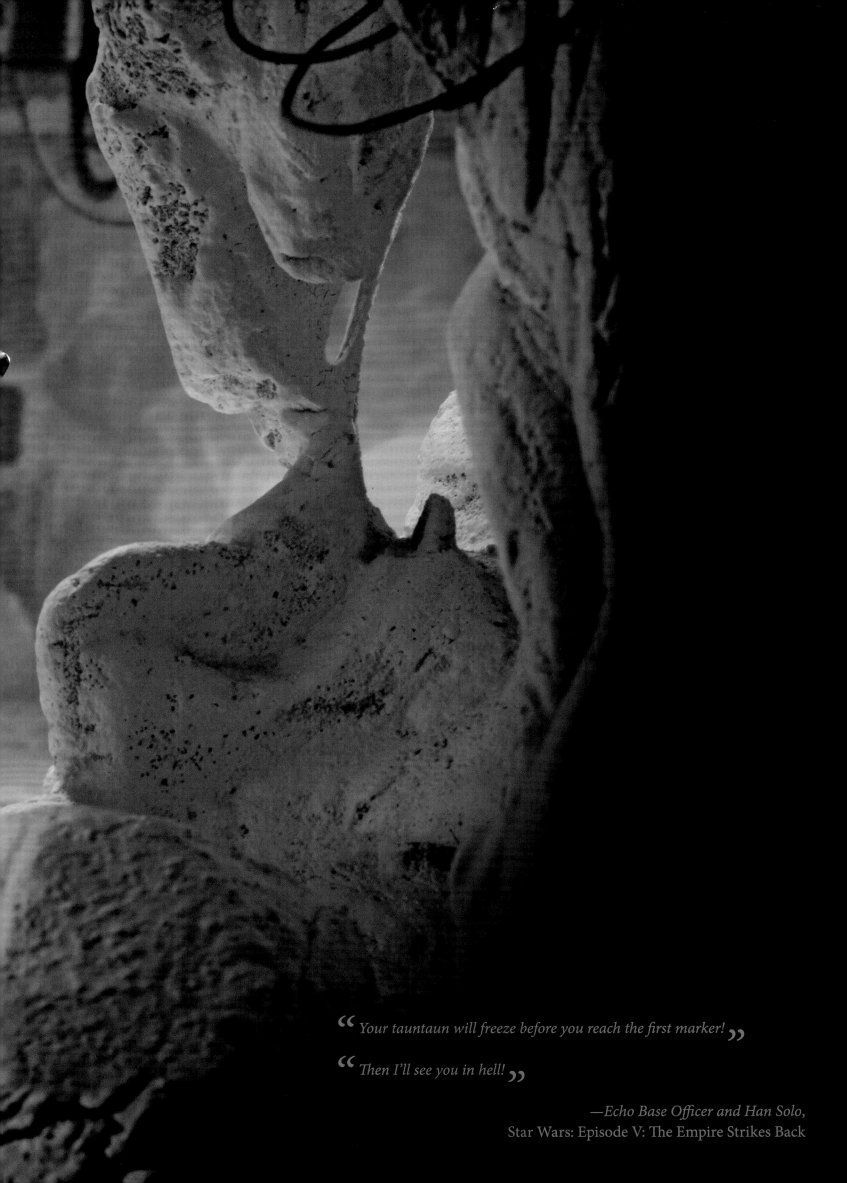

*“ Your tauntaun will freeze before you reach the first marker! ”*

*“ Then I'll see you in hell! ”*

*—Echo Base Officer and Han Solo,*
Star Wars: Episode V: The Empire Strikes Back

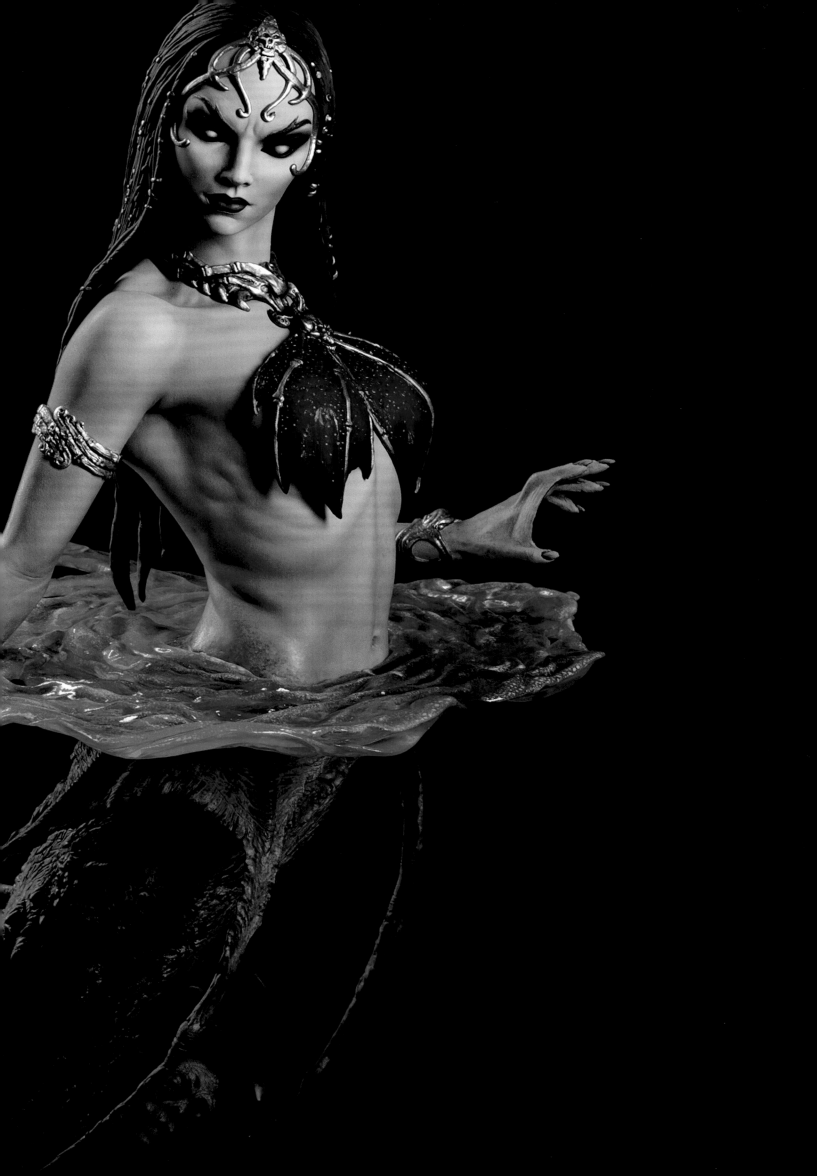

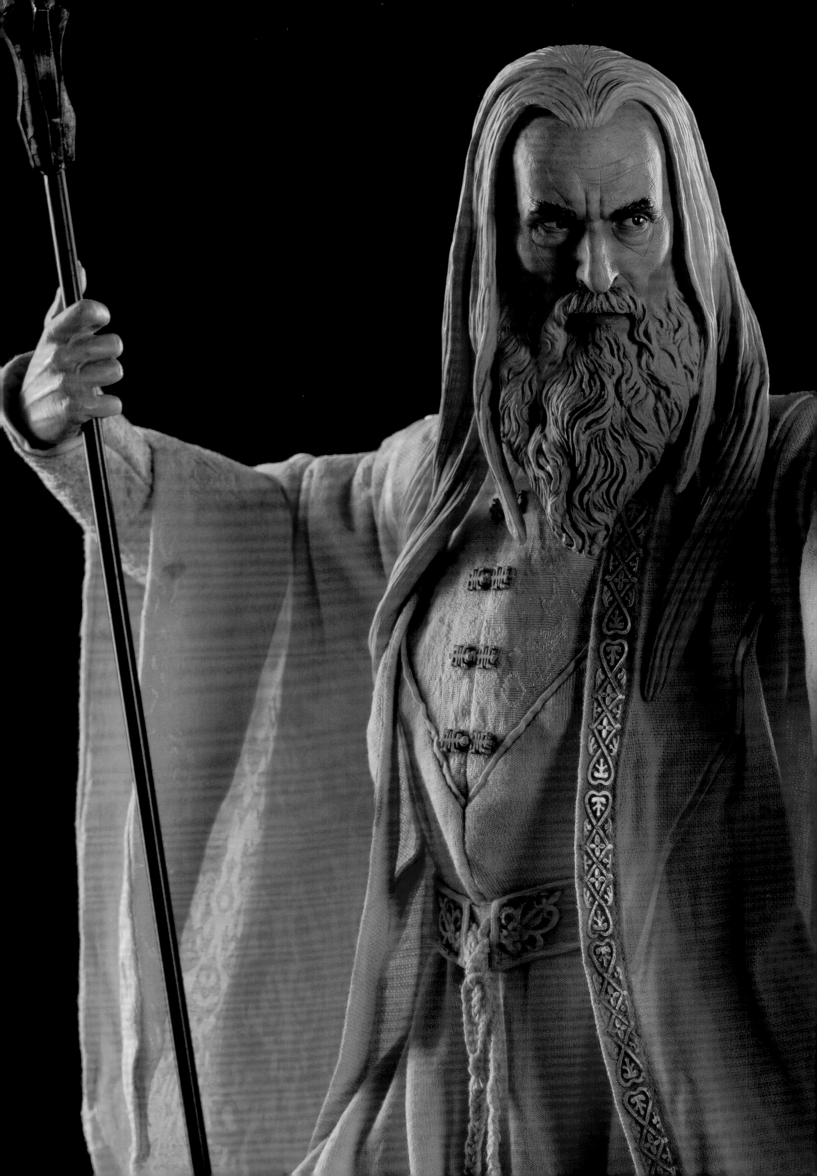

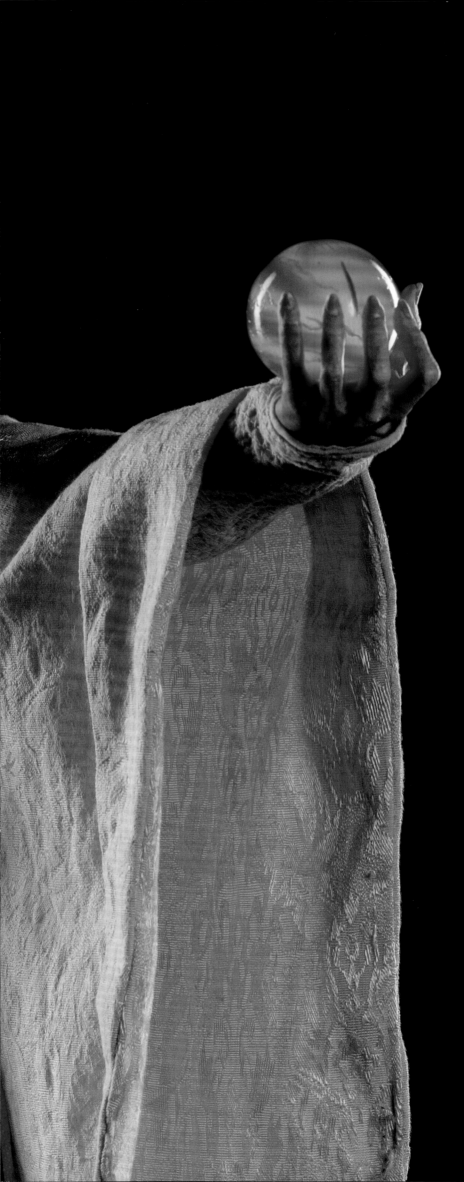

> *It was not an earthquake; it wasn't a typhoon! Because what's really happening is that you're hiding something out there! And it is going to send us back to the Stone Age! God help us all.*
>
> —*Joe Brody*, Godzilla *(2014)*

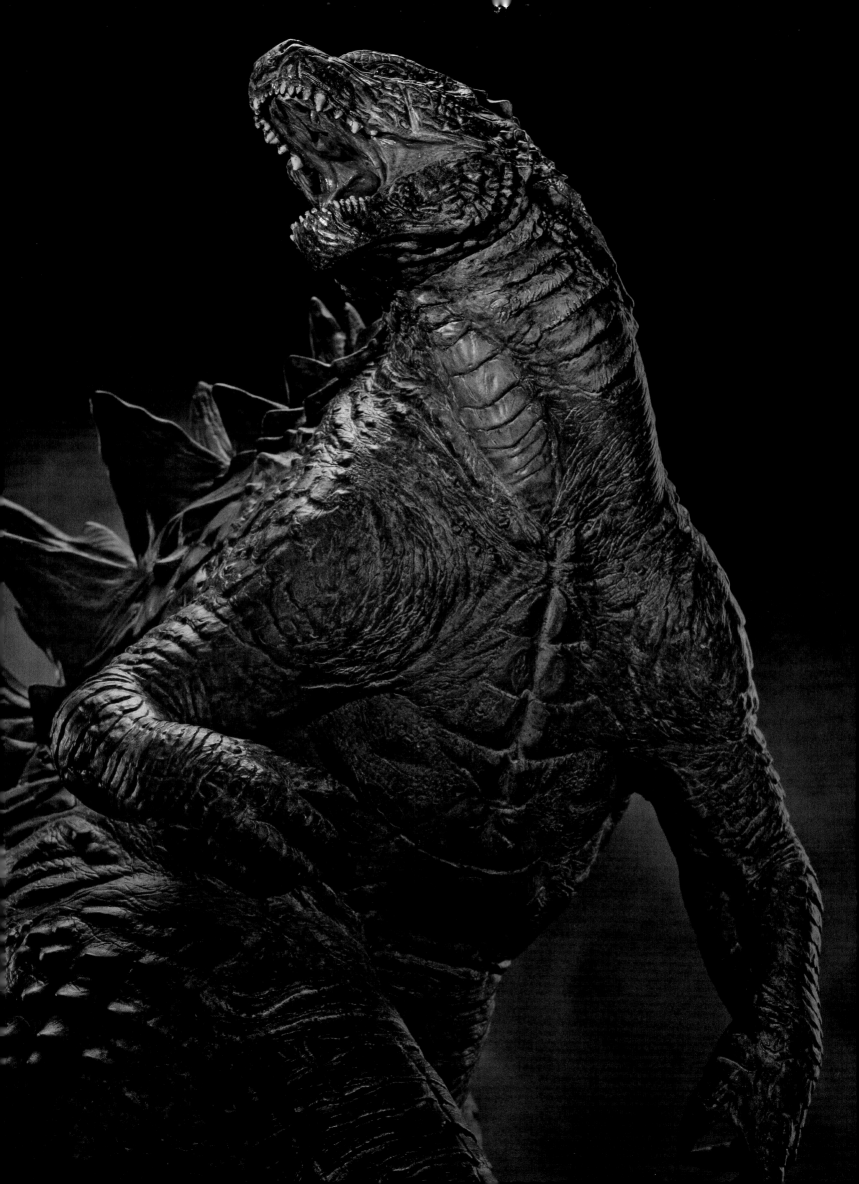

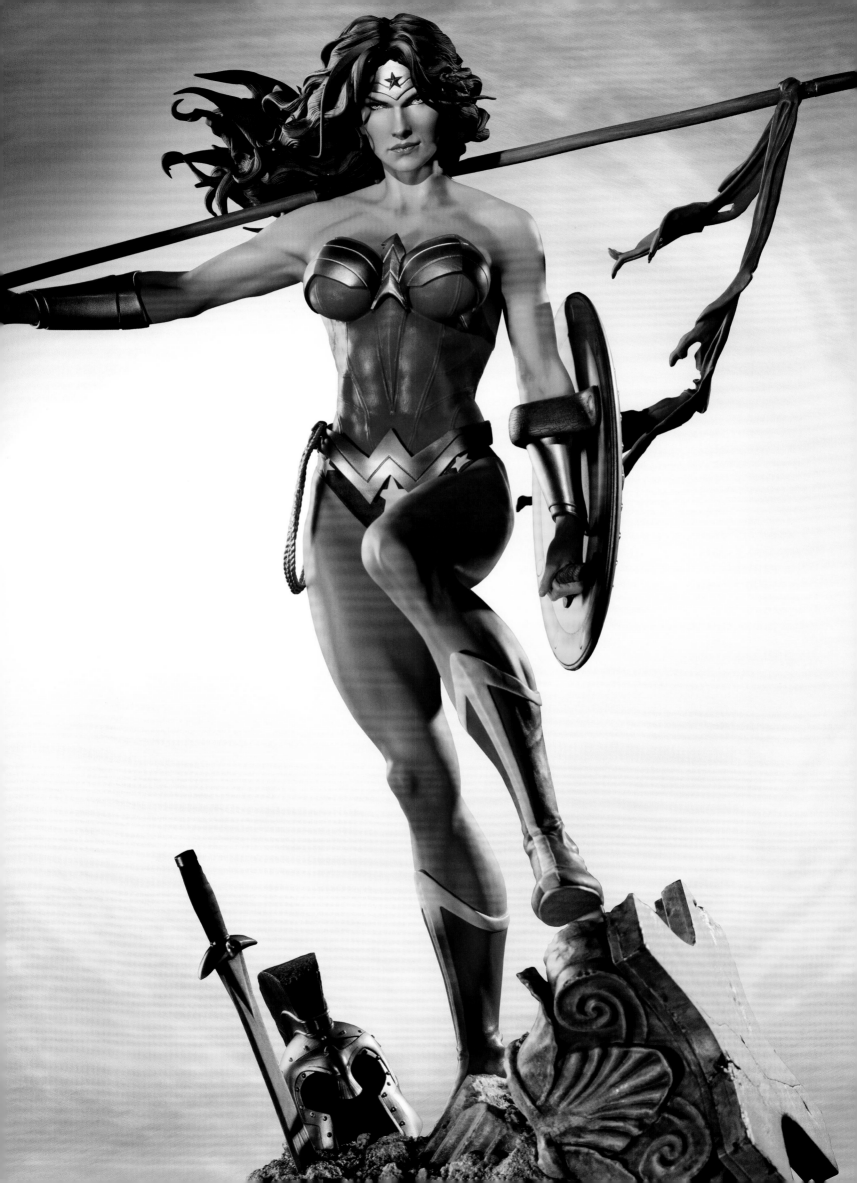

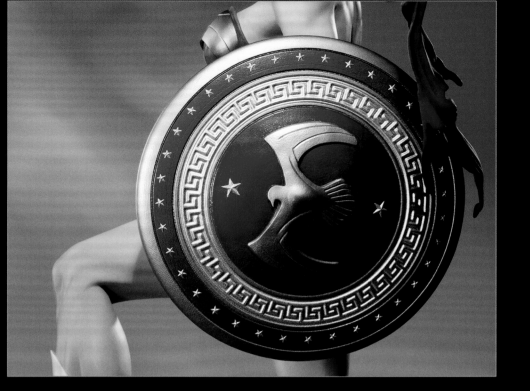

"Wonder Woman continues to be one of the most iconic female characters in the comic book arena. She first appeared in DC Comics in 1941, a time when there weren't any strong female role models for women and girls to look up to in comics. She's an Amazon princess who means business. She is never afraid to confront the bad guys and save the world from the forces of evil. Everything about her outfit, her superpowers, her invisible airplane . . . They are all such a powerful part of our pop culture landscape today. This statue was our first redesign of our DC characters for the Premium Format™. We toned down the stars in her costume. Originally, her costume reflected the American flag much more. There's more gold-work in there now. We added more practicality to the elements, and the result is a sexy, confident, and strong icon."

—Jason Eastman, Vice President | Creative Development

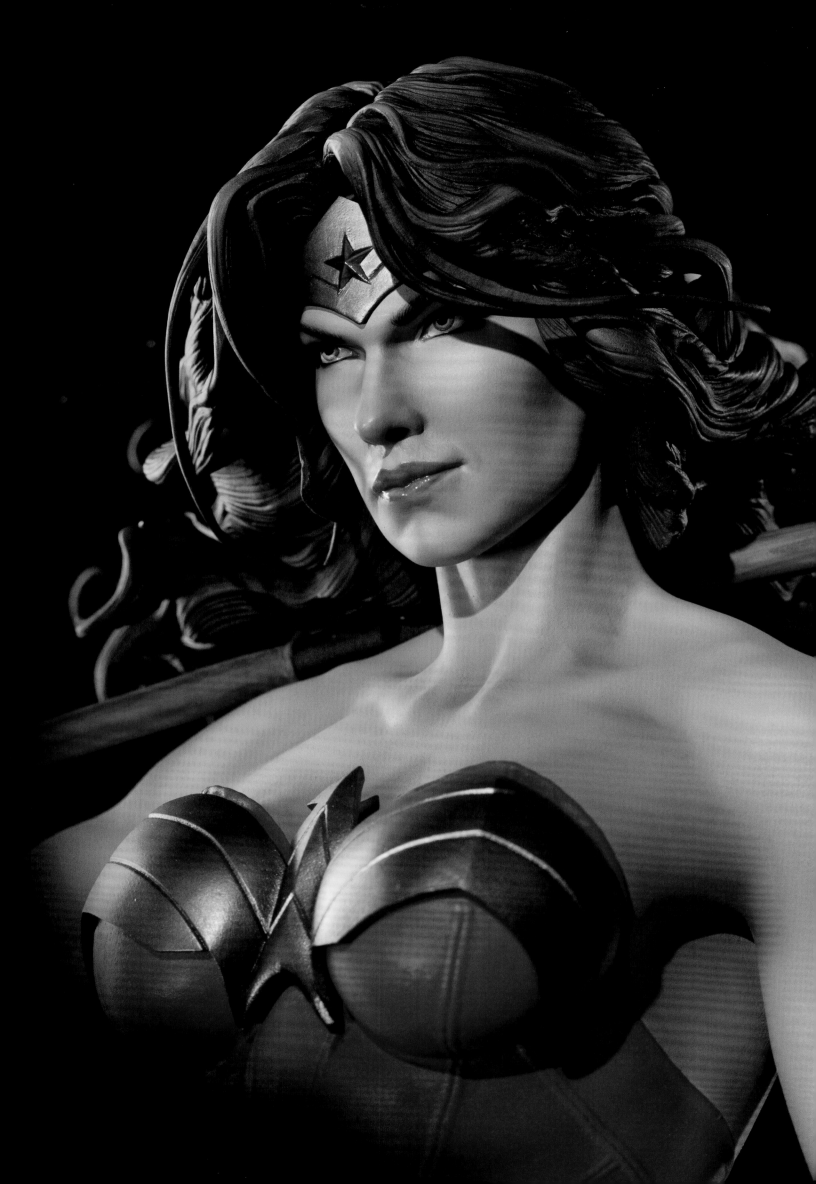

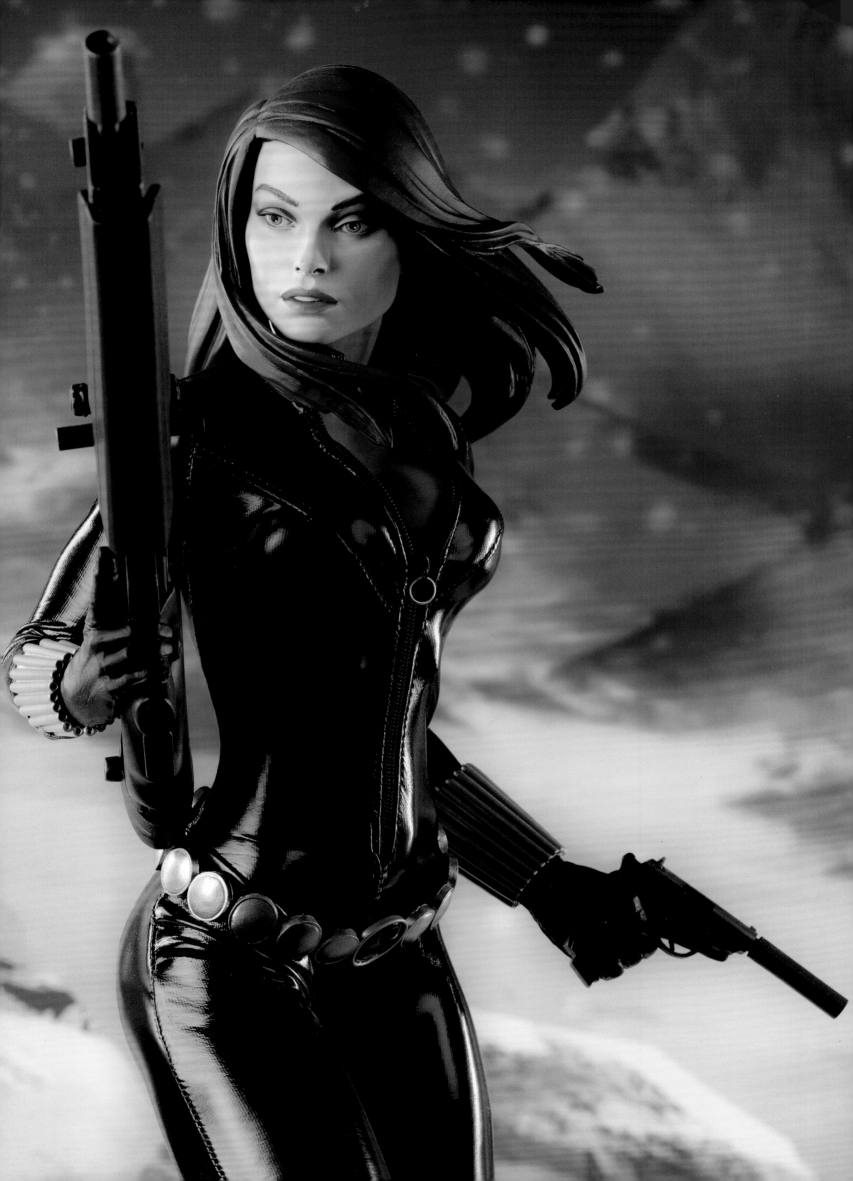

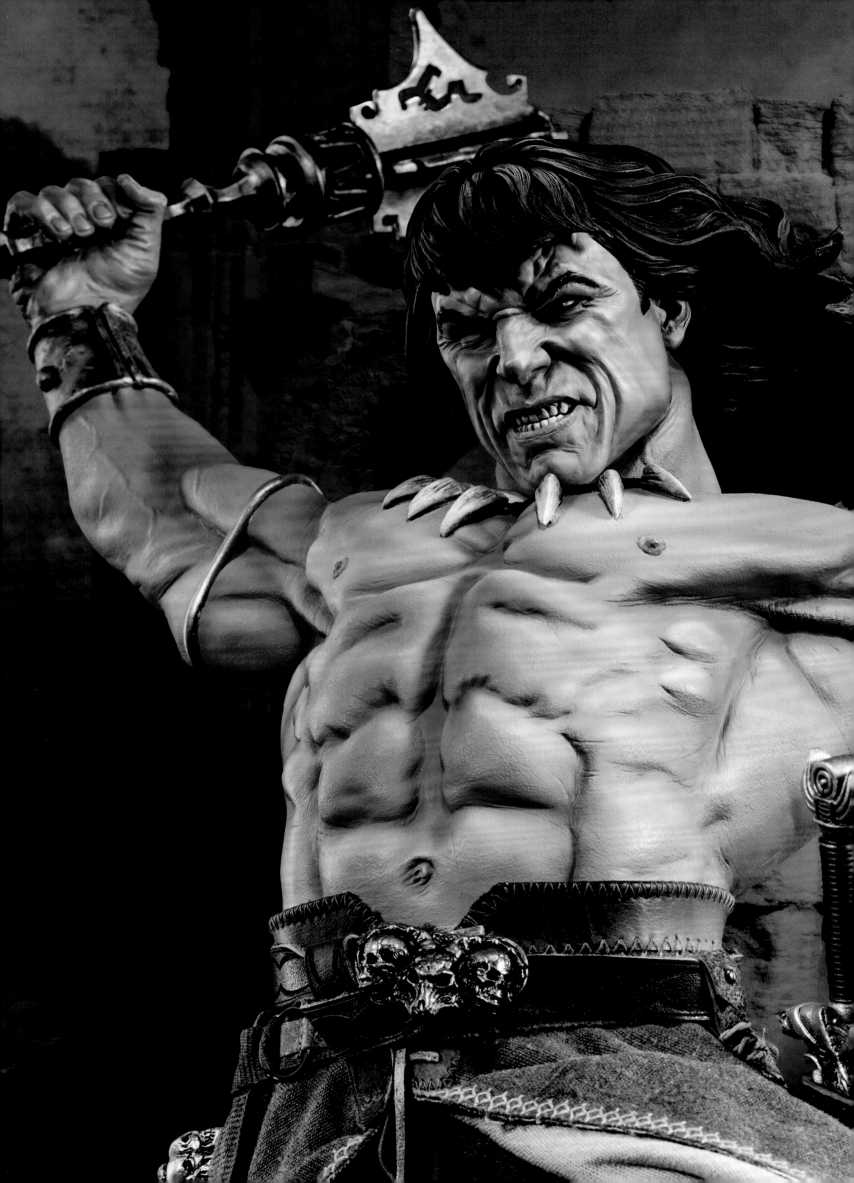

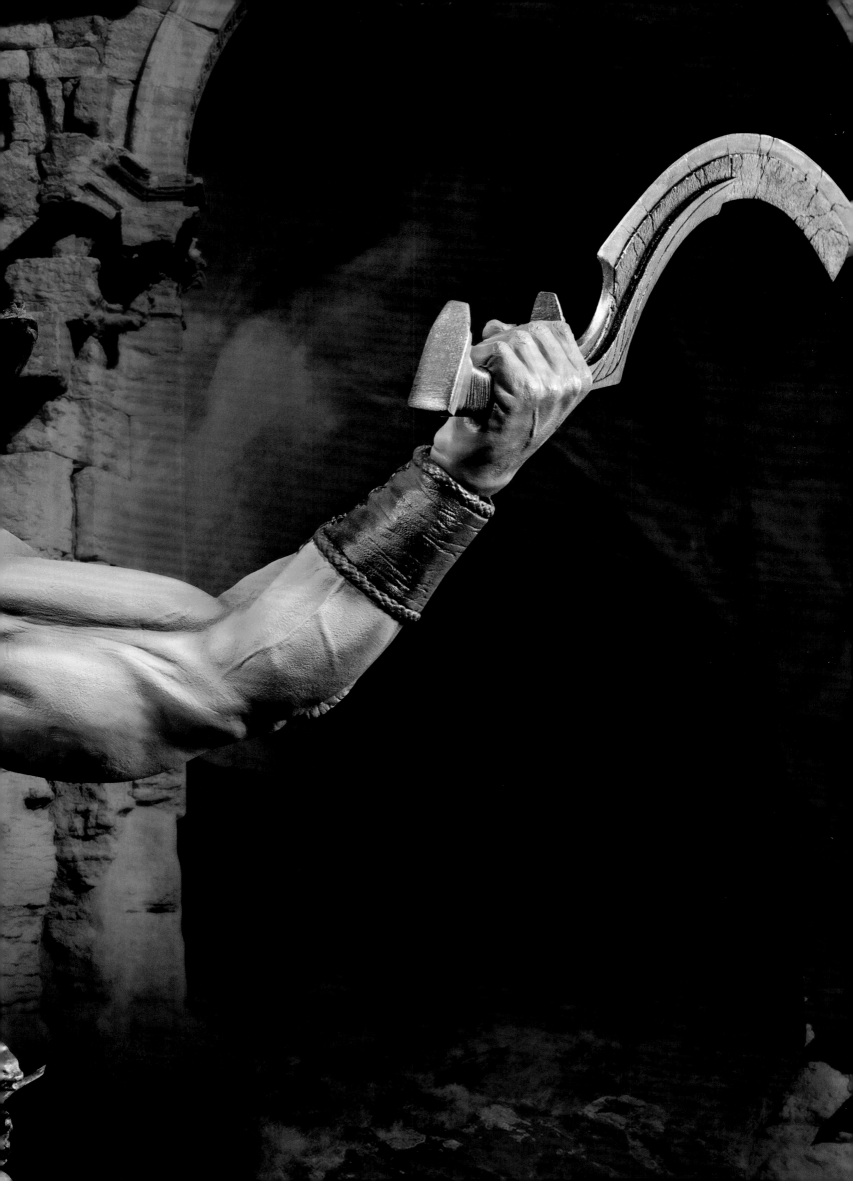

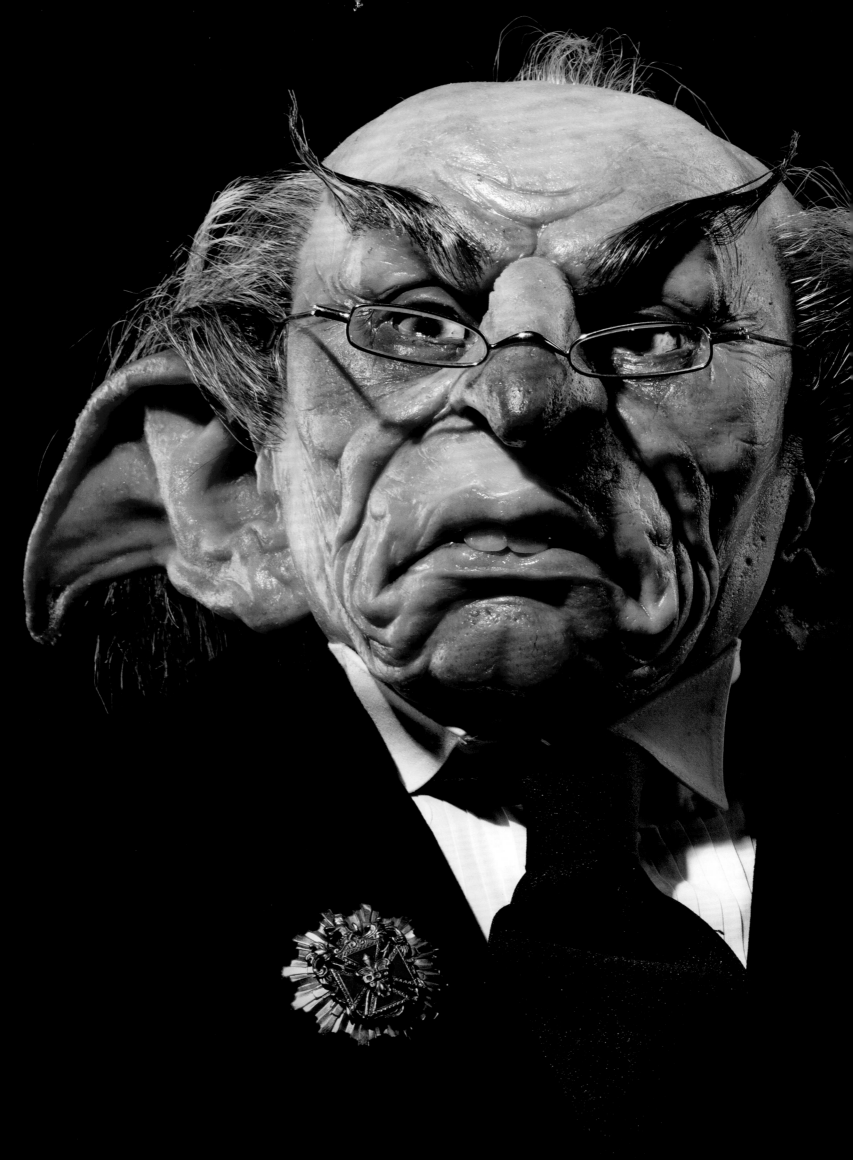

*It was Krypton that made me Superman . . . but it is the Earth that makes me human!* ,,

—*Superman*, Man of Steel #6

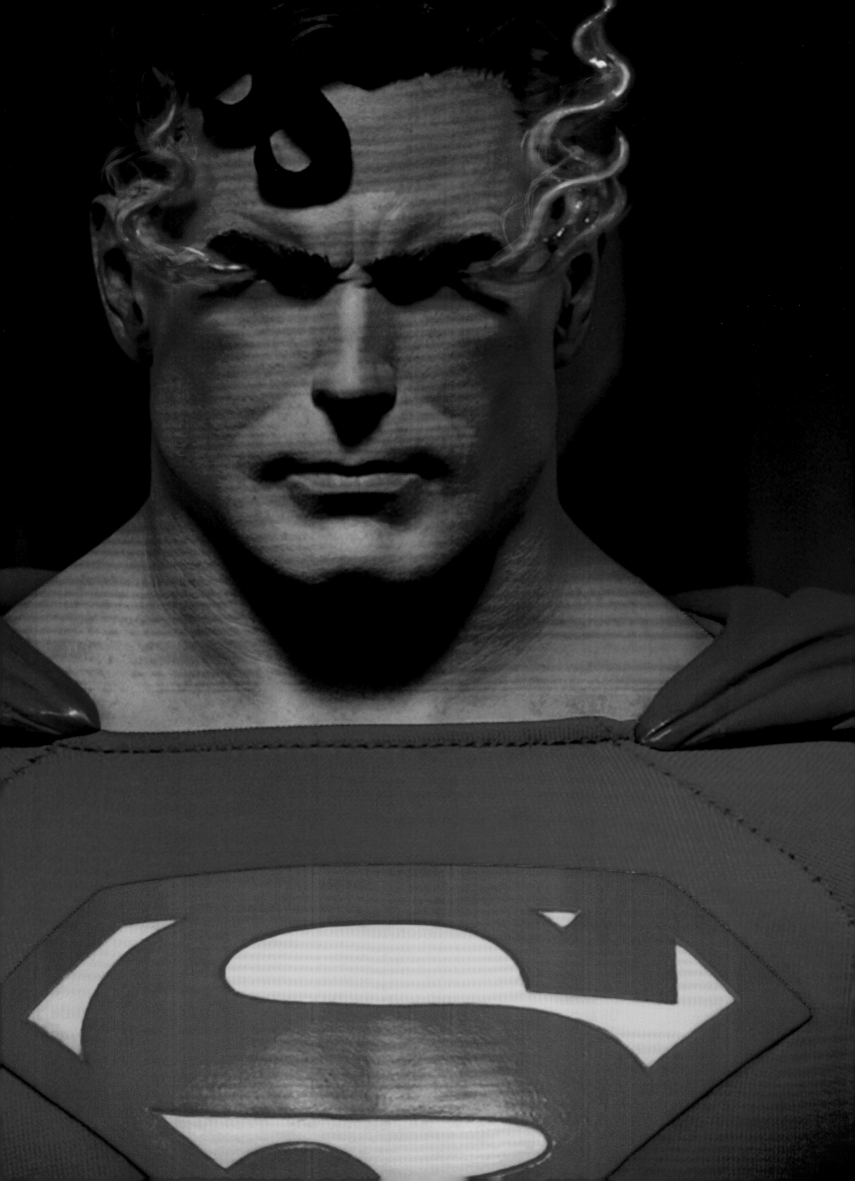

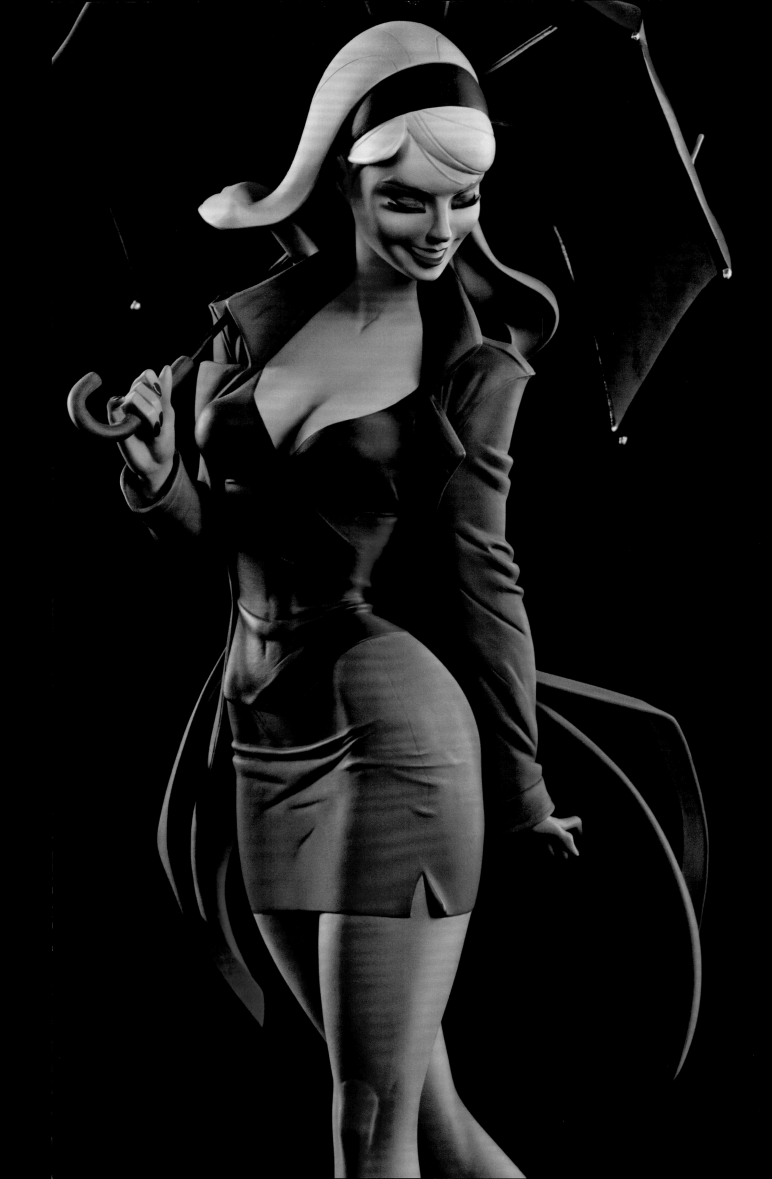

*"I ain't no fraggin' hero. I'm th' main man. I booze. I womanize. I swear.
An' I beat th' living crap outta anybody I fraggin' feel like."*

*—Lobo, Lobo #62*

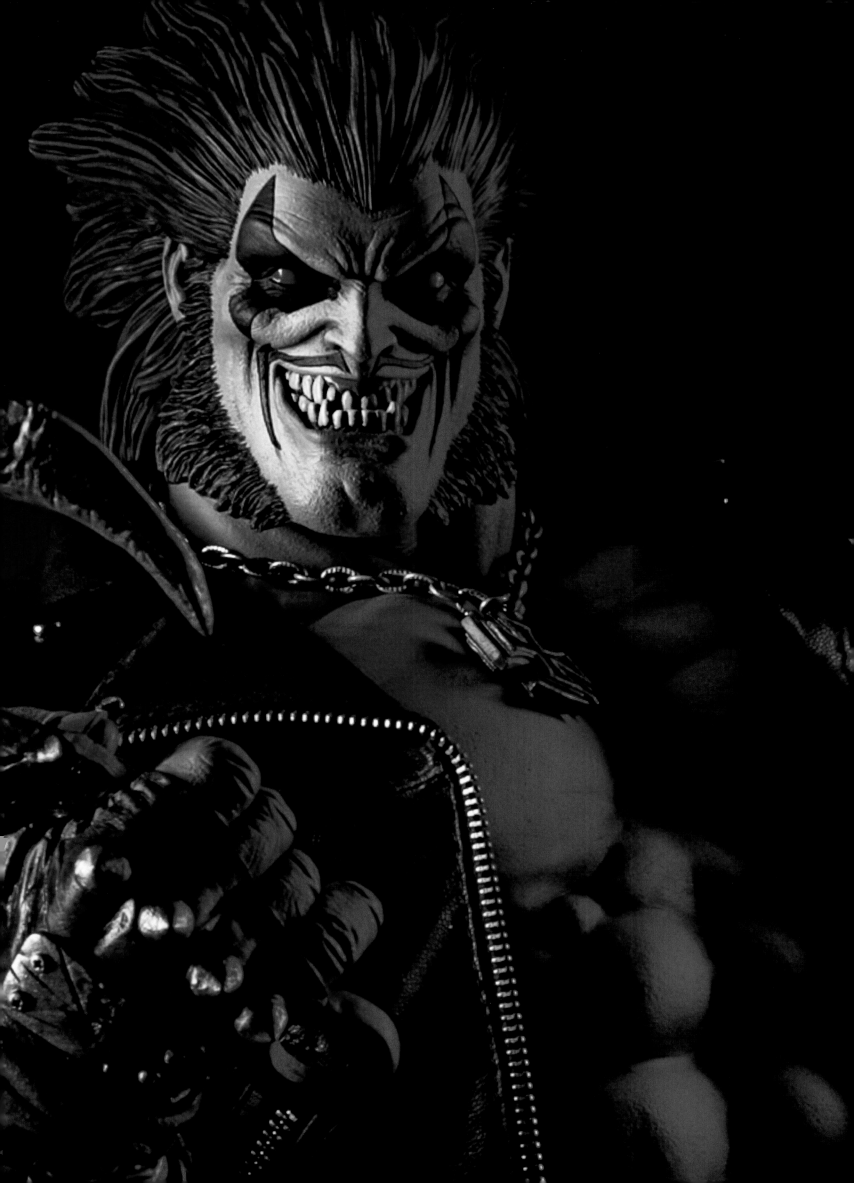

"*Lobo epitomizes everything that is cool to me. He is the last of a certain race and is a bounty hunter with the exact same strength as Superman, but with the exact opposite attitude. He is like this rock star with all these tattoos and a different color skin—powerful, smart, funny, super R-rated, and obnoxiously cocky. He really doesn't give a damn and just wants to get the job done.*"

—David Igo, Art Director

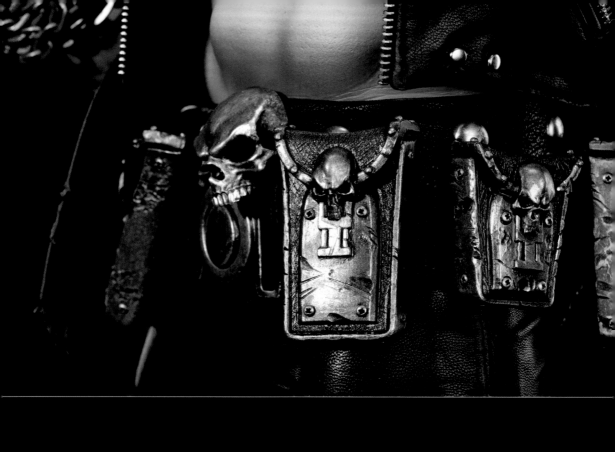

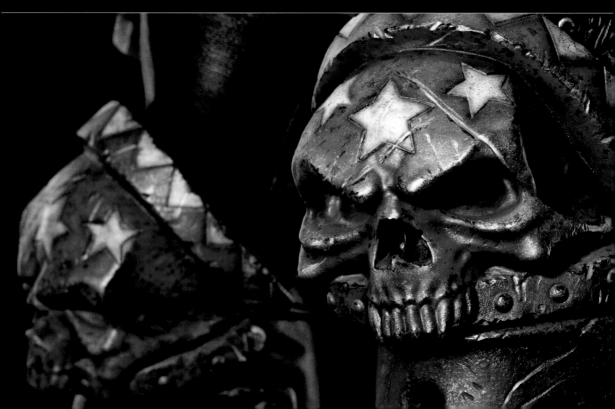

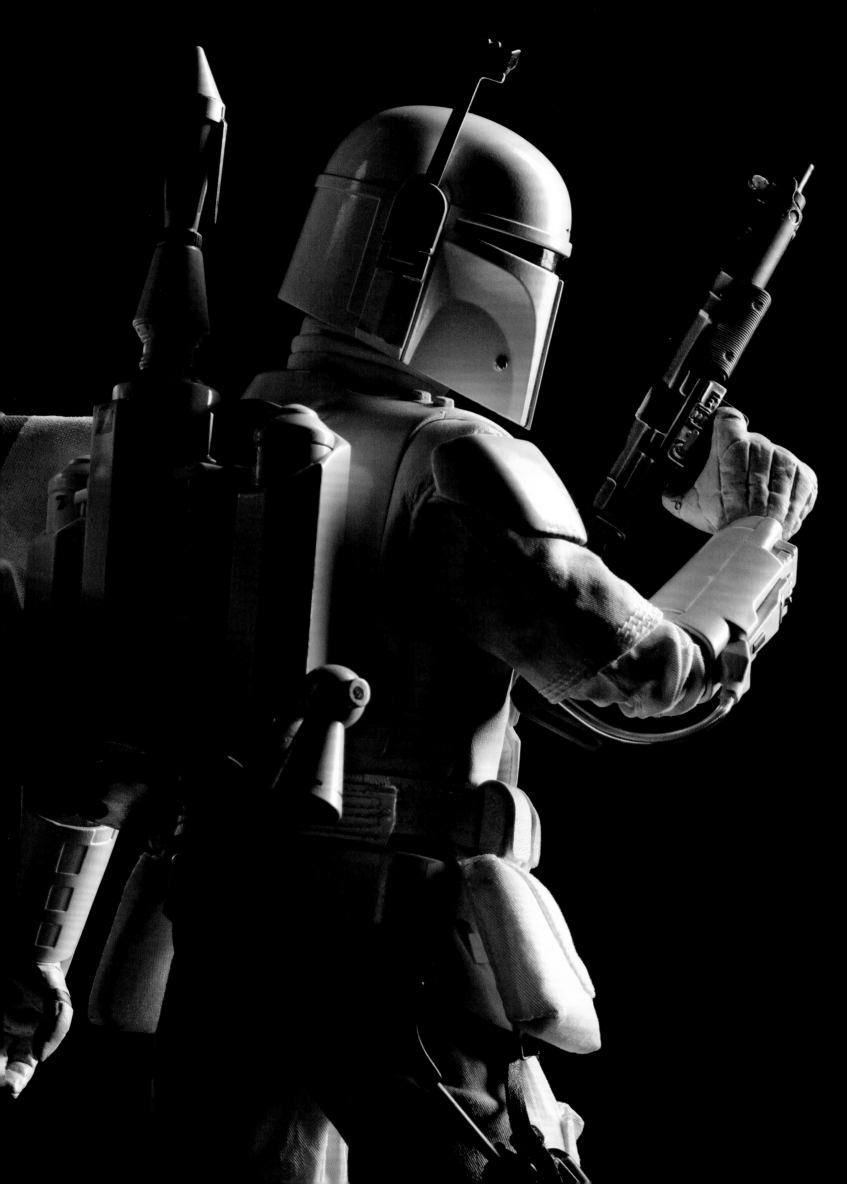

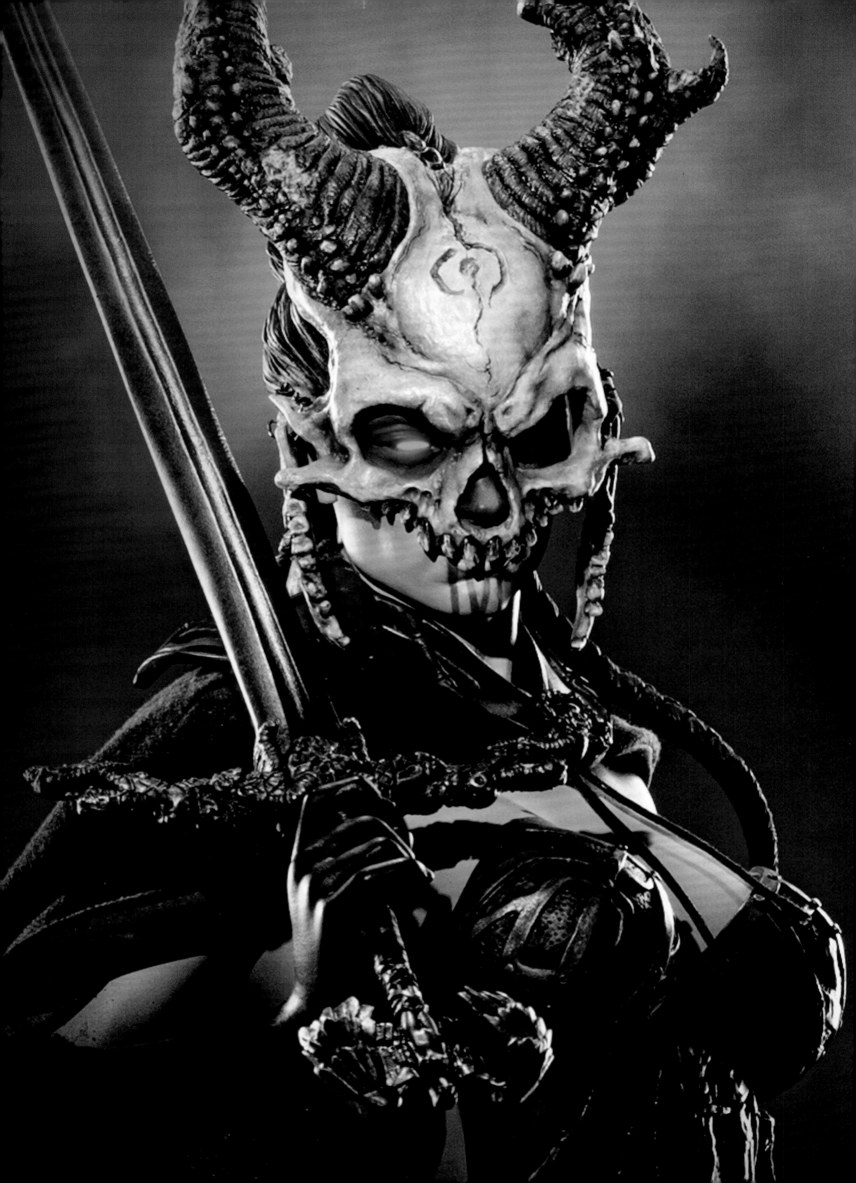

*She is out there somewhere. My sister. She stole all that I was and all that I could have been and left nothing but death for me. So to Death I belong . . . and someday, so shall she.*

—*Kier,* Court of the Dead:
The Chronicle of the Underworld

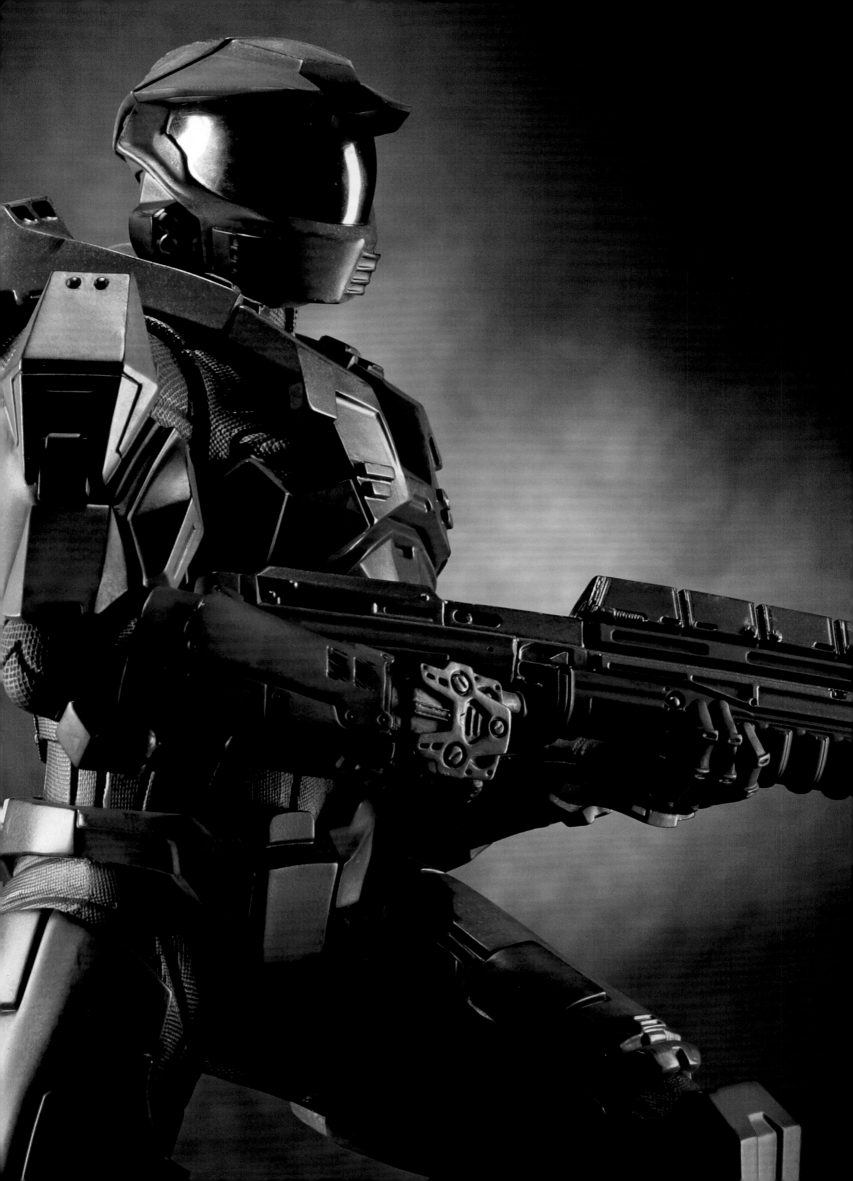

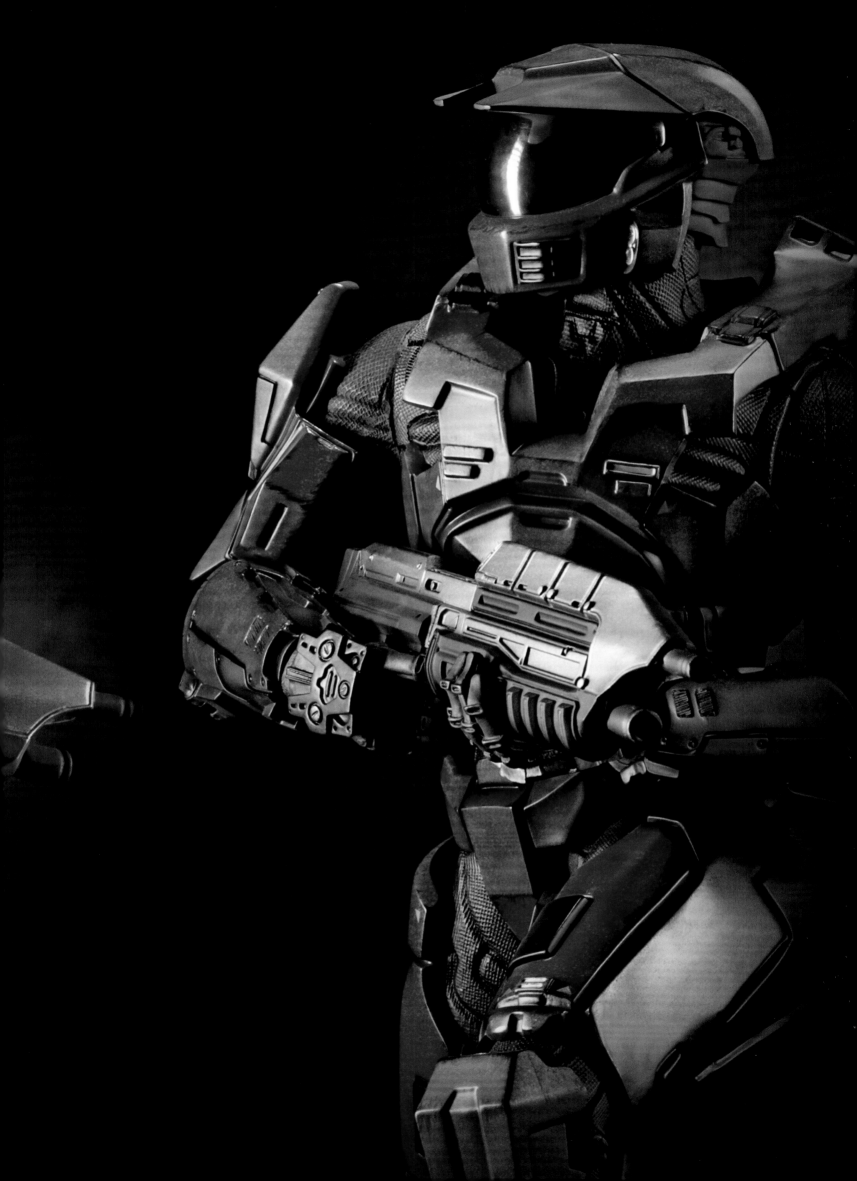

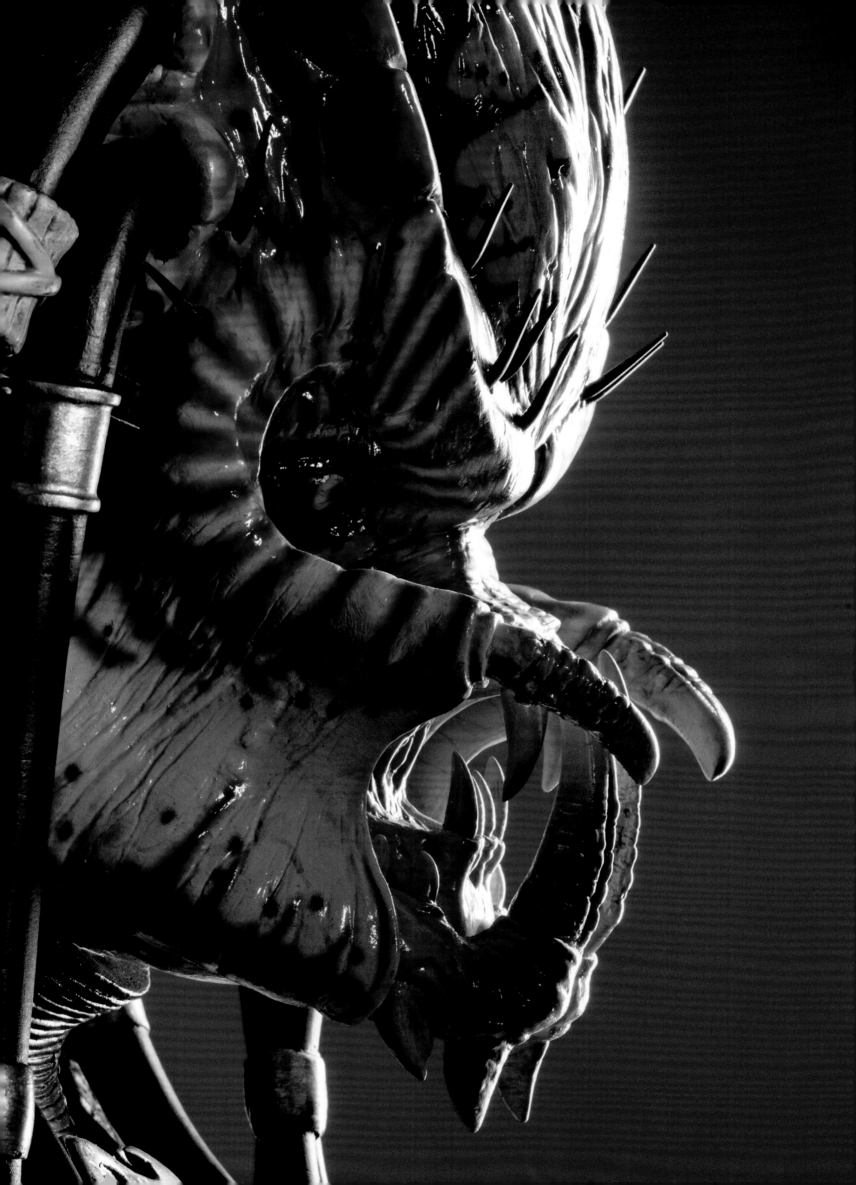

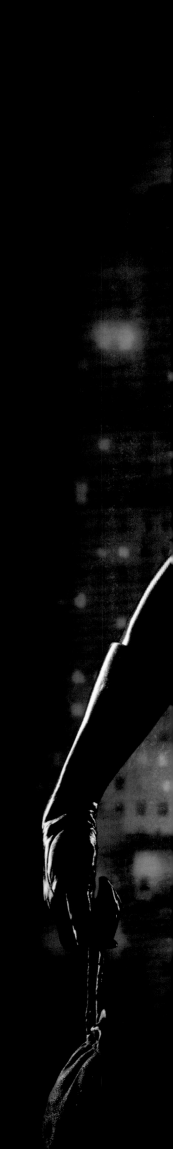

*"Don't be a baby. You'll live, which is more than I can say for anyone else who trusted me tonight."*

—*Catwoman*, Catwoman: Selina's Big Score

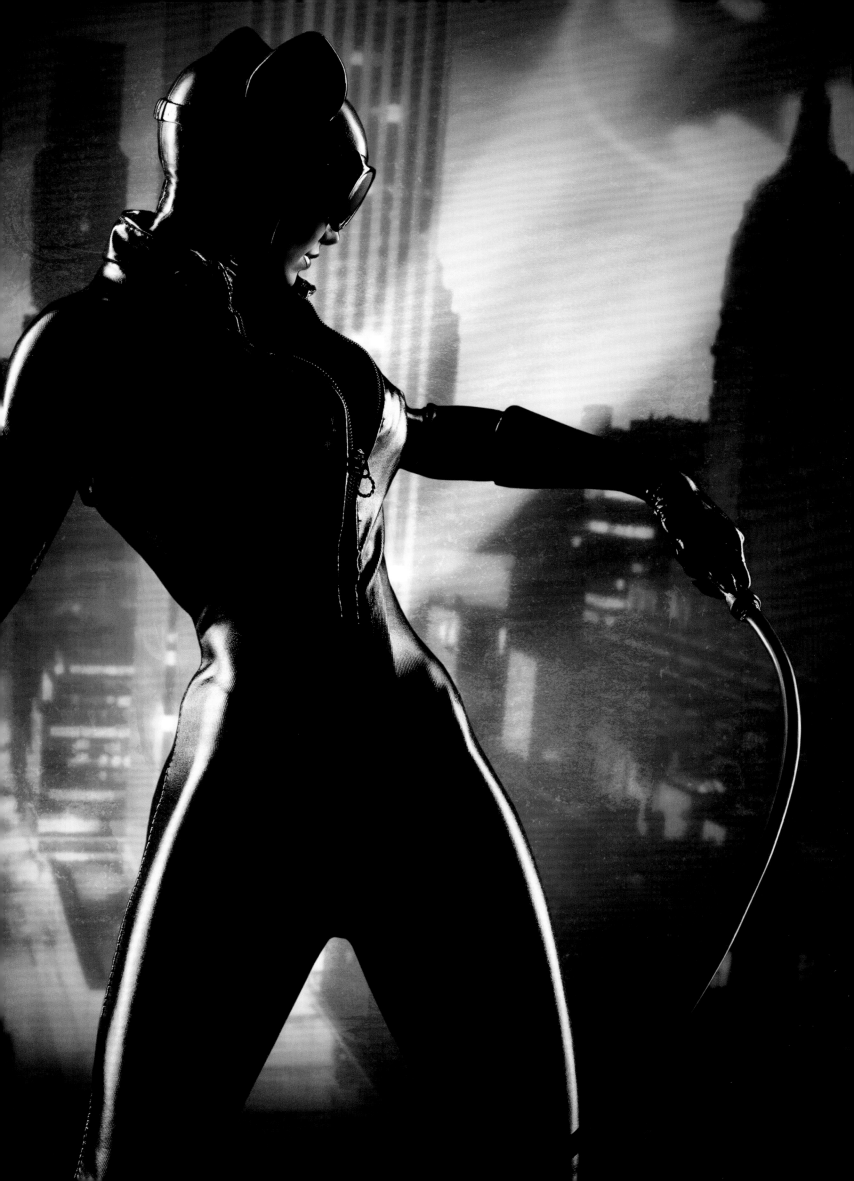

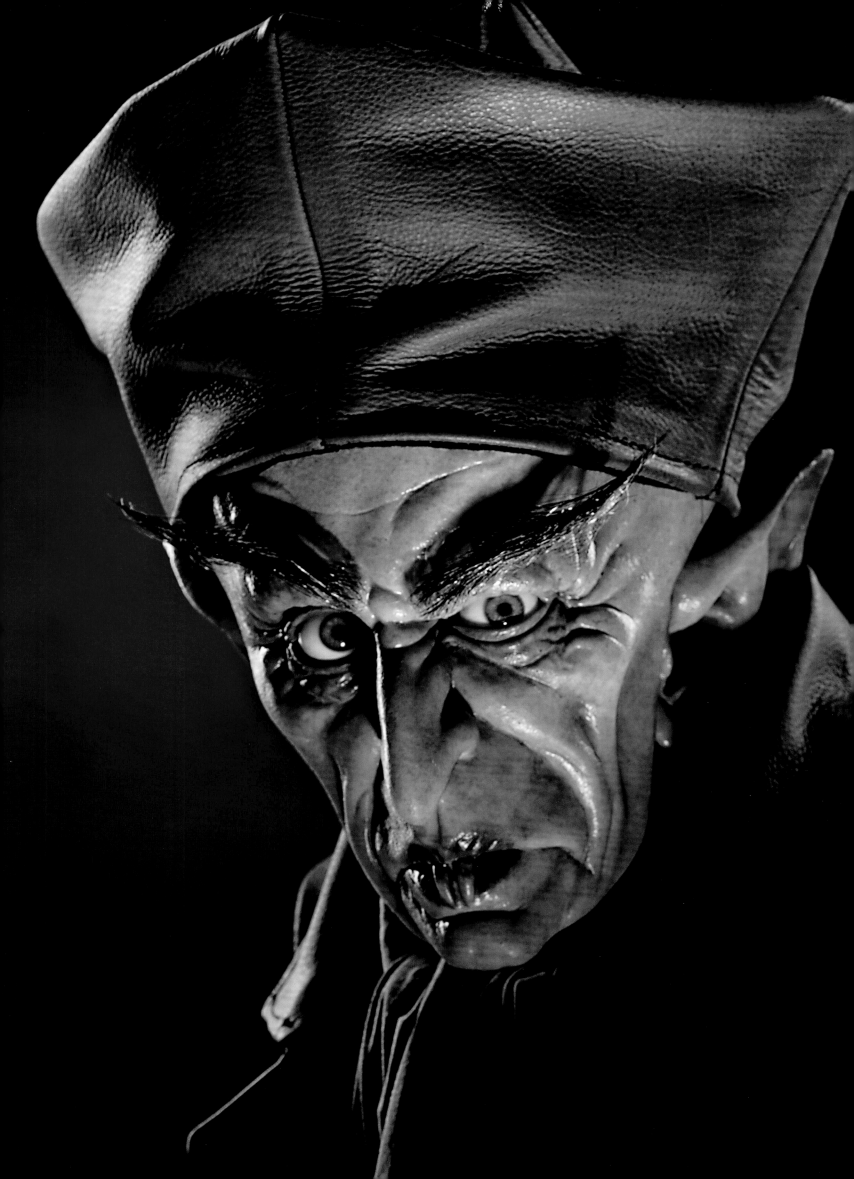

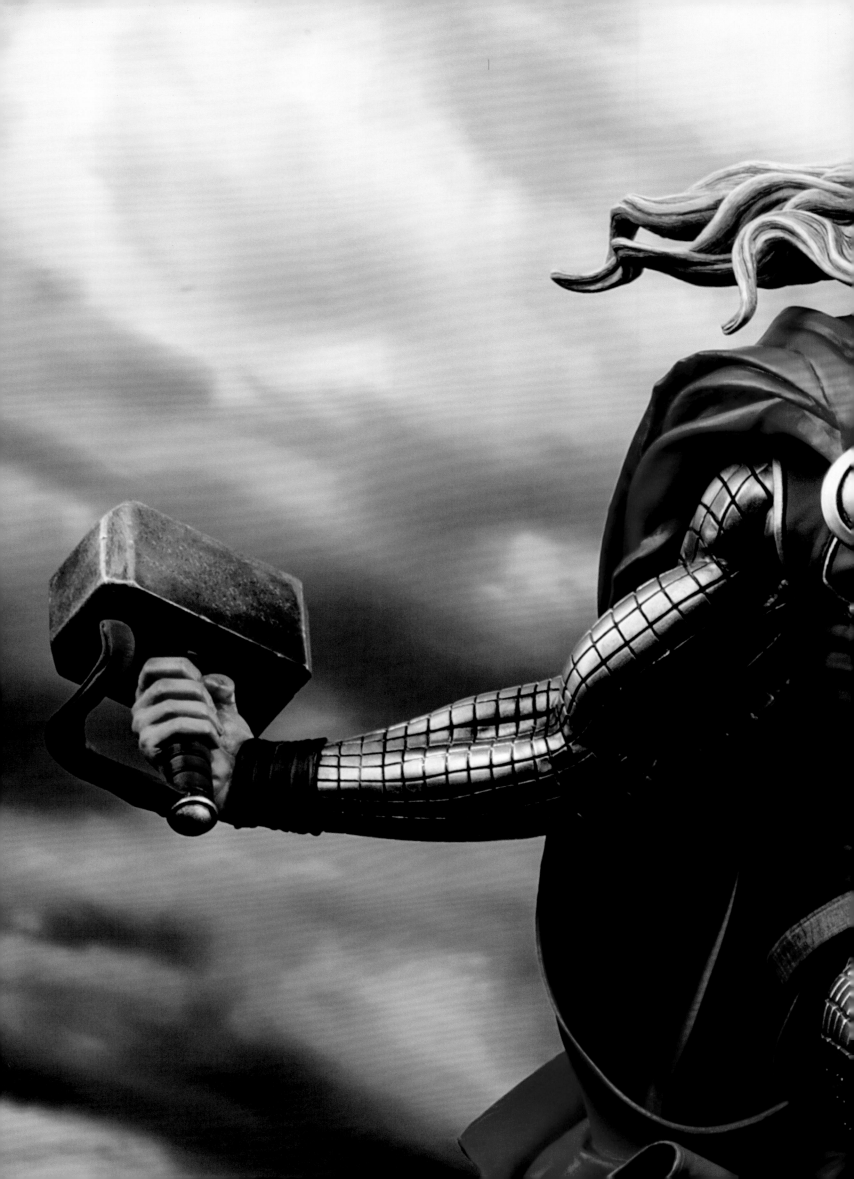

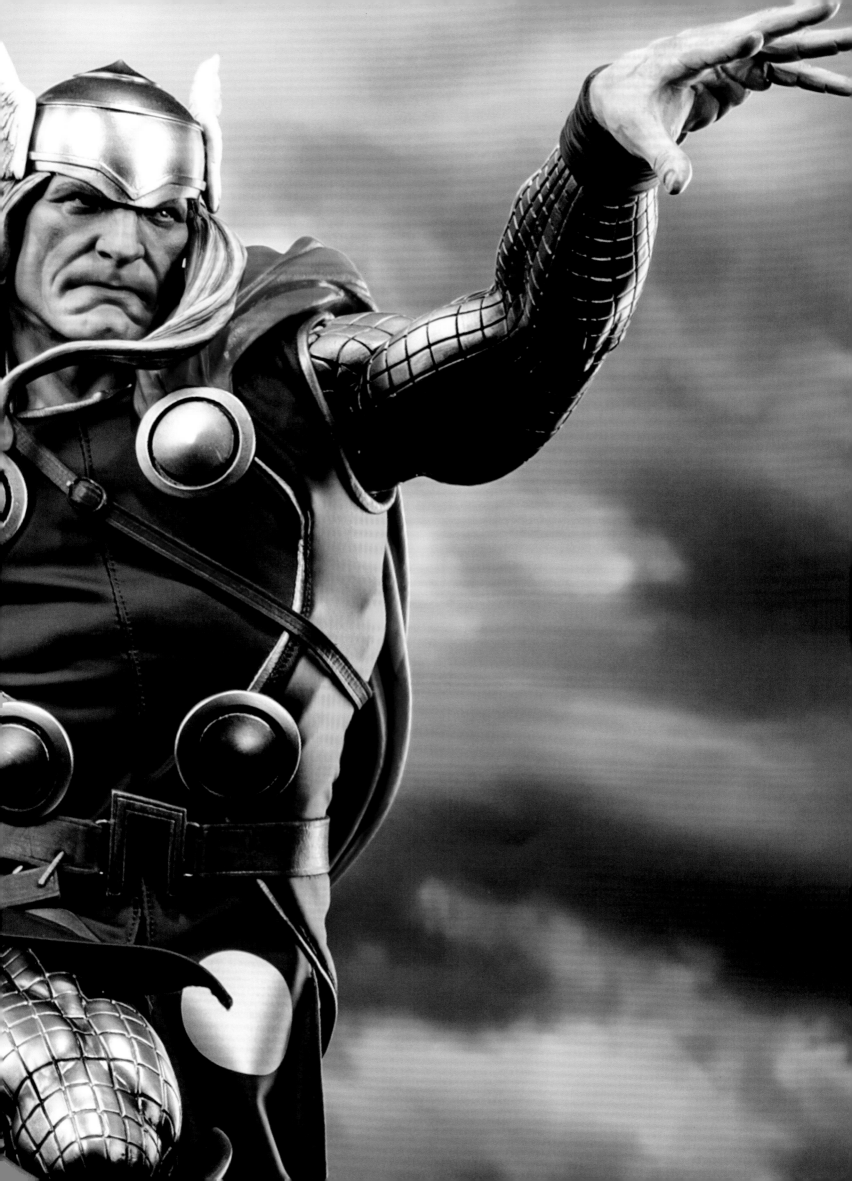

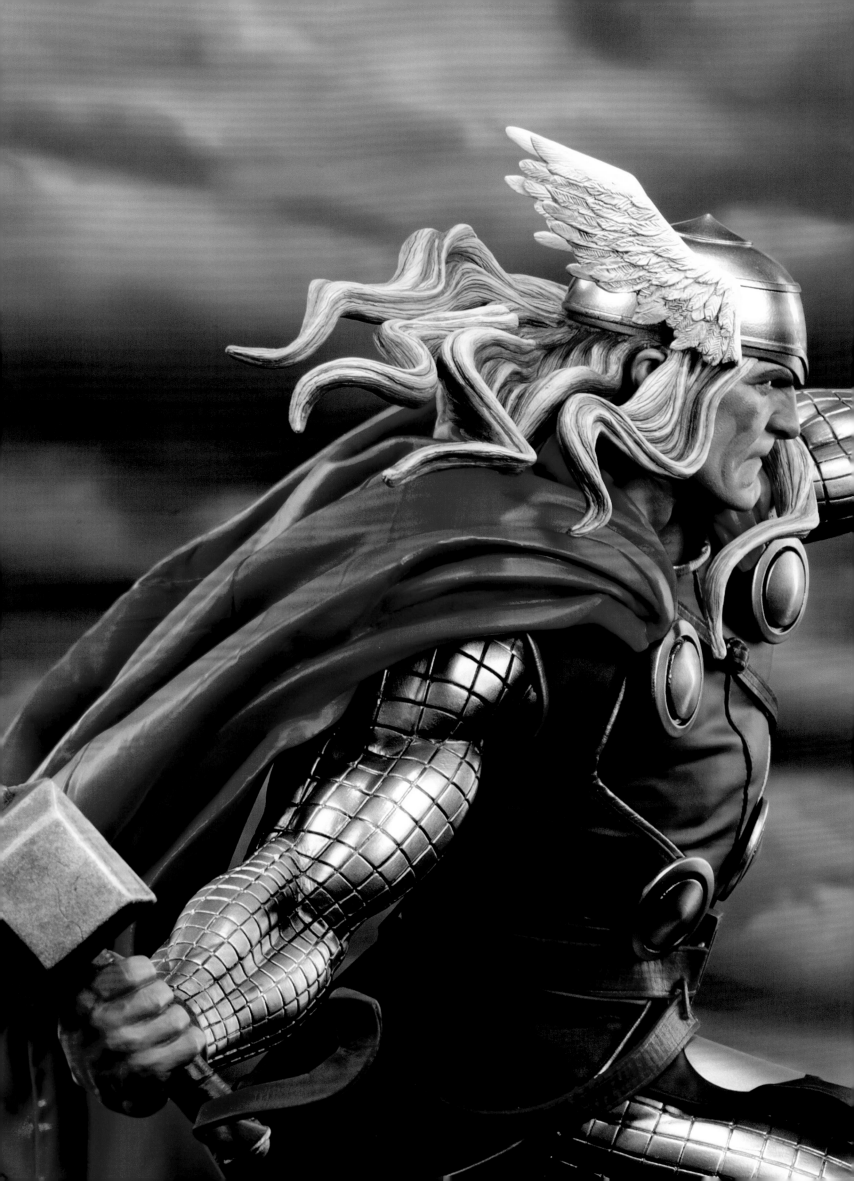

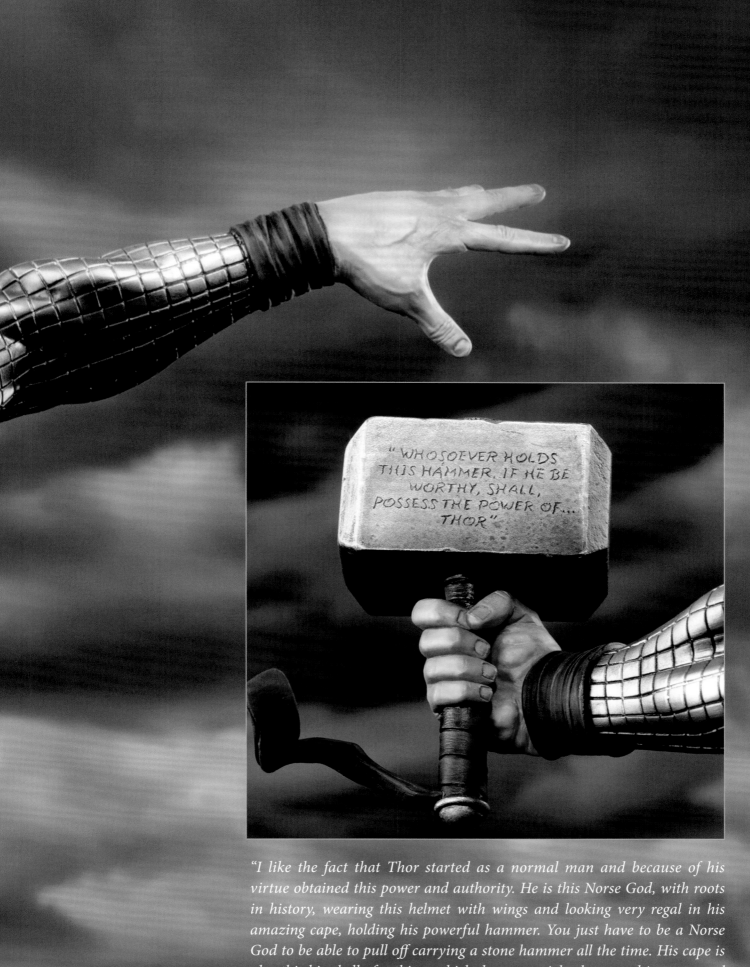

"WHOSOEVER HOLDS THIS HAMMER, IF HE BE WORTHY, SHALL, POSSESS THE POWER OF... THOR"

"I like the fact that Thor started as a normal man and because of his virtue obtained this power and authority. He is this Norse God, with roots in history, wearing this helmet with wings and looking very regal in his amazing cape, holding his powerful hammer. You just have to be a Norse God to be able to pull off carrying a stone hammer all the time. His cape is also this big shell of a thing, which drapes straight down and is structured in a very particular way. It's not your average superhero cape. Of course, he also controls thunder and lightning. Now that's a cool superpower to have."

—Matt Black, Sculptor & 3D Key Artist

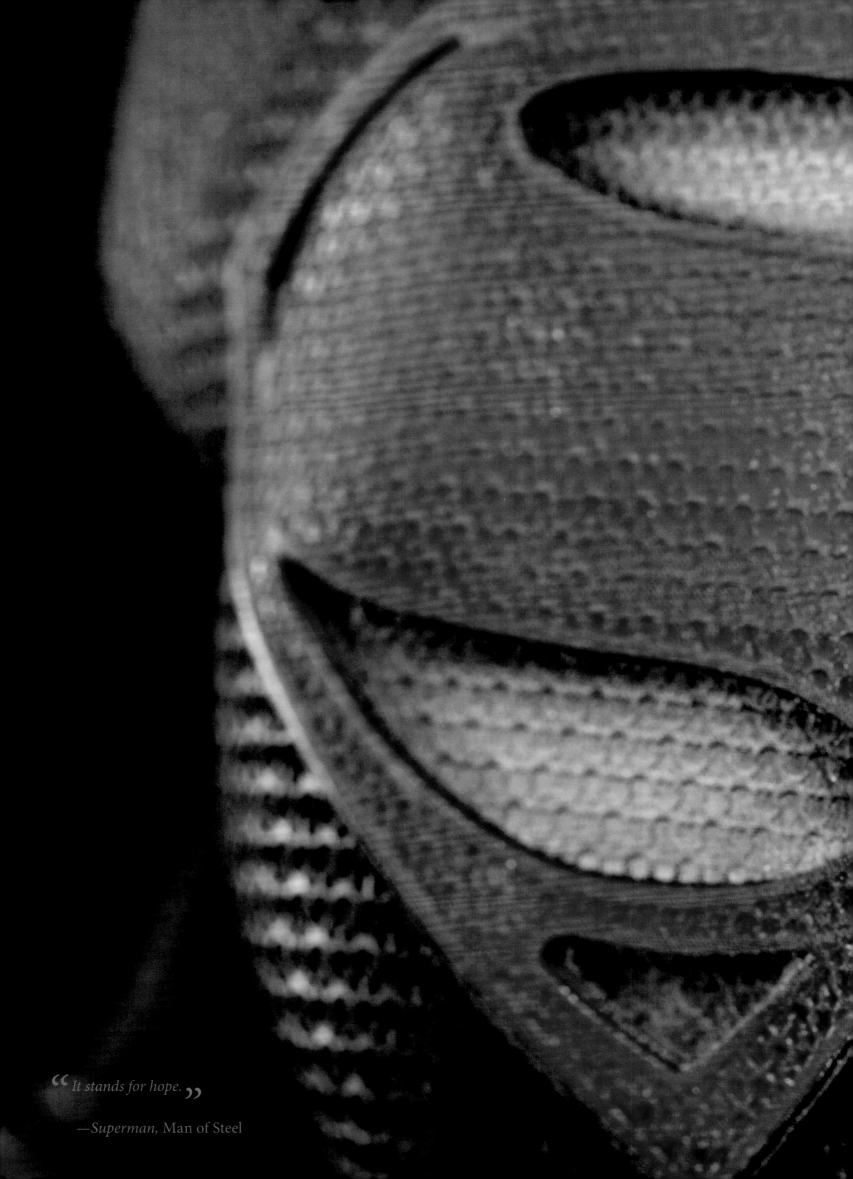

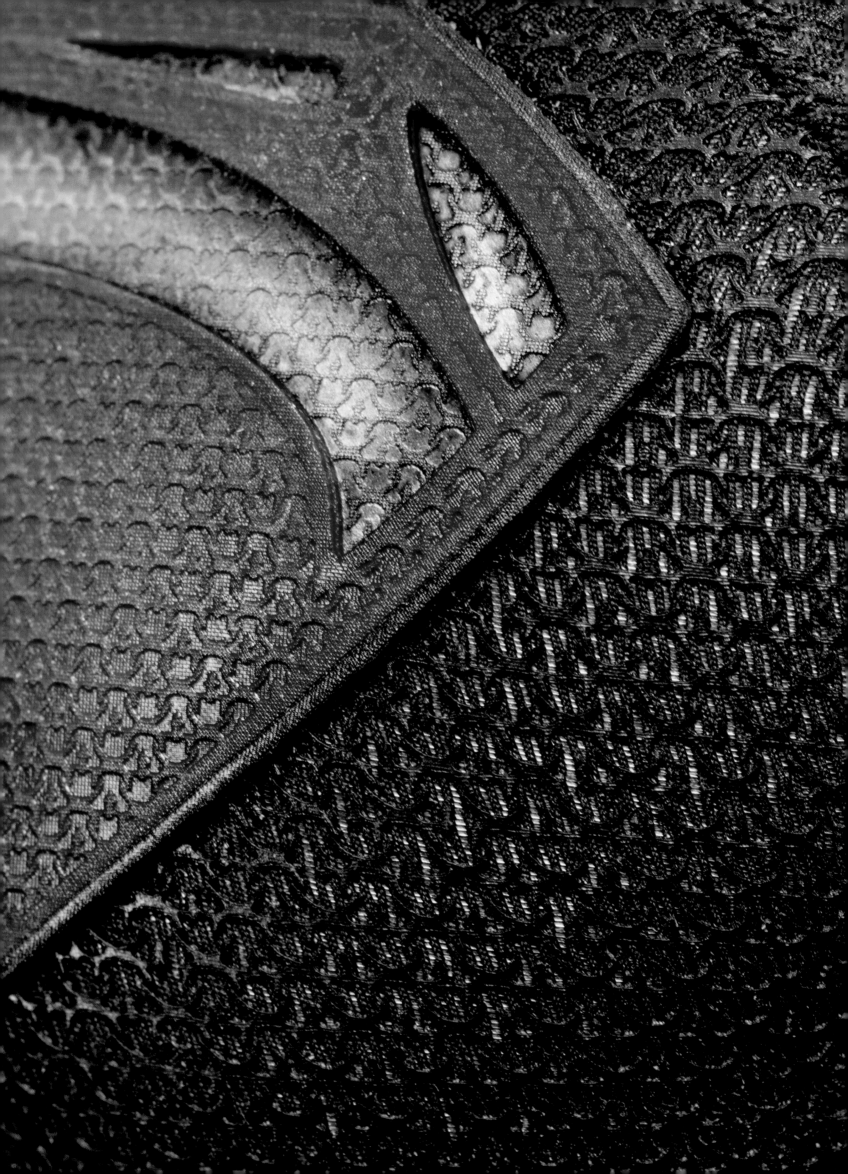

> "*I can smell it on you. The greed. The lust for gold and flesh and power. It is so sweet, is it not? It makes me so hungry . . . just to smell you.*"

—*The Red Death*, Court of the Dead
The Chronicle of the Underworld

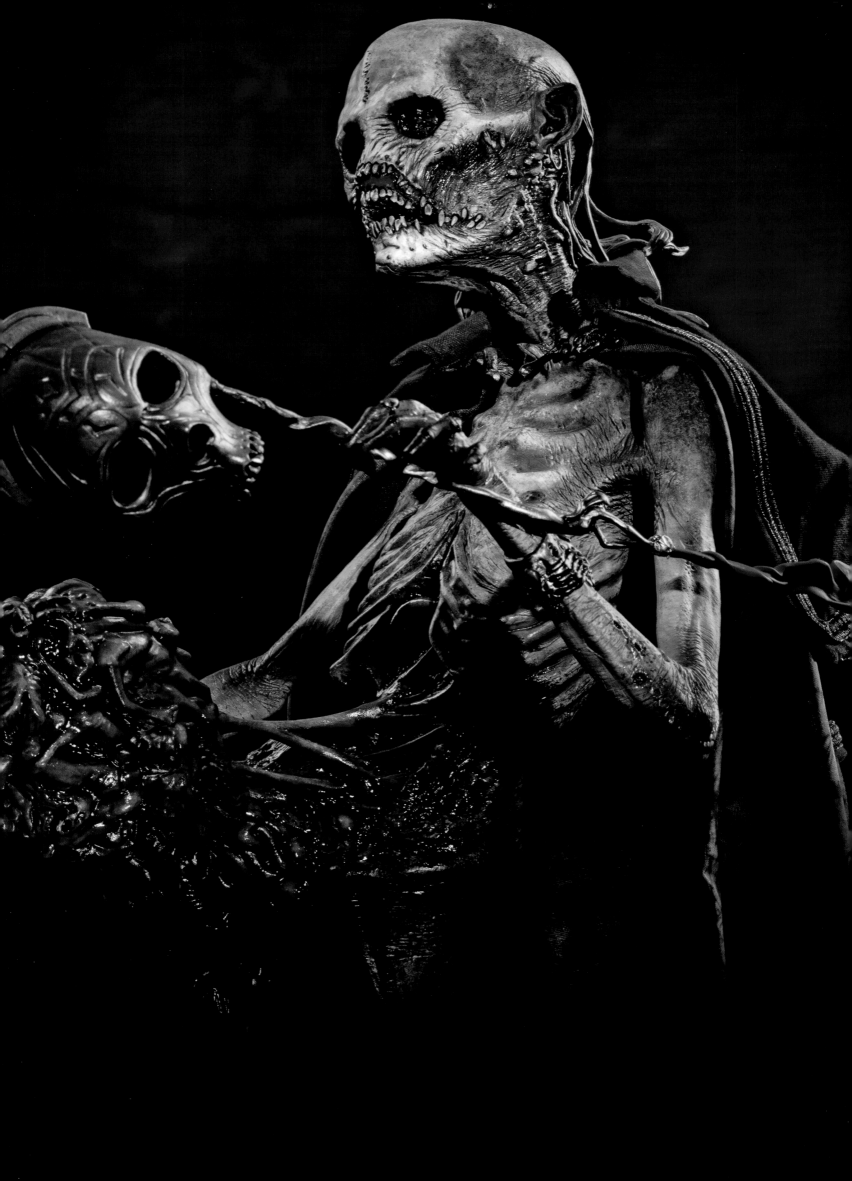

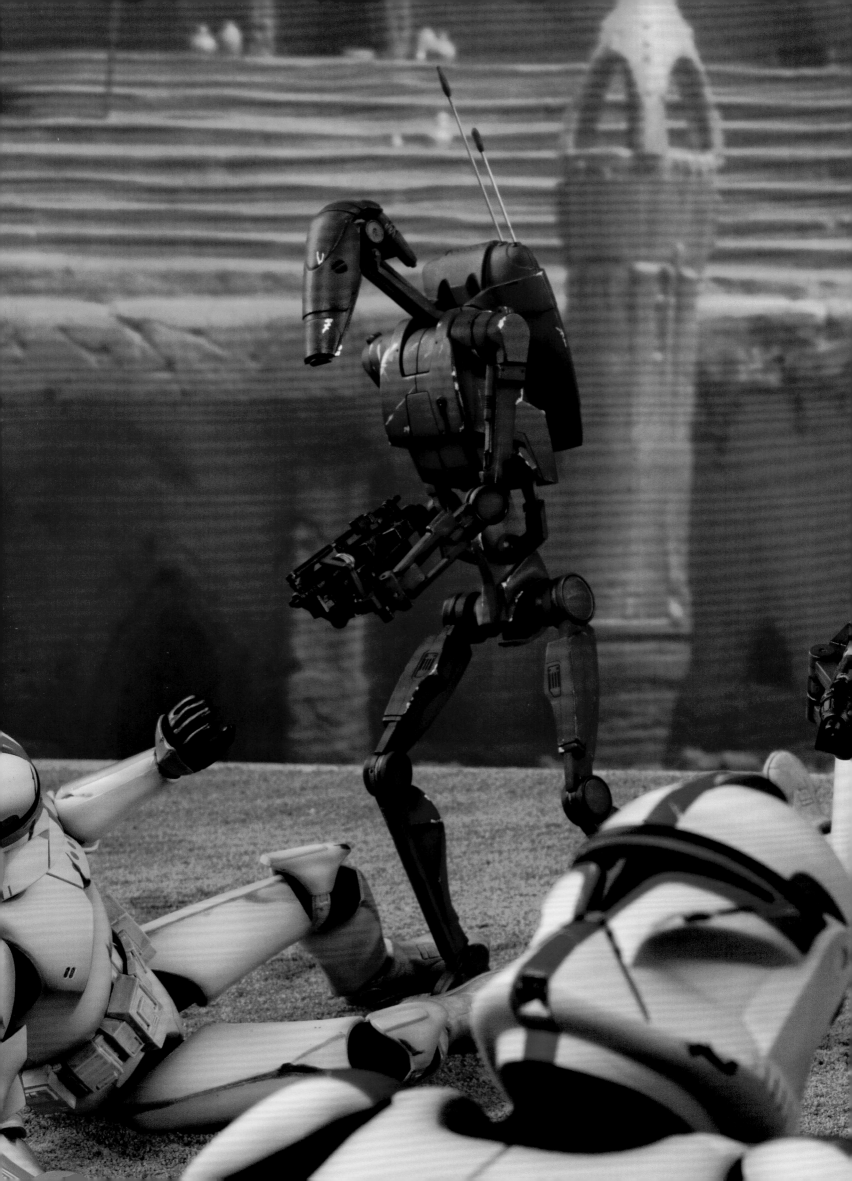

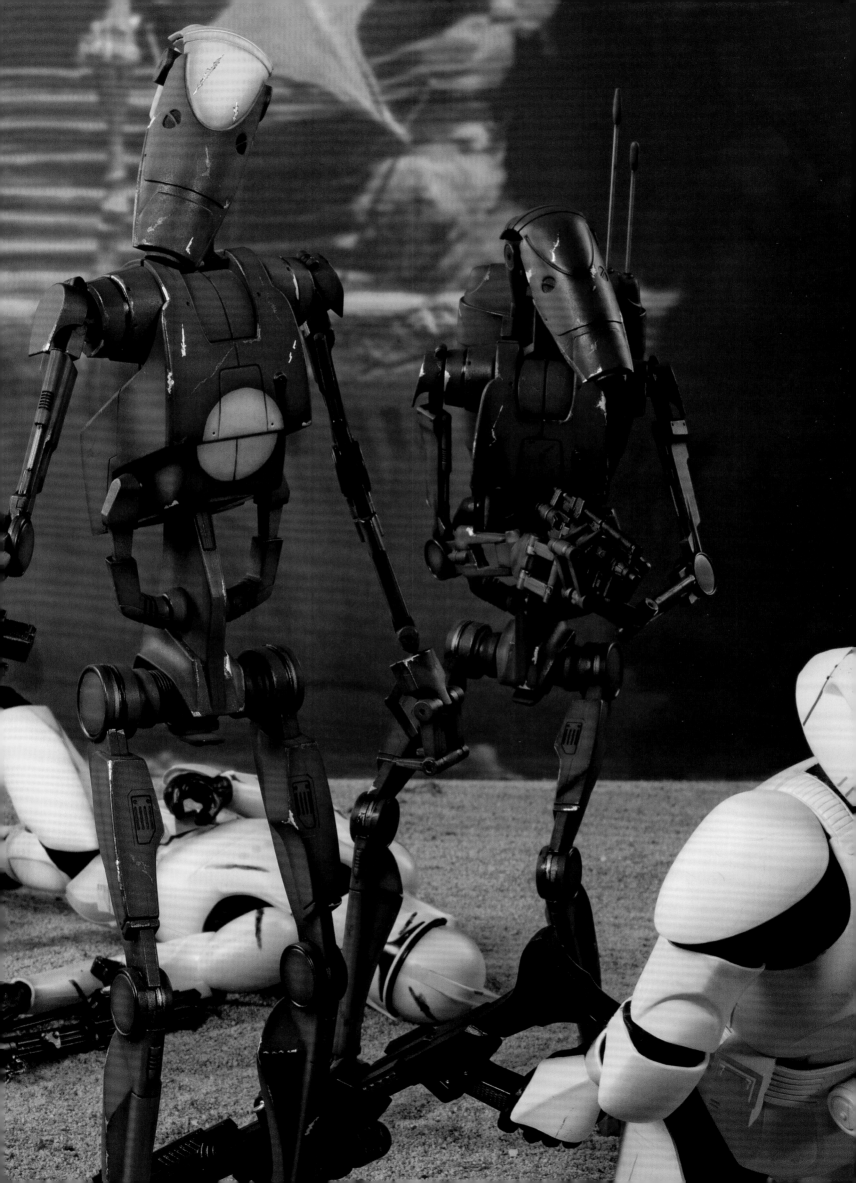

*Madness is the emergency exit. You can just step outside, and close the door on all those dreadful things that happened. You can lock them away . . . forever.*

—*The Joker*, Batman: The Killing Joke

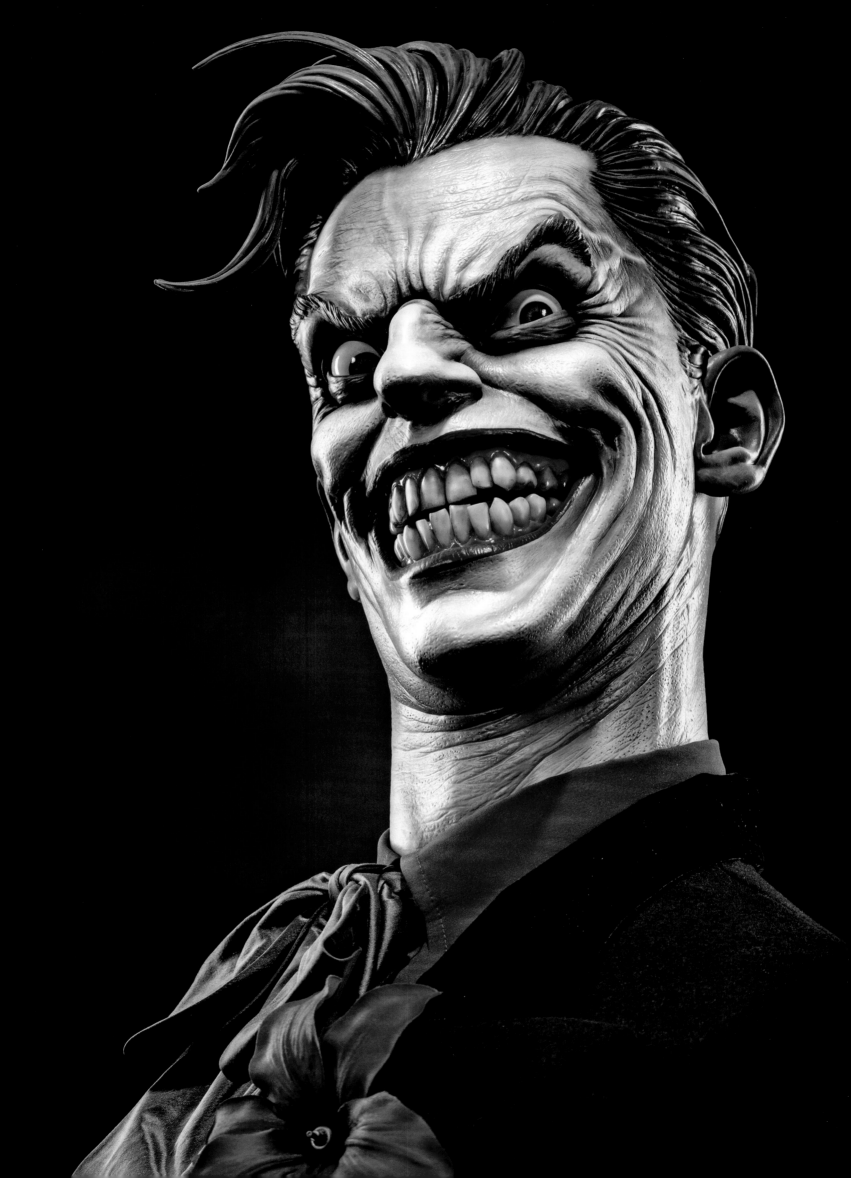

"The Joker is a villain, pure and simple. I love the fact that he isn't in it for lots of money or world domination. His intentions are beyond something that one would consider typical; they are pure chaos. And the Joker thrives on chaos. He is comedy and tragedy personified. For everything that Batman represents, the Joker is the antithesis: His character offers the silliness and humor that Batman's serious personality lacks. I love that this bust literally brings the Joker's big personality to a life-size confrontation with the viewer. The Joker is caught in a maniacal laugh, head held slightly back, his eyes making an intense eye contact. Caught in his gaze, I'm trapped within the reality that I'm about to become his next punch line, and I realize that I may not have much time left to live, so I might as well laugh along."

—*Ginny Guzman, Photography Manager*

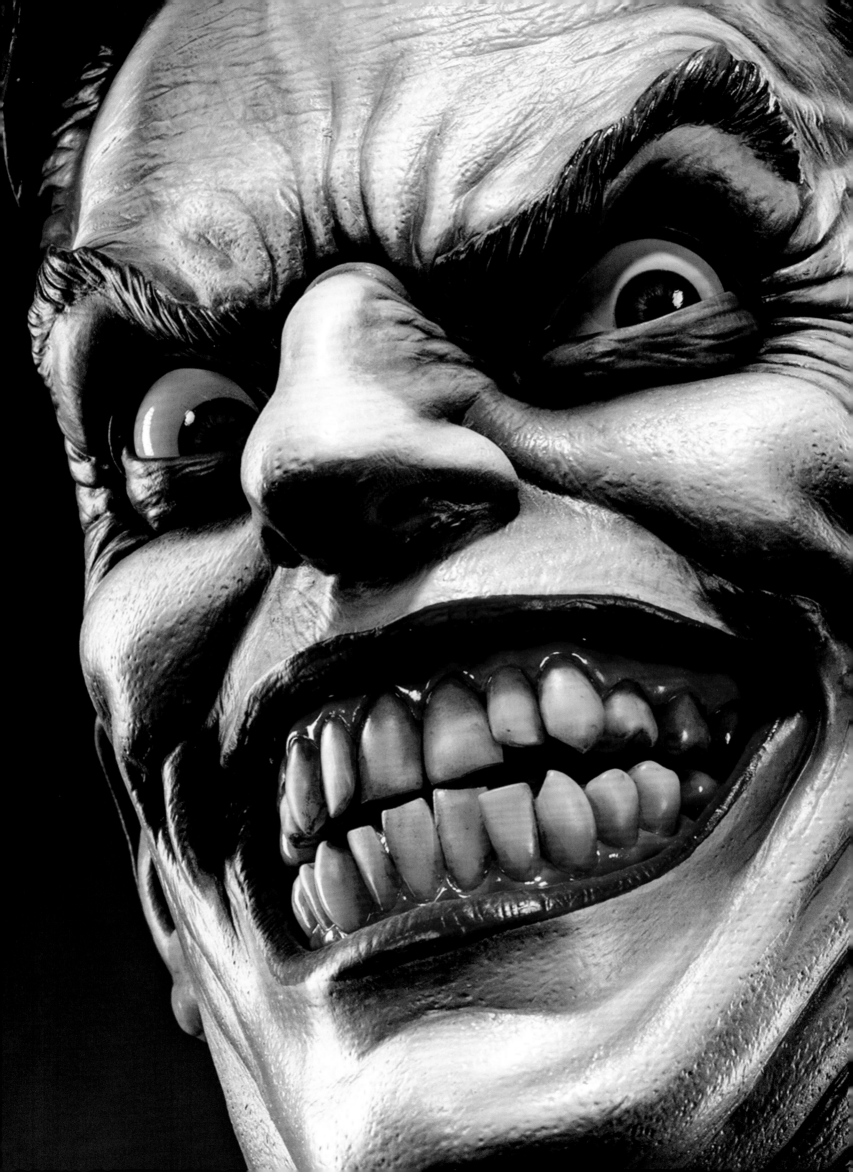

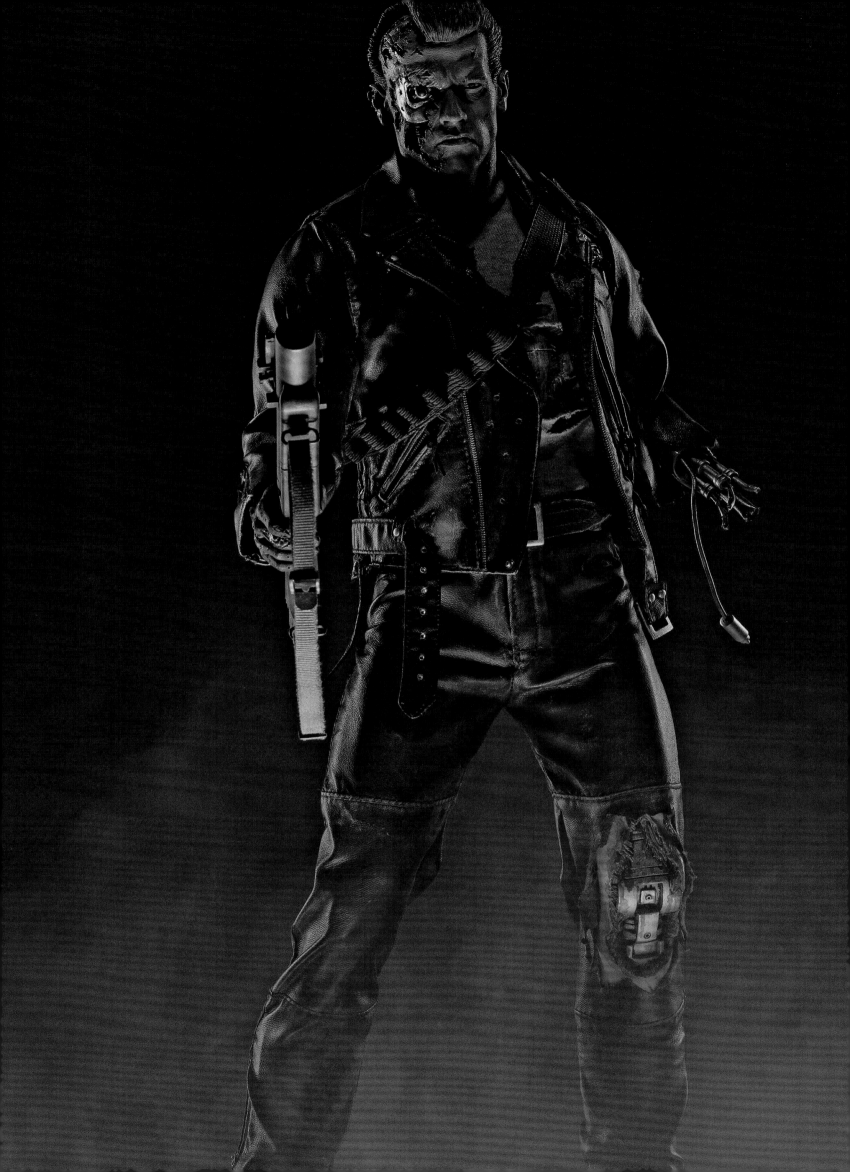

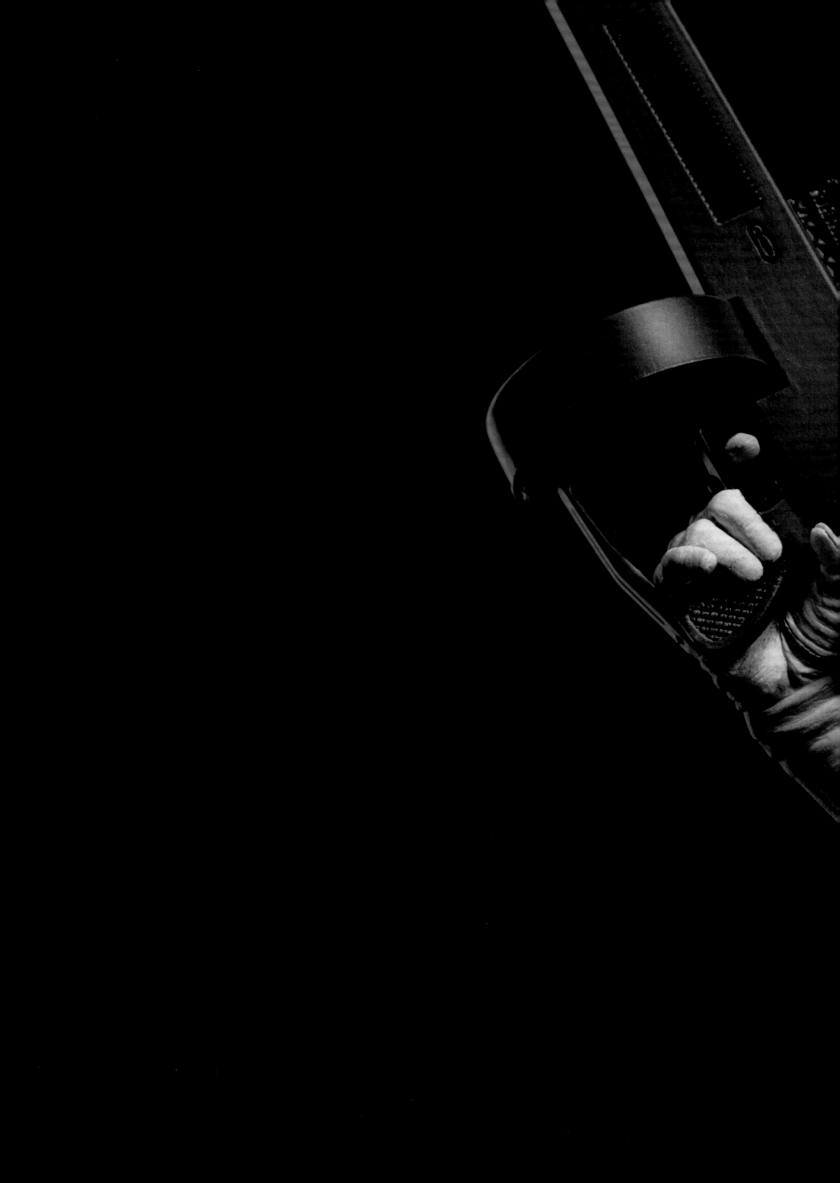

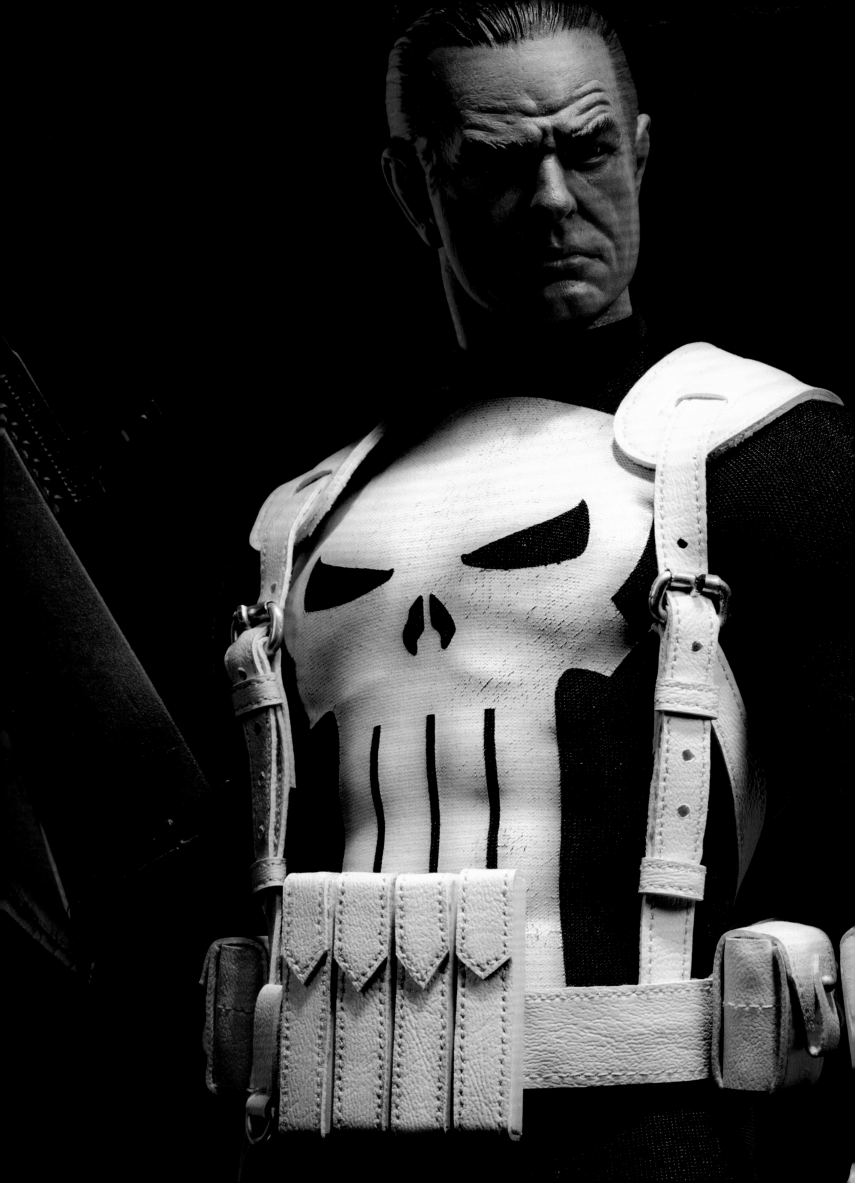

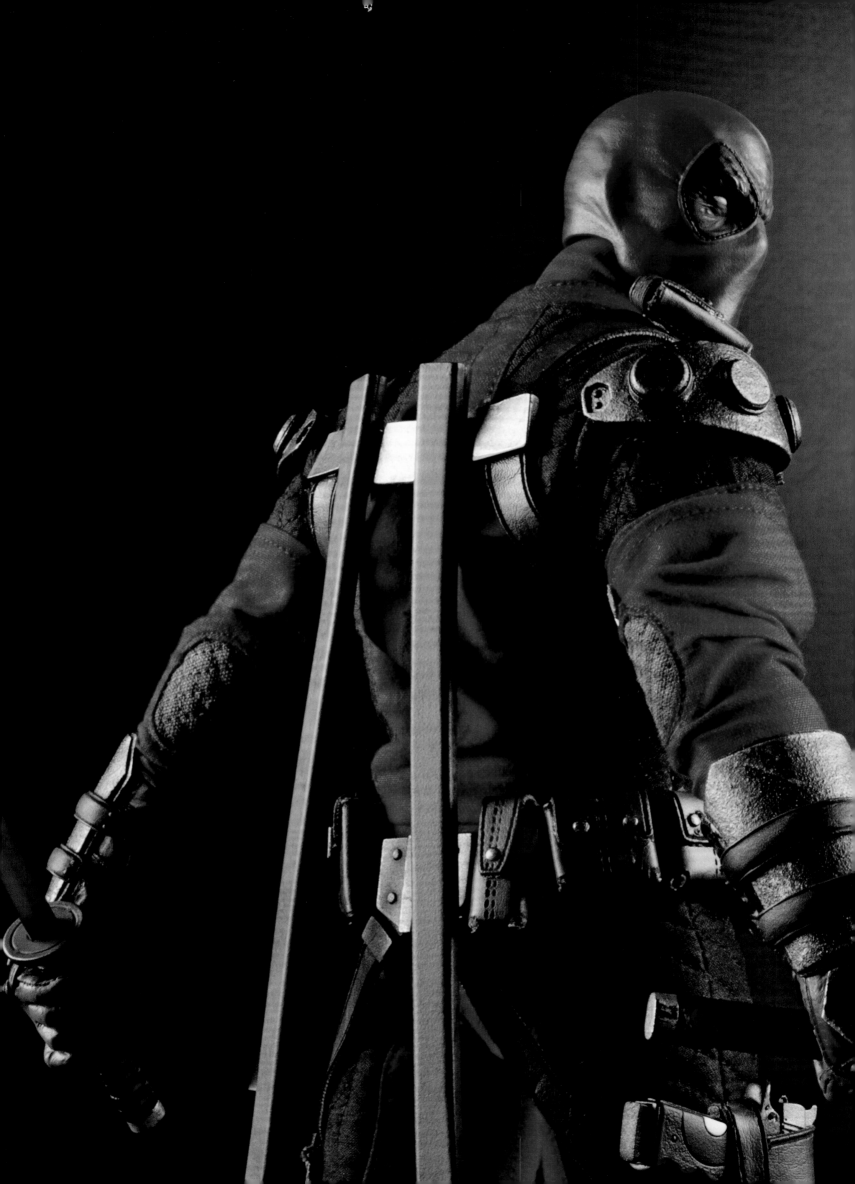

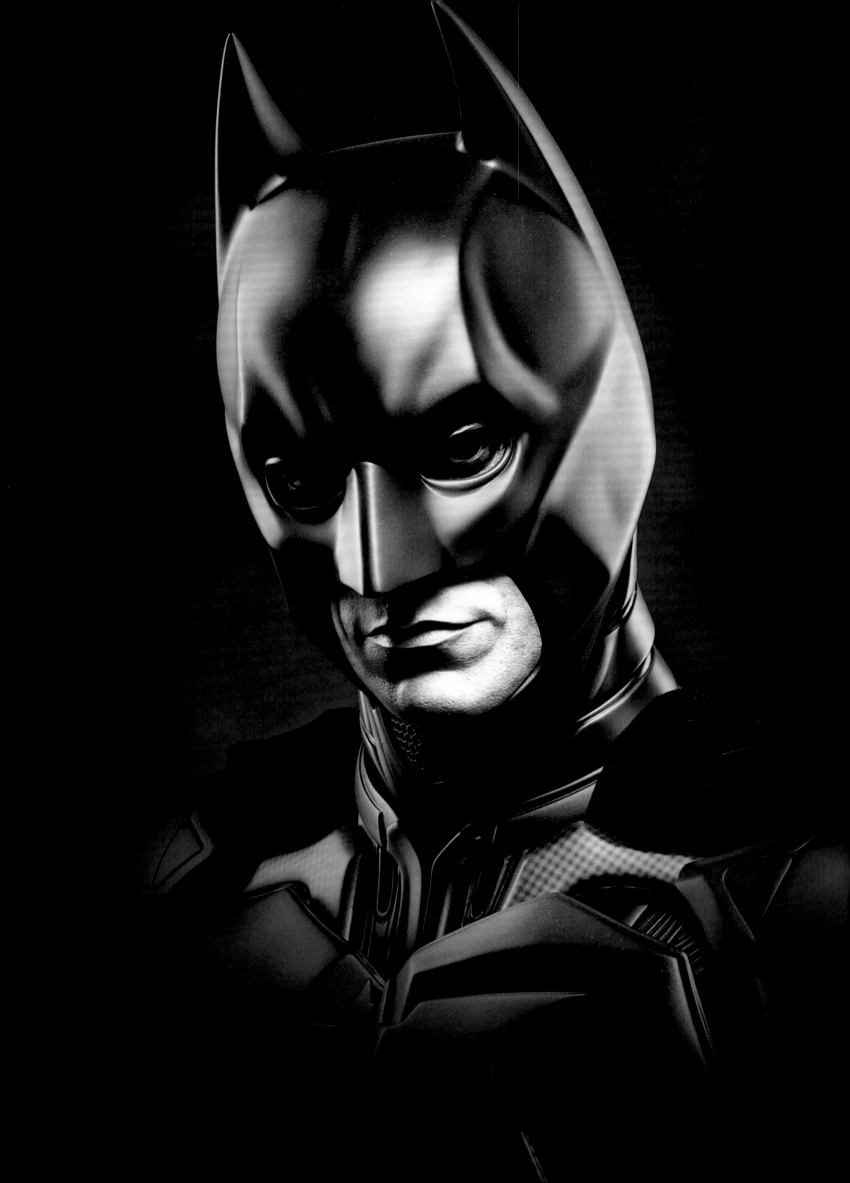

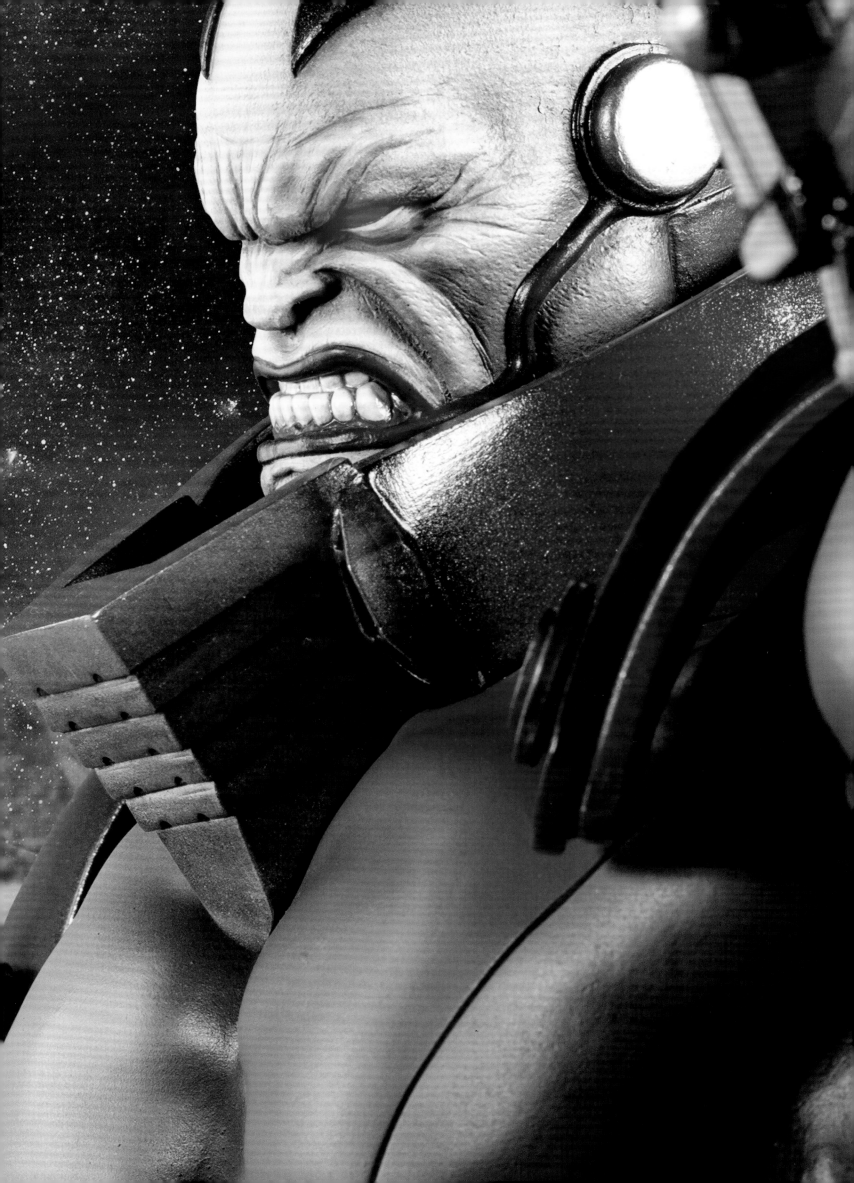

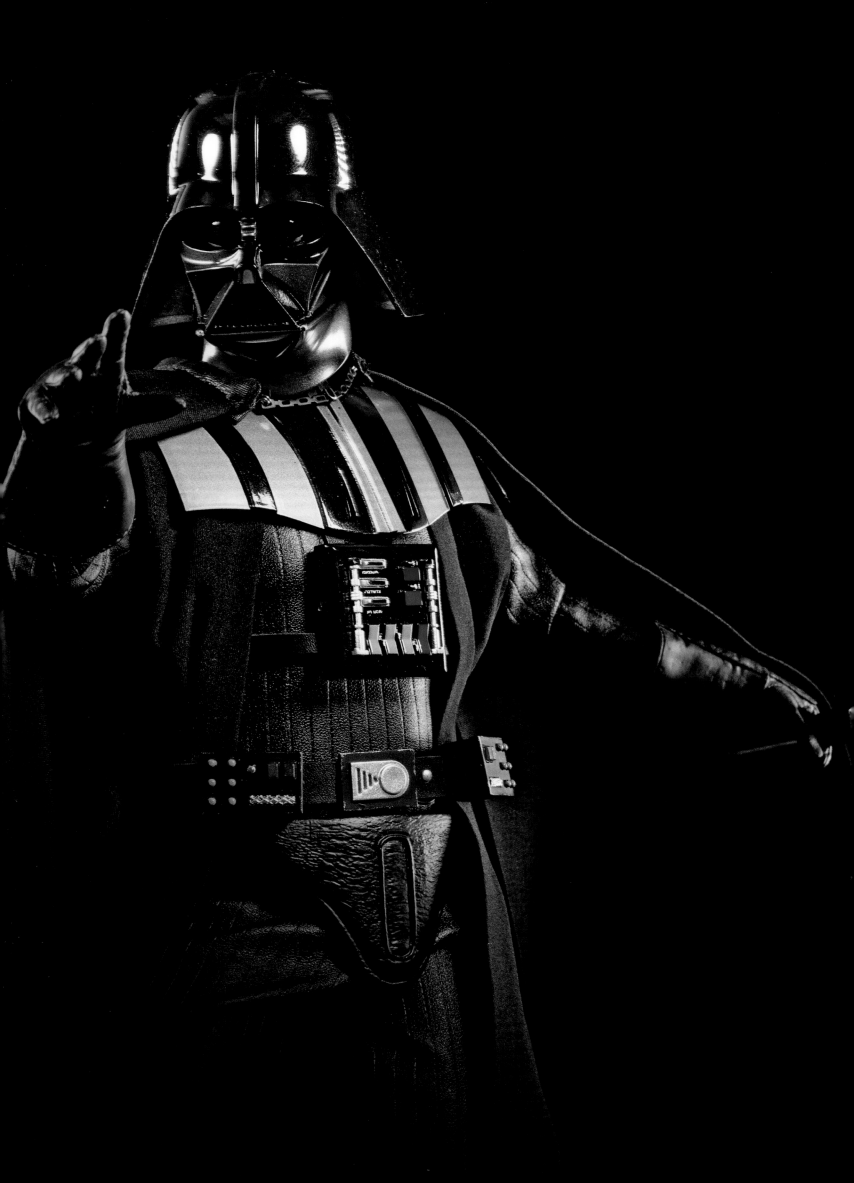

"We first came to know Darth Vader as this very dark, ominous, ultimate representation of evil. As a kid, you wanted to know whether he was an alien or a robot. What did his face look like underneath all that metal? He could lift people up and choke them. There was even a hint of a samurai about him. Who is this figure in this shiny black and silver armor? He really stood out against all the Stormtroopers in their white armor. In the first Star Wars trilogy, you learn about all the people he has killed, how he destroyed a whole planet. Then, in the prequels, you realize that he didn't start out that way and that he wasn't always a villain. He's the archetype of a villain and a father figure rolled into one. You will definitely take out the trash if he tells you to do so."

—Matt Bischof, Project Manager, Sixth Scale

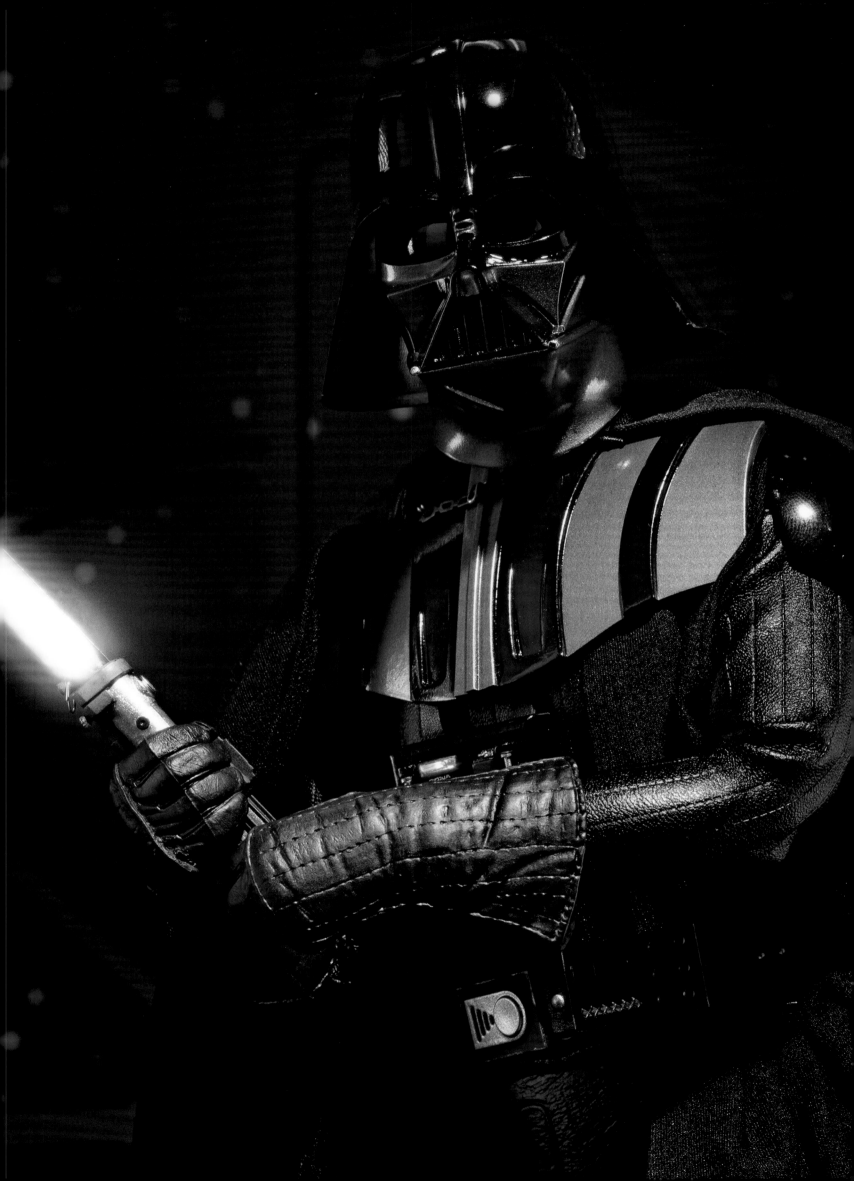

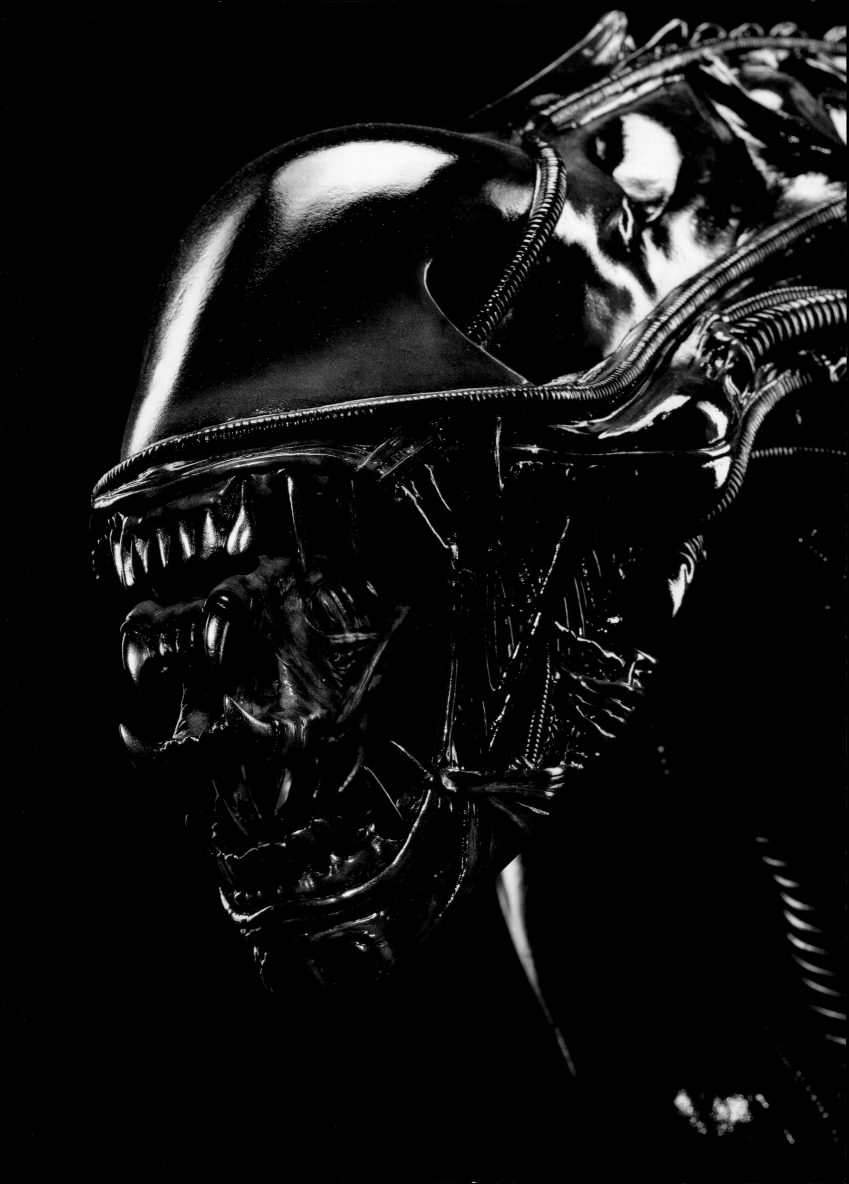

"*Do you understand? I don't want to hurt you. I don't want either of us to end up killing the other . . . but we're both running out of alternatives.* "

—*Batman,* Batman: The Killing Joke

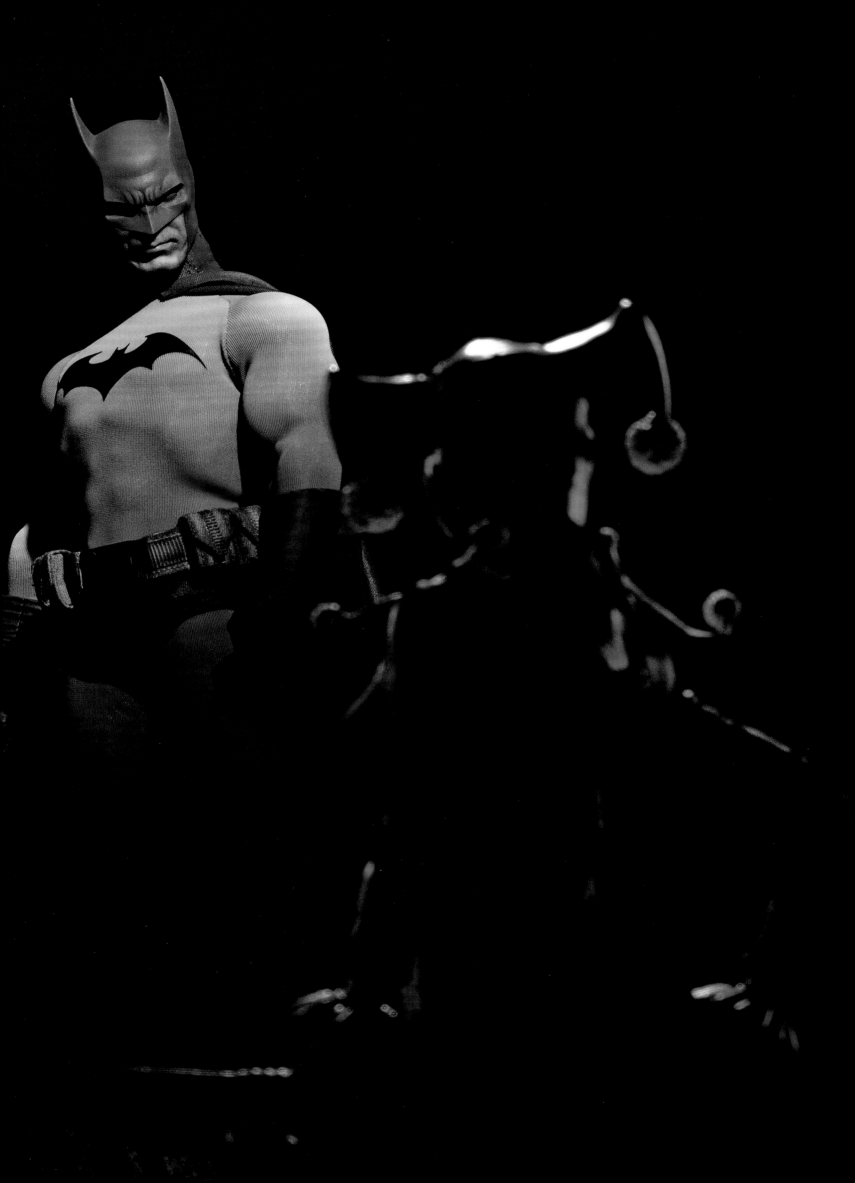

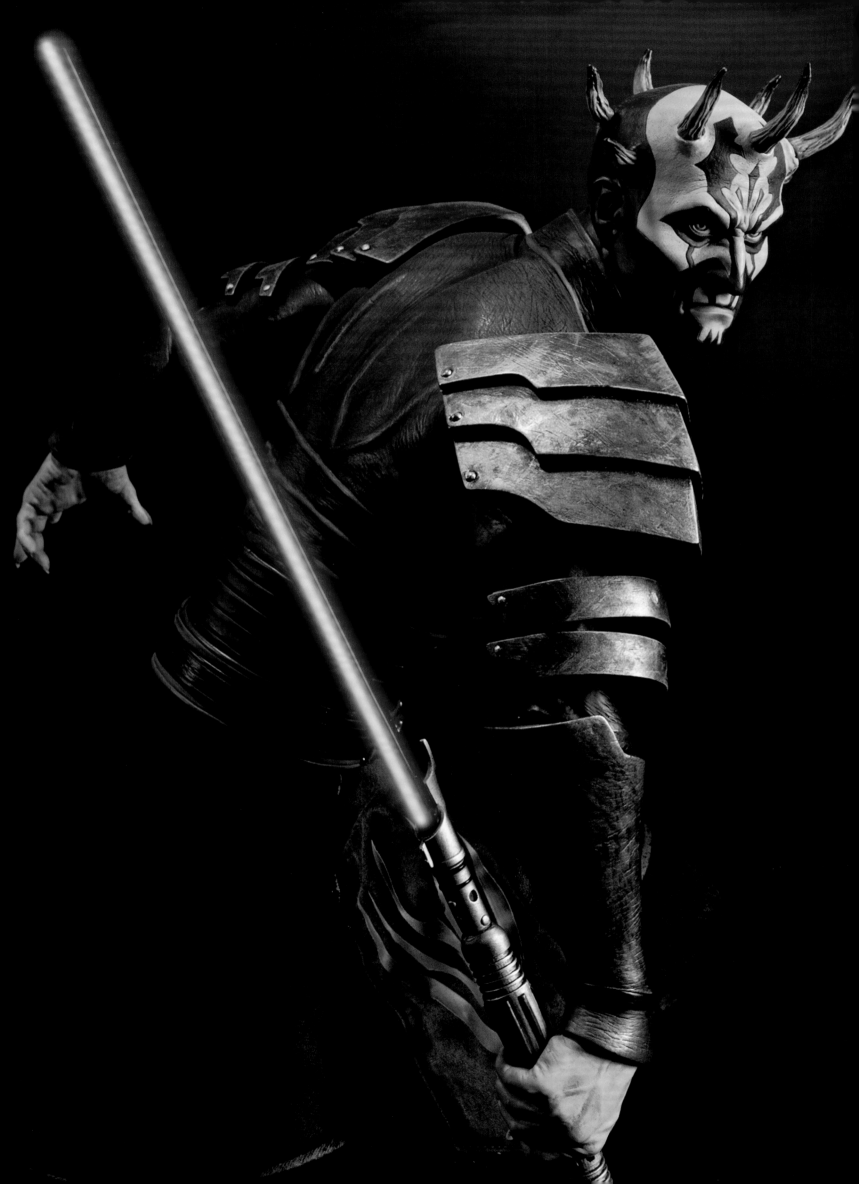

*" Then you must have your revenge, my brother. "*

—*Savage Opress,* Star Wars: The Clone Wars

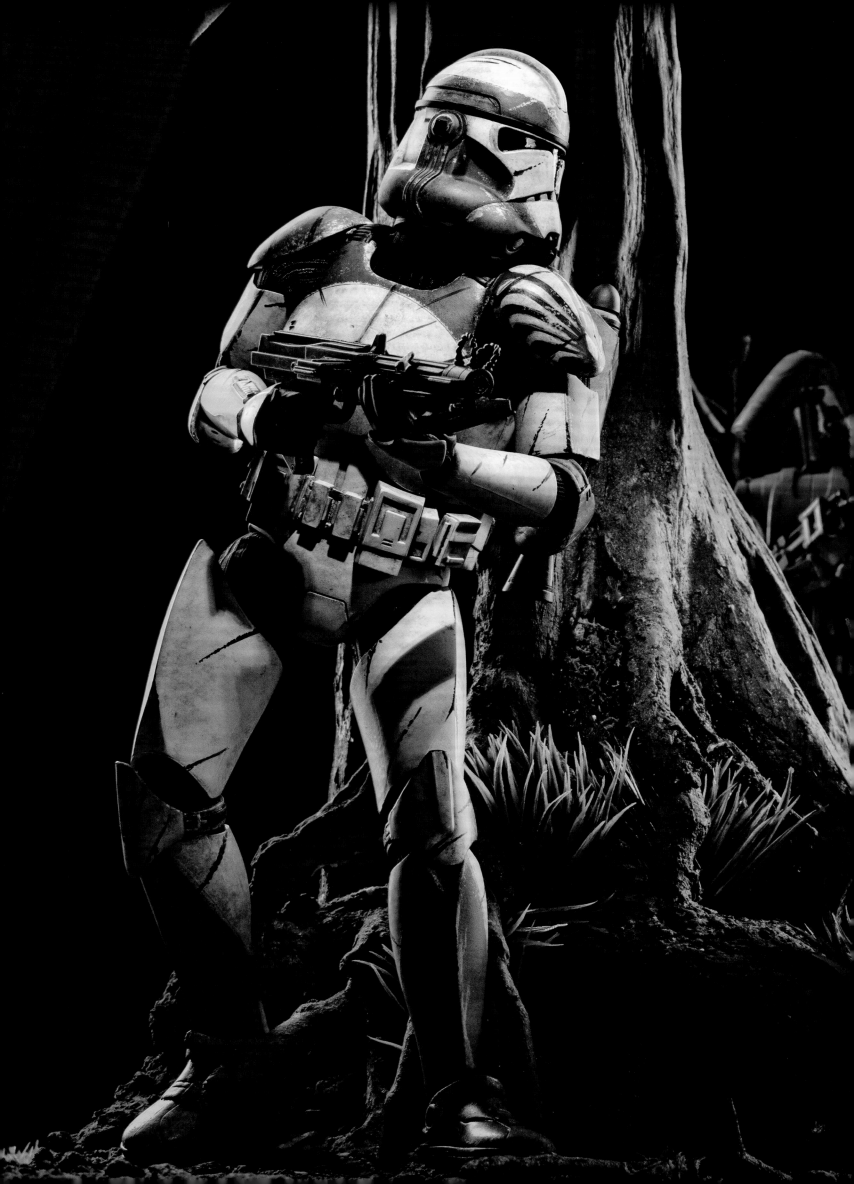

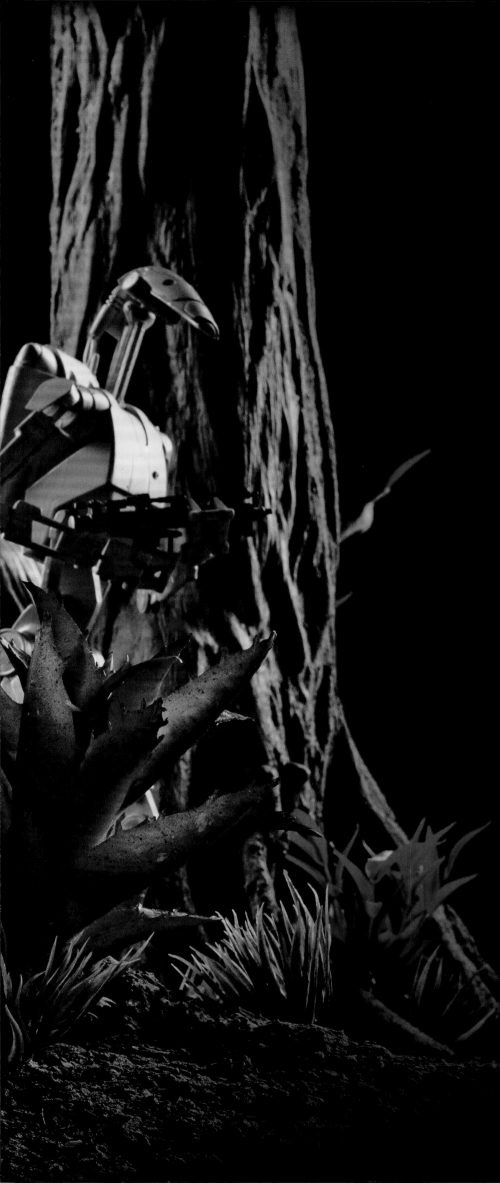

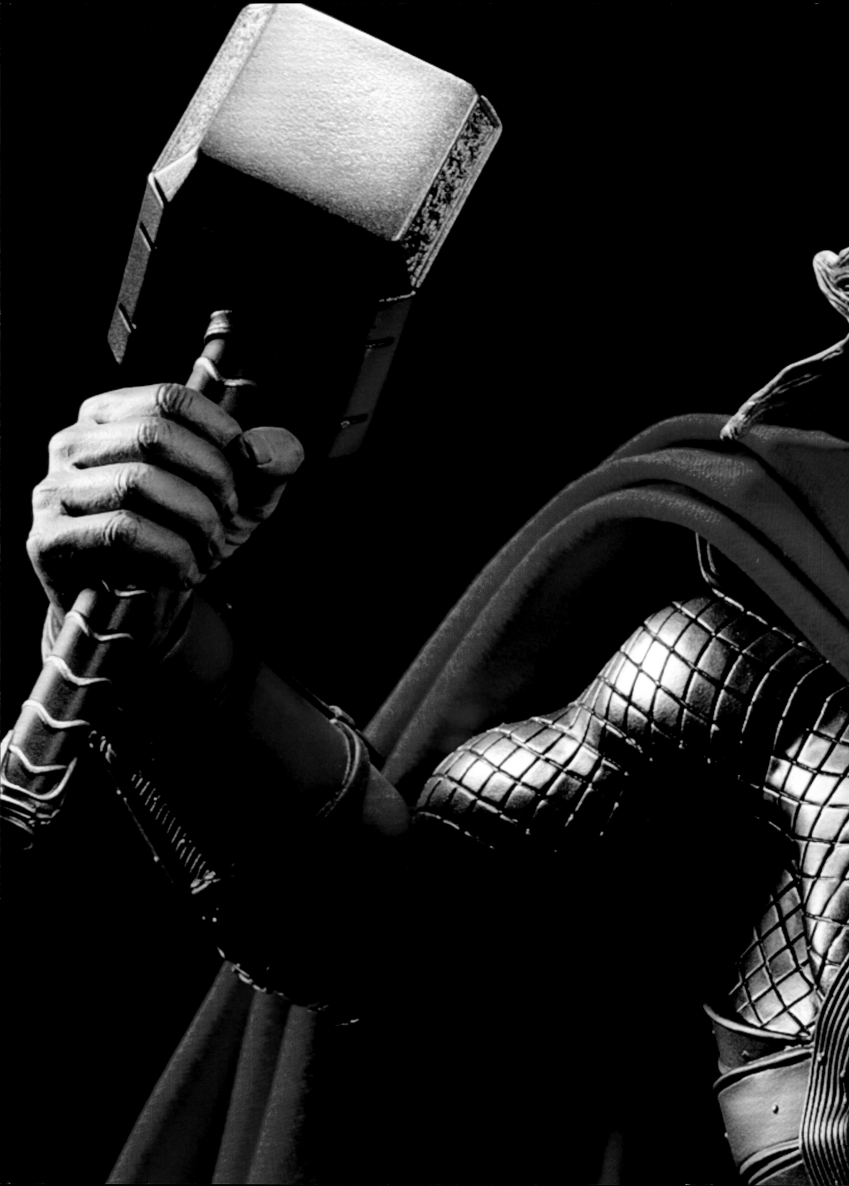

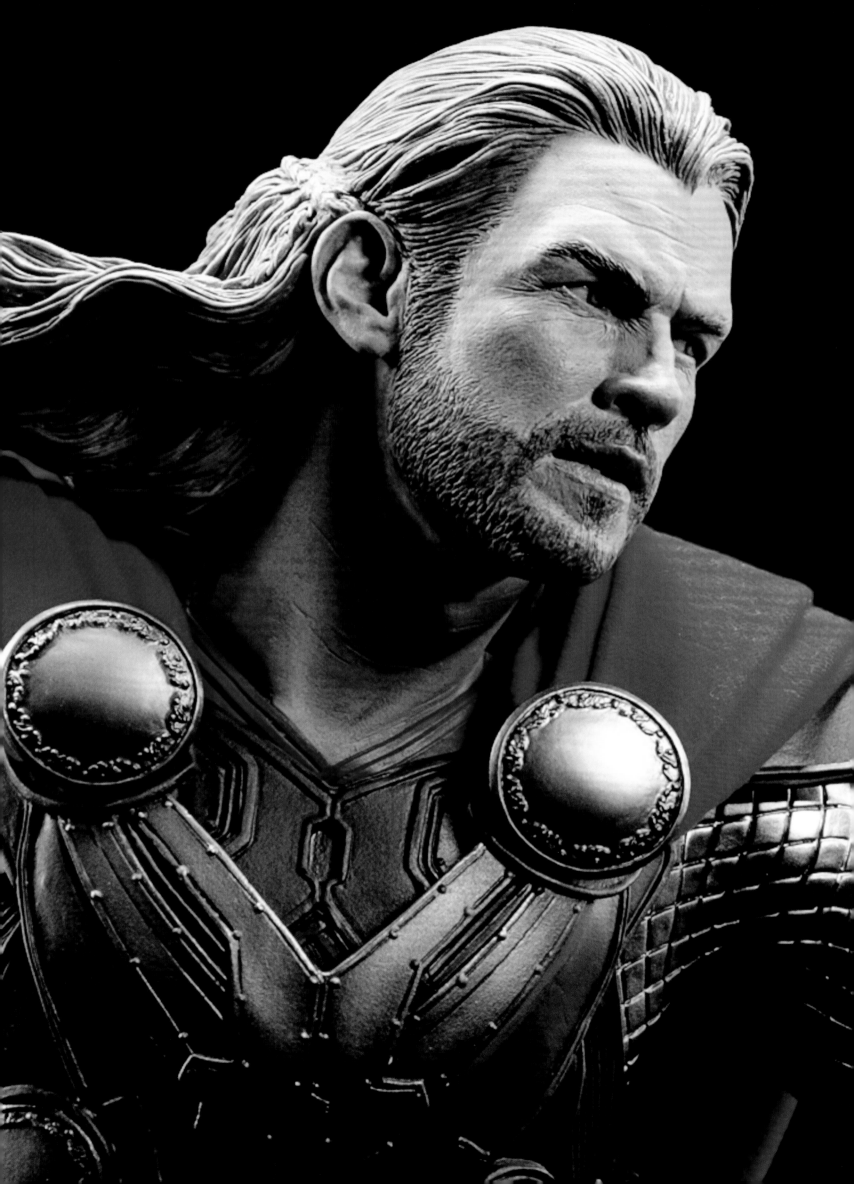

" *This game shall soon reach its inevitable conclusion—and the final triumph shall belong to Doctor Doom!* "

—*Doctor Doom*, Fantastic Four:
The World's Greatest Comics Magazine #3

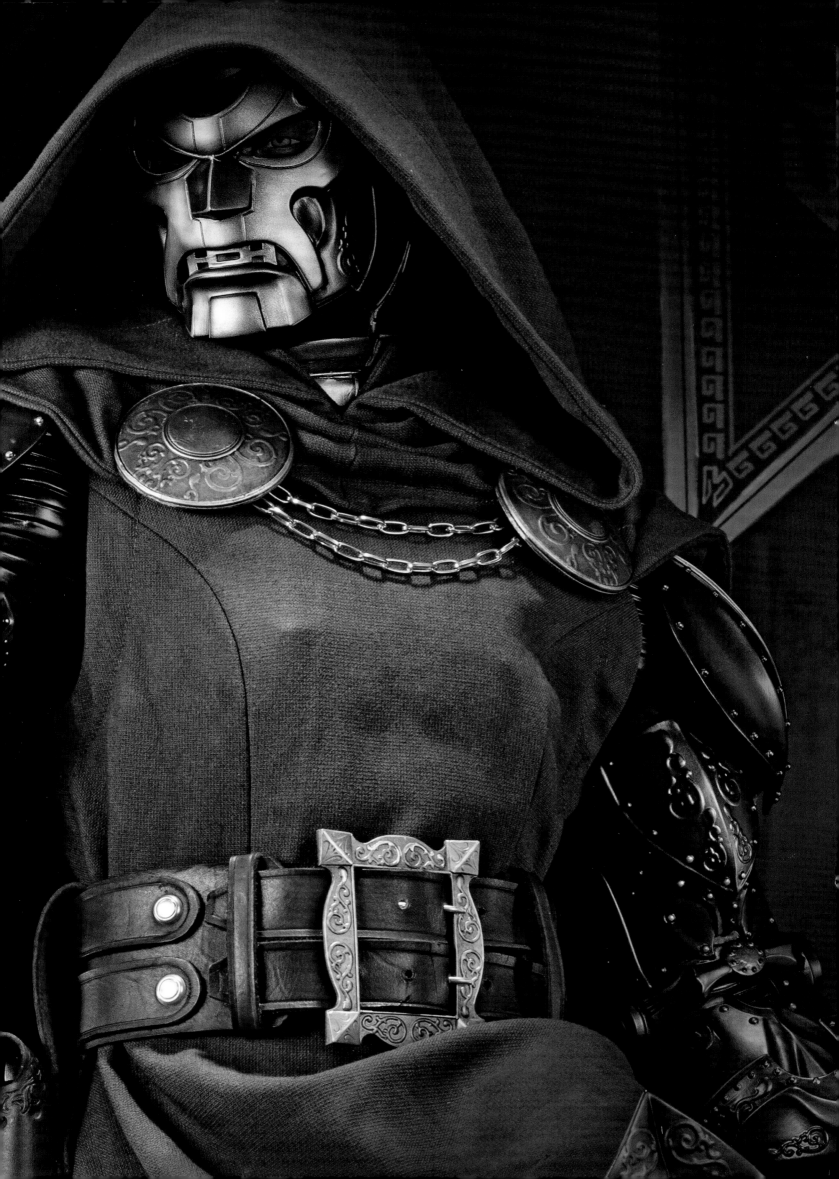

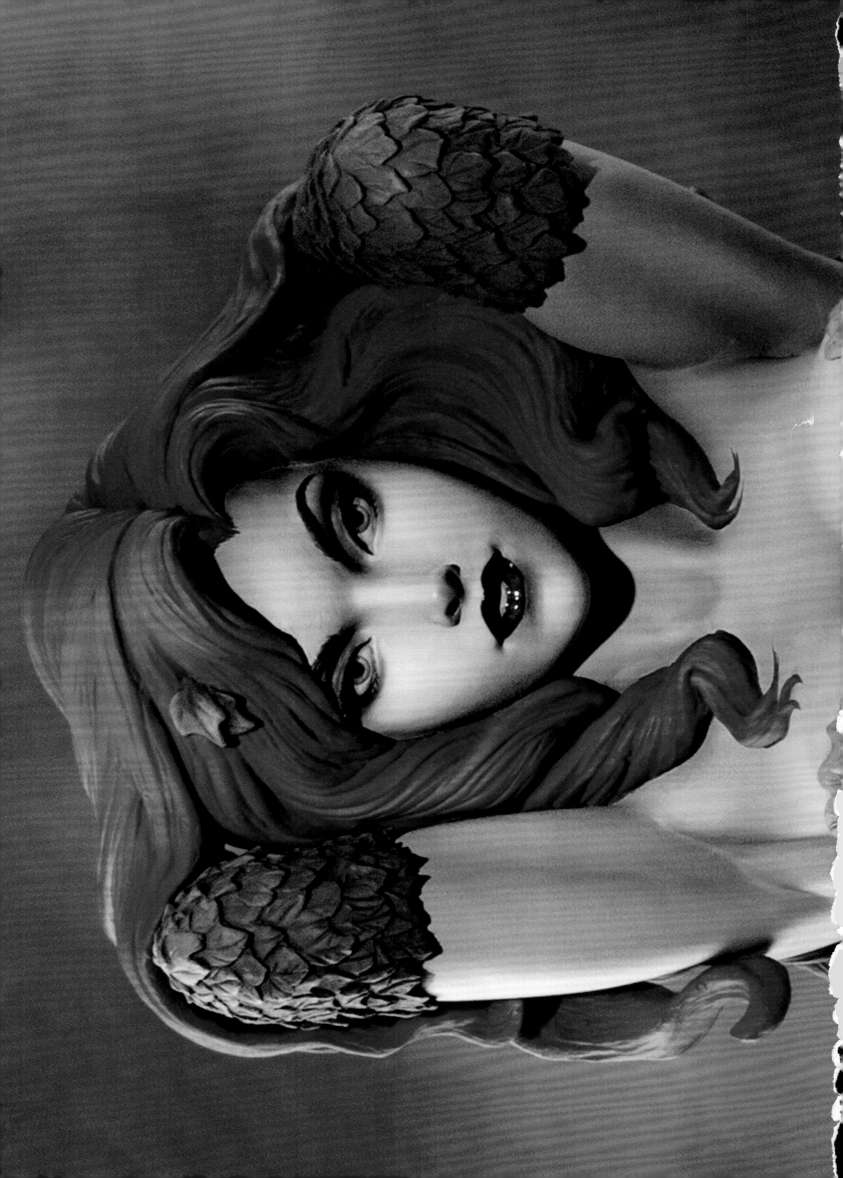

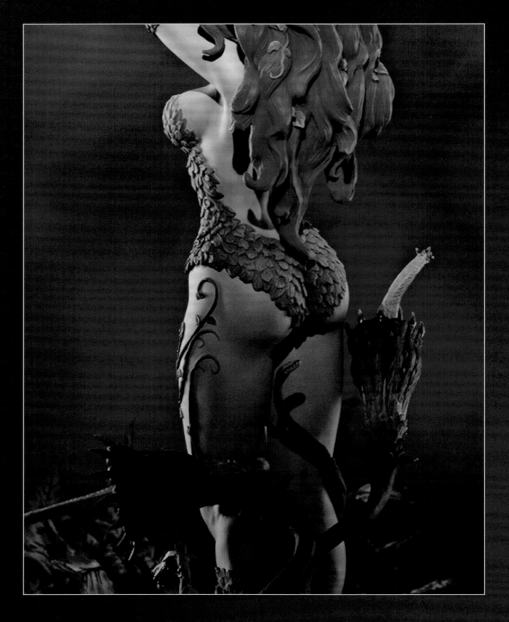

"*Poison Ivy got introduced as this femme fatale type of a villainess, who was also all about saving the planet and green life forms. She cares a lot more about plants than people. She's a powerful seductress, and she has an amazing way of manipulating plant life to realize her goals. A simple rose bush, for example, can turn into something pretty deadly in her hands. She can certainly overwhelm Batman in her own environment, and it's always cool to witness her particular manipulations.*"

—*Tim Hanson, Cut & Sew Department Manager*

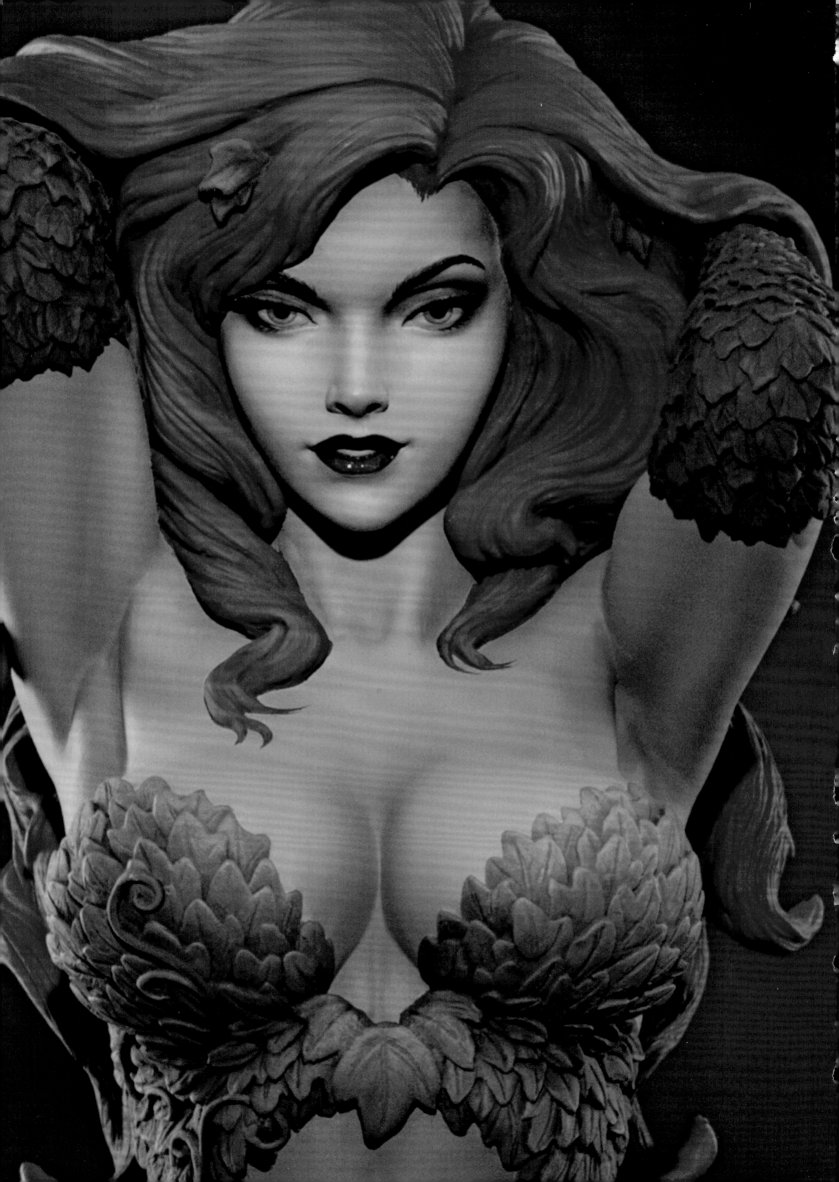

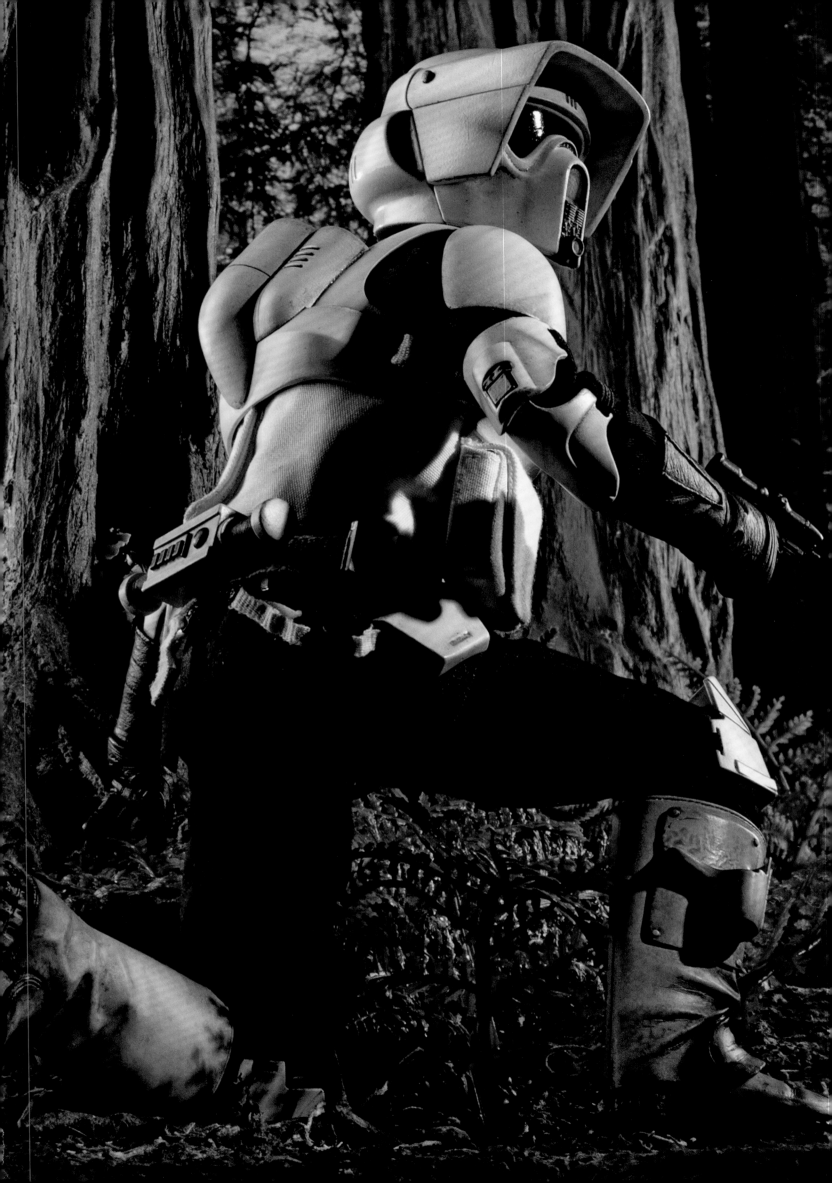

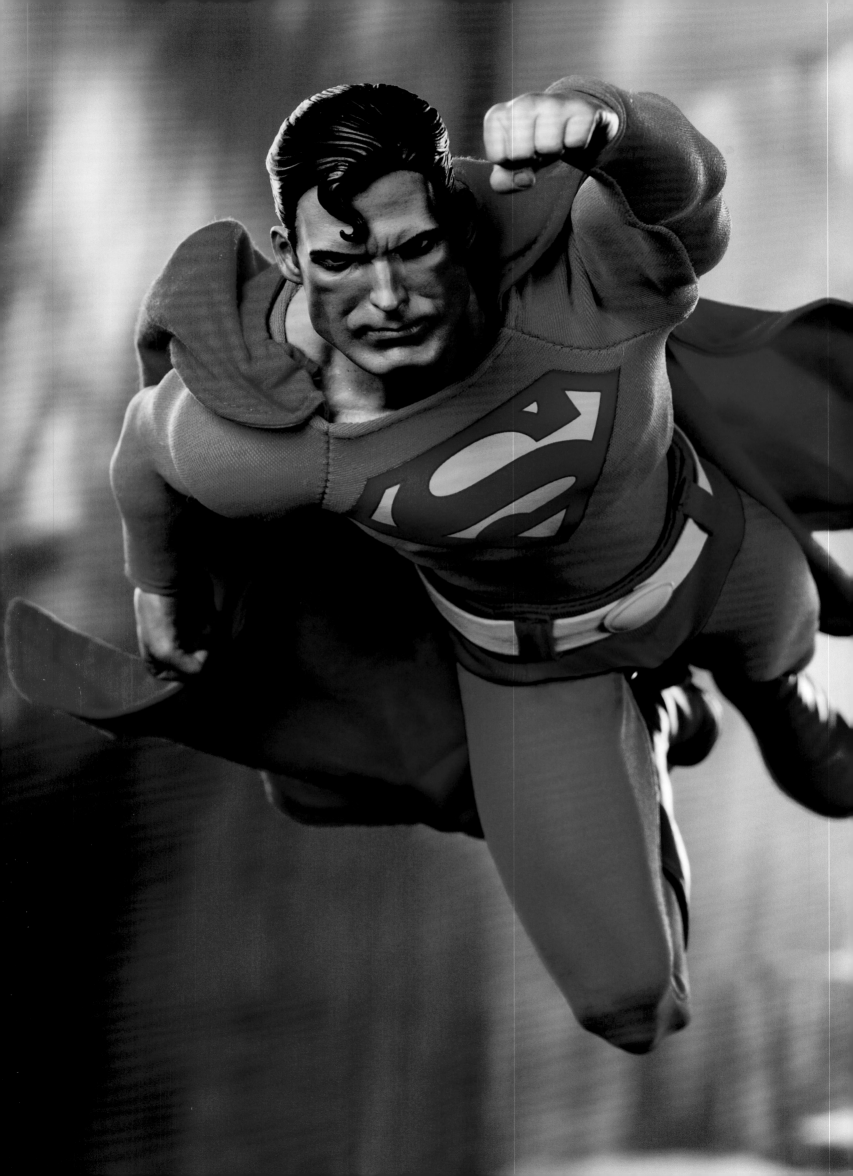

*"When you look back at the history of Superman, who was created by writer Jerry Siegel and artist Joe Shuster back in 1933, it's hard not to be amazed at how little he has changed through the years. Superman continues to be this ultimate representation of good. With Superman there is not as much of a gray area as with some of the other superheroes. He still struggles with his identity and who he is, which is this godlike alien figure on Earth. What is also very important in Superman's character is the way he was brought up by his mom and dad. He was taught to be compassionate and caring; these were not character traits he was born with, but rather they were nurtured by his adopted parents. Superman uses his power to honor his parents and the people of Earth."*

*—Tim Hanson,*
*Cut & Sew Department Manager*

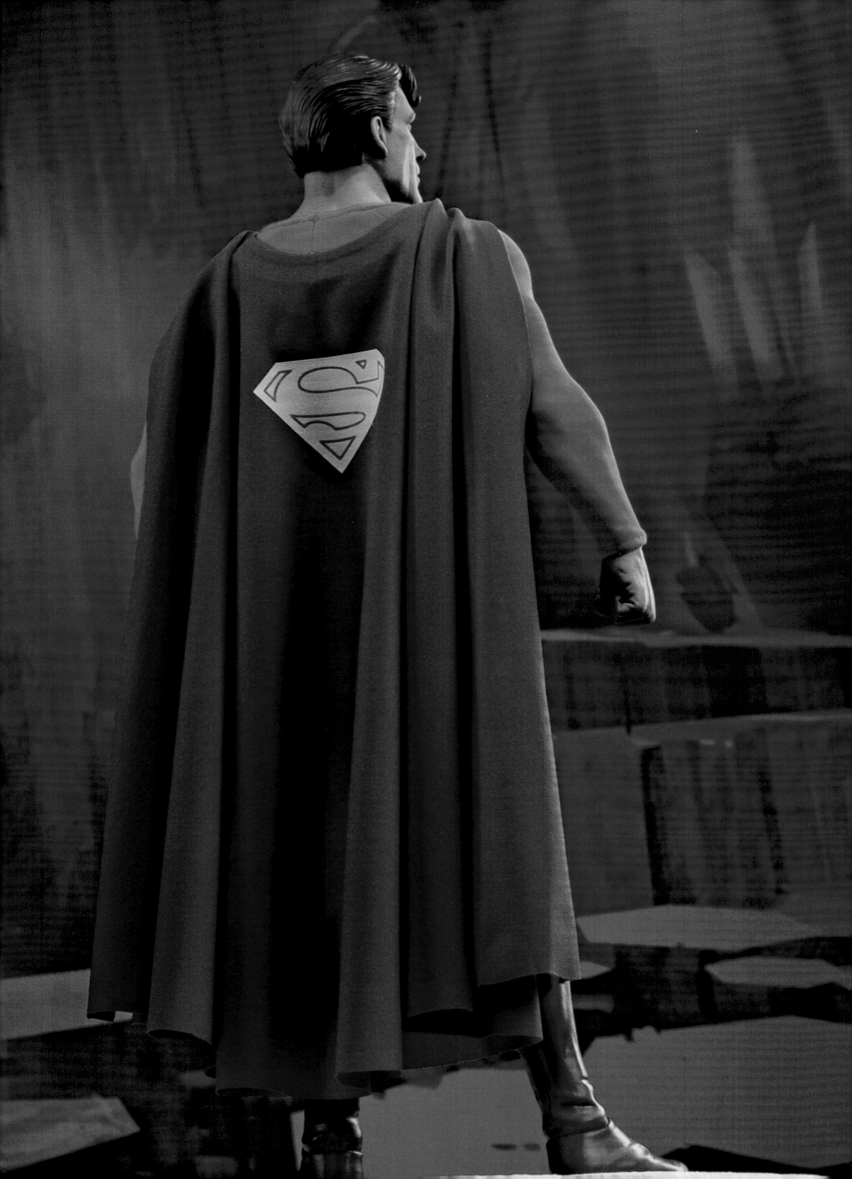

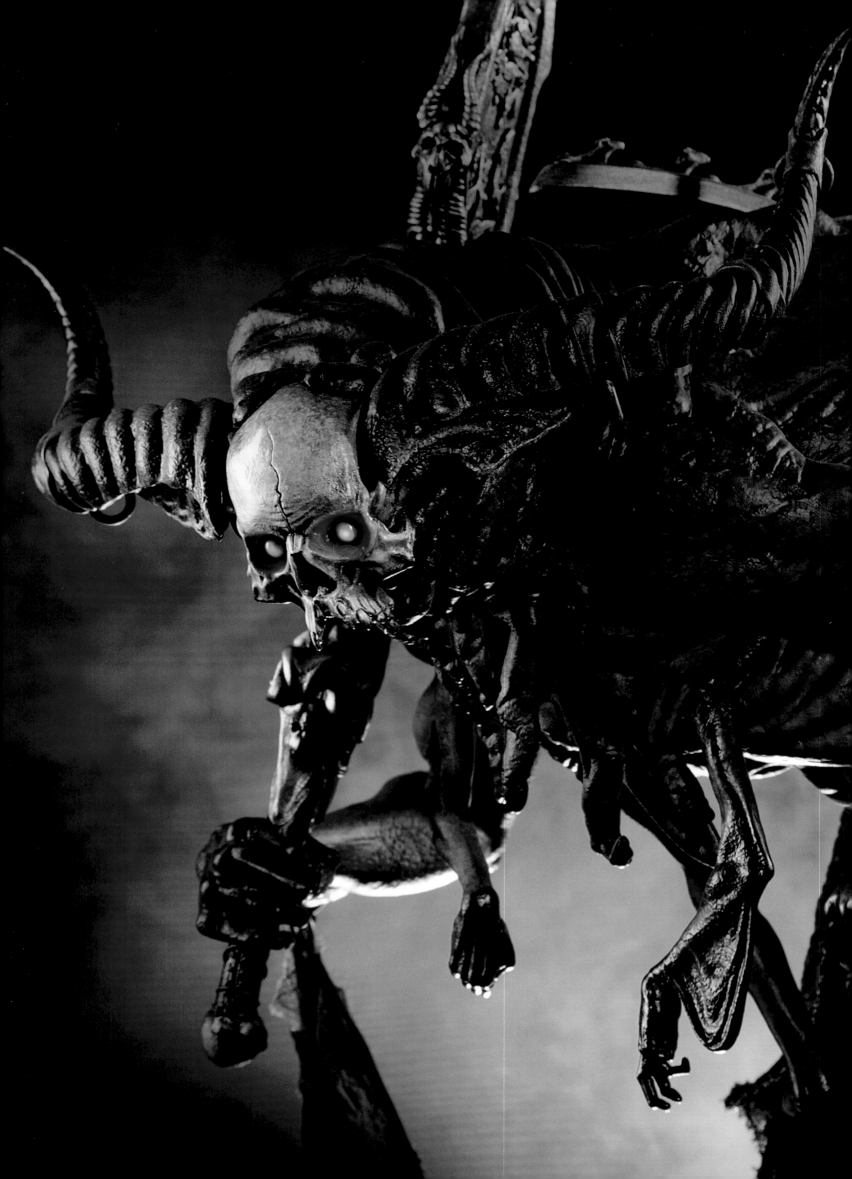

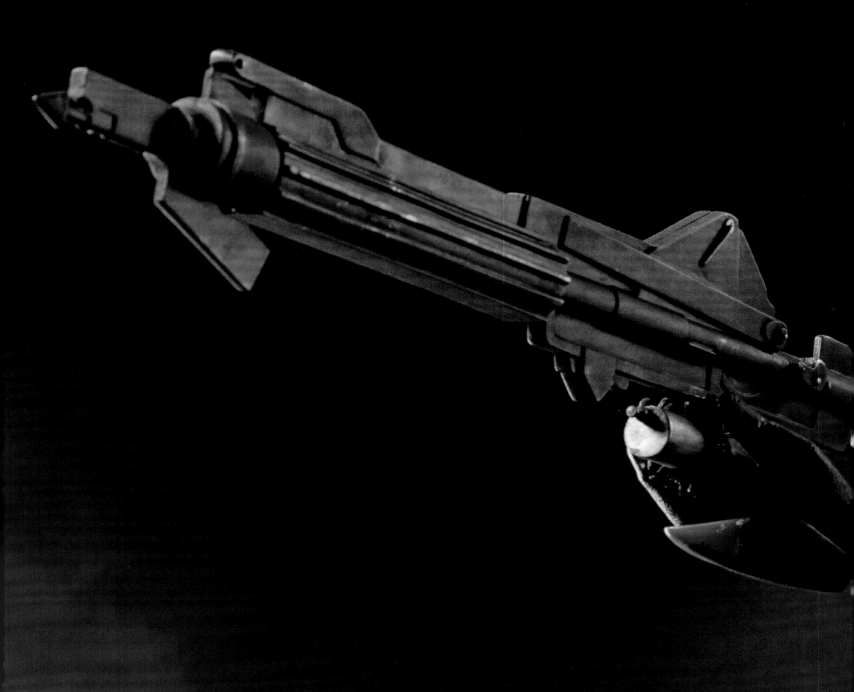

"Commander Cody, the time has come. Execute Order 66."

"Yes, my Lord."

—Darth Sidious and Commander Cody,
Star Wars: Episode III: Revenge of the Sith

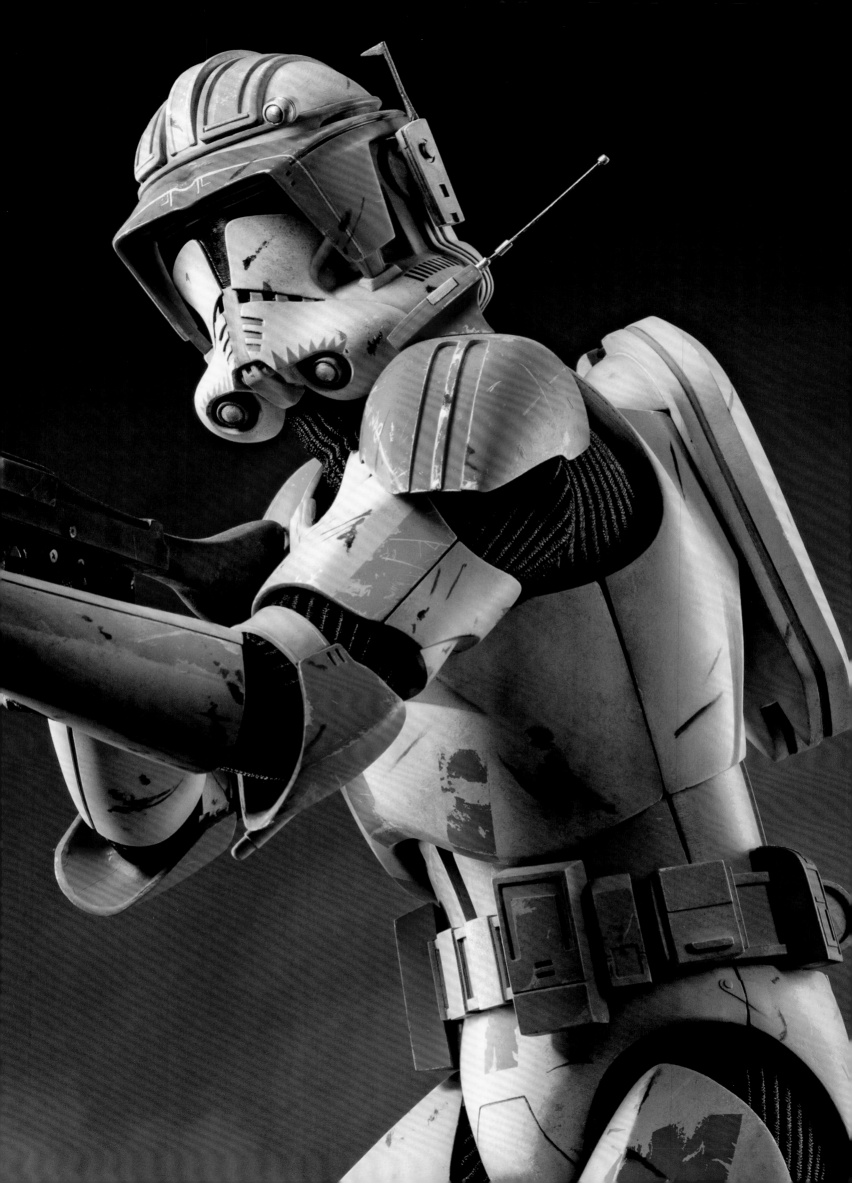

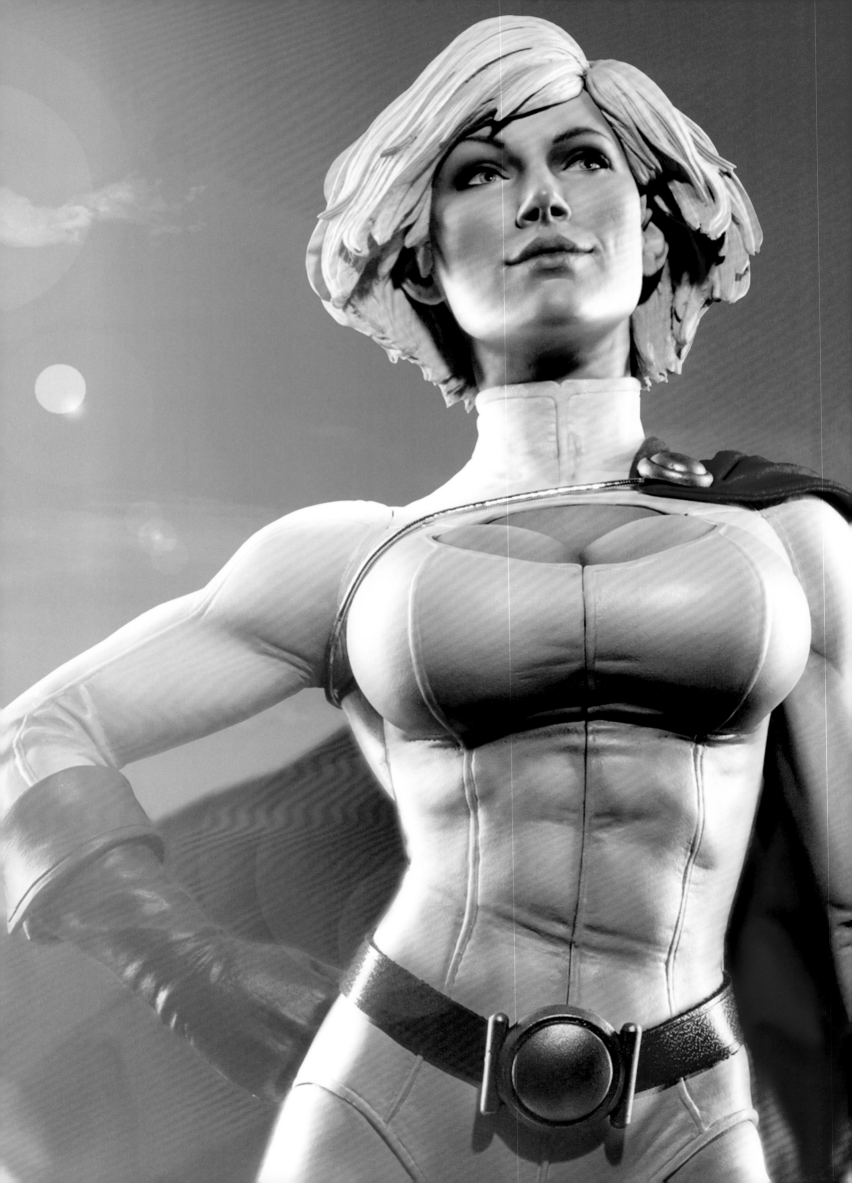

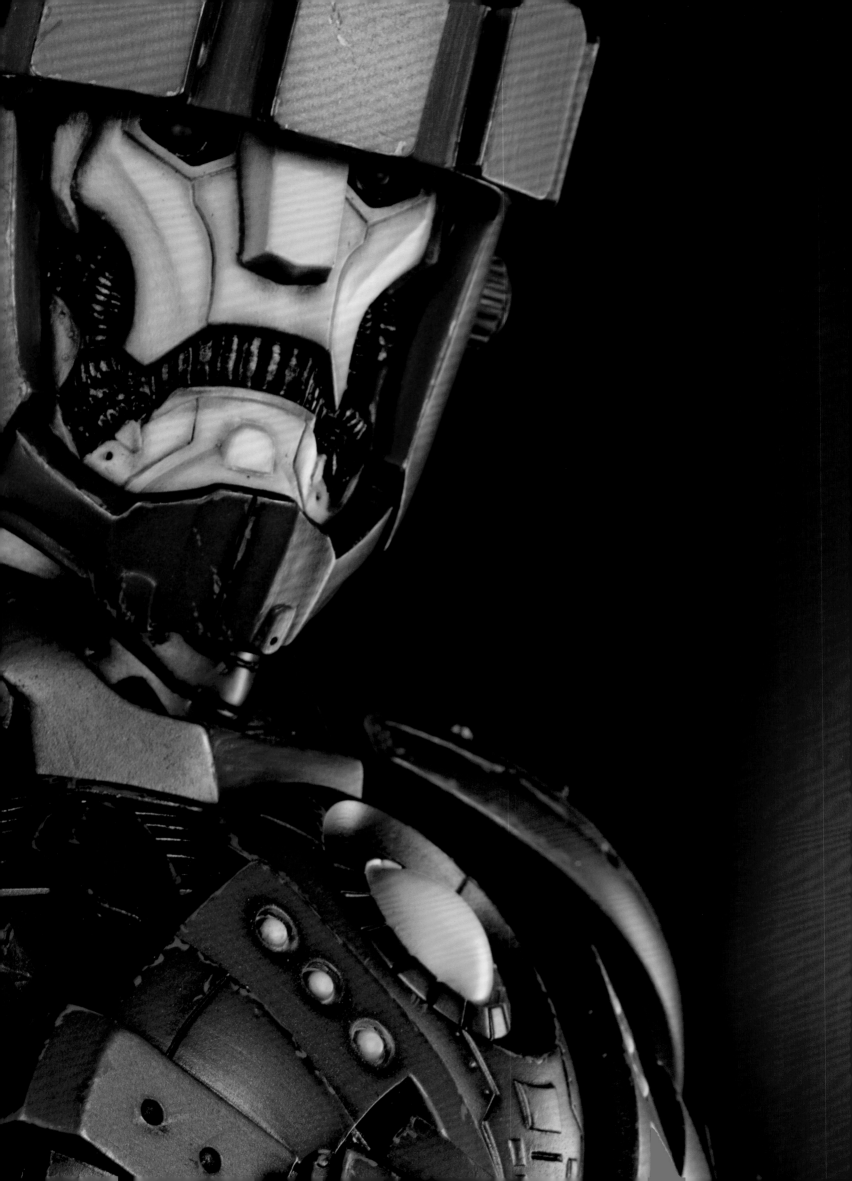

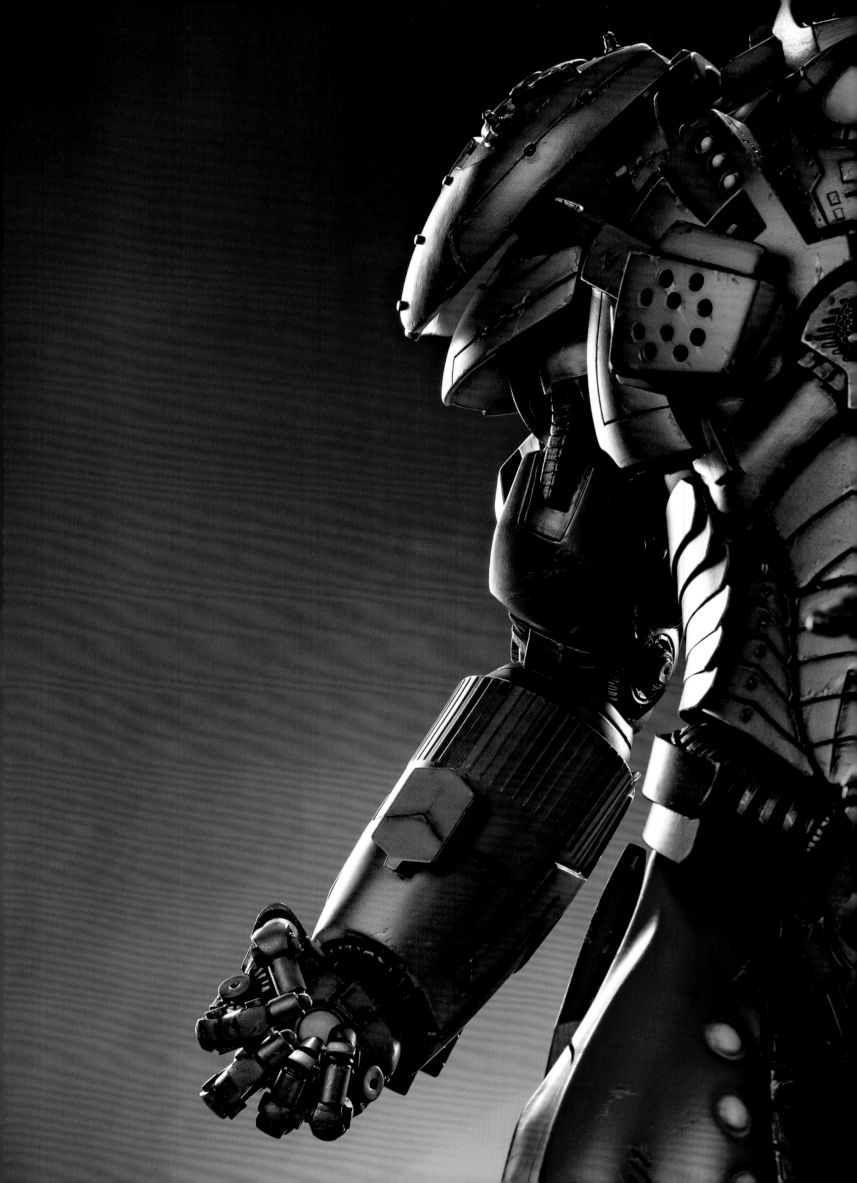

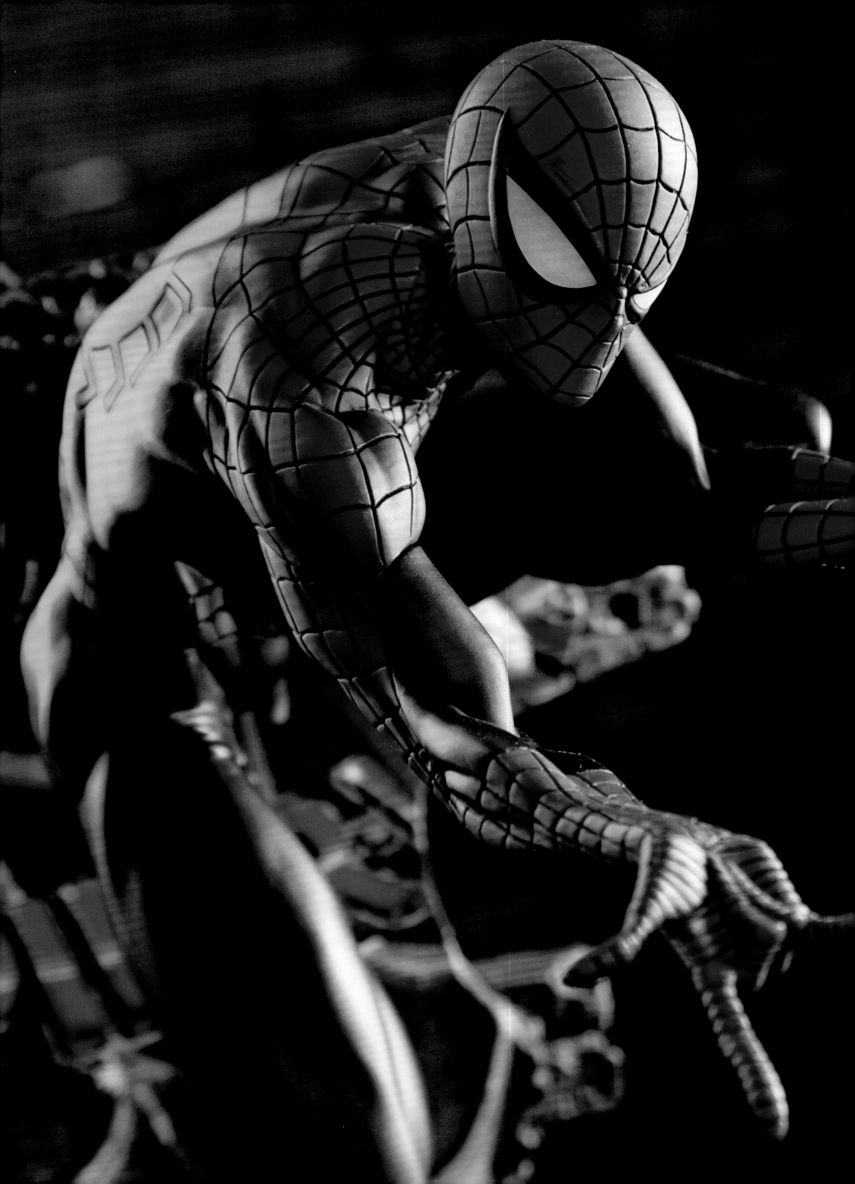

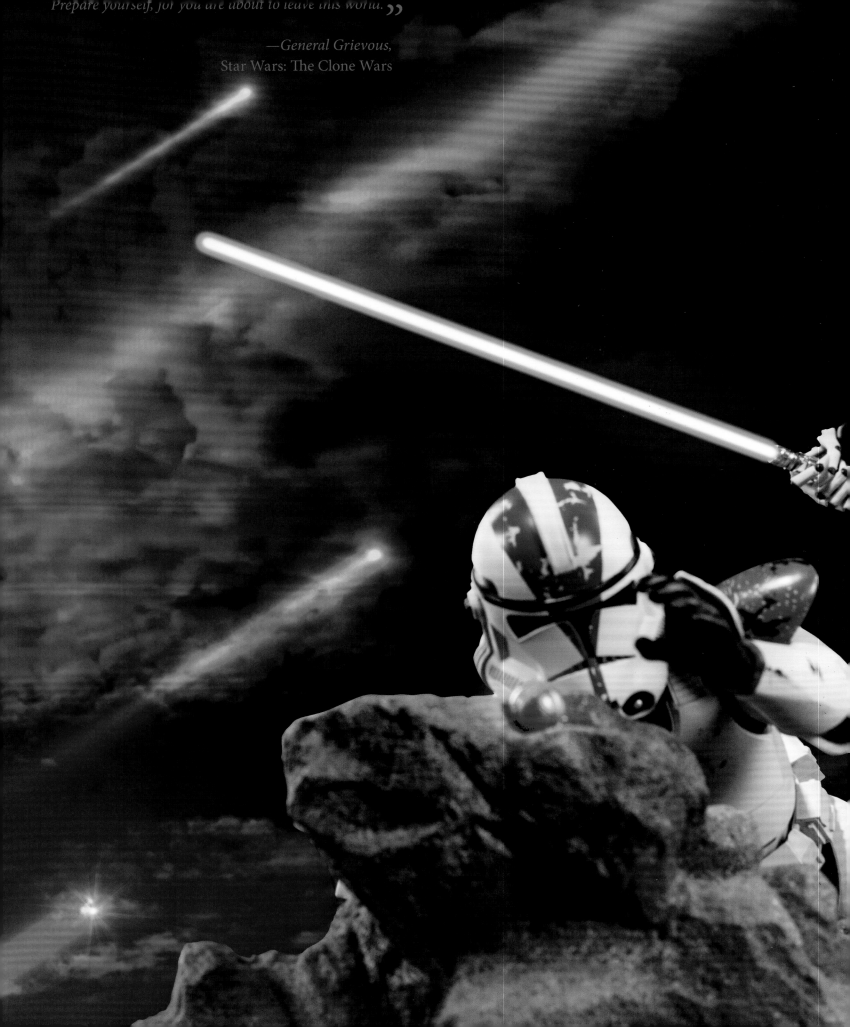

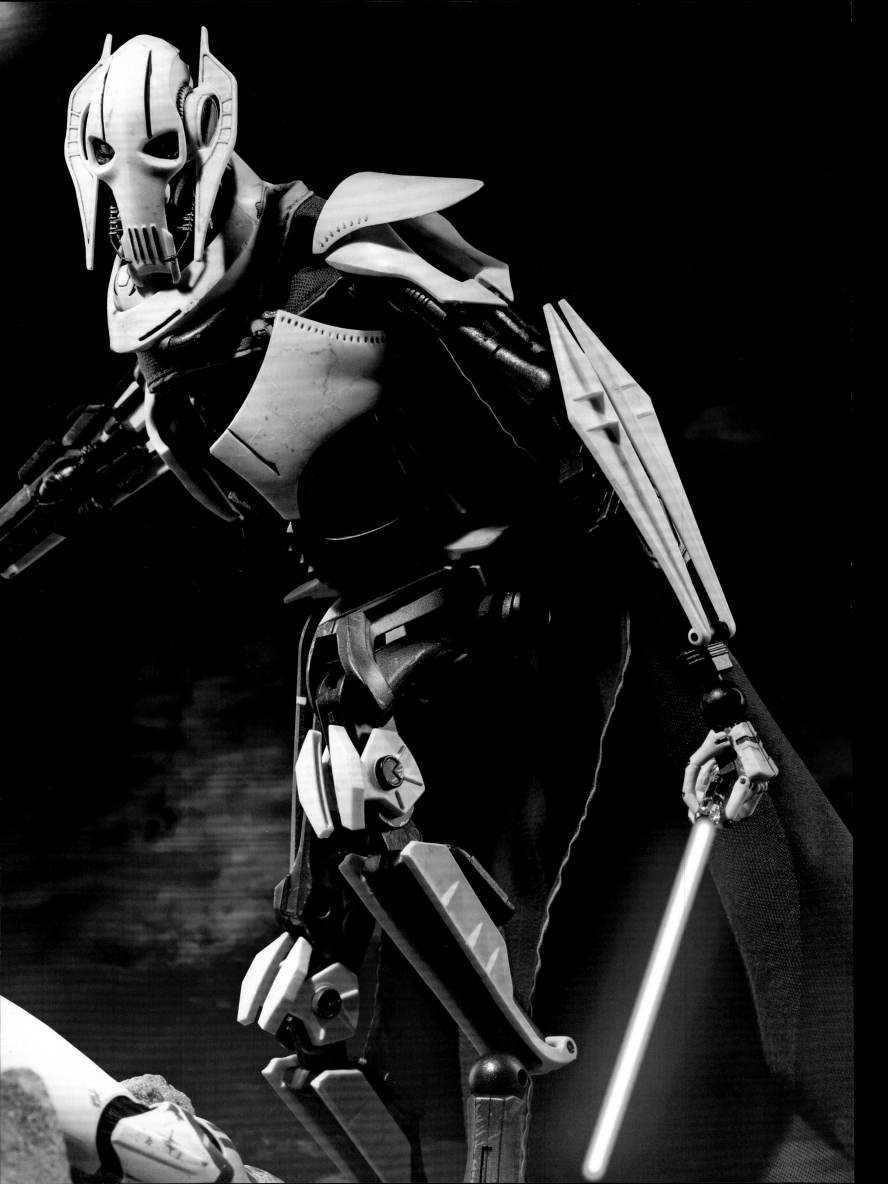

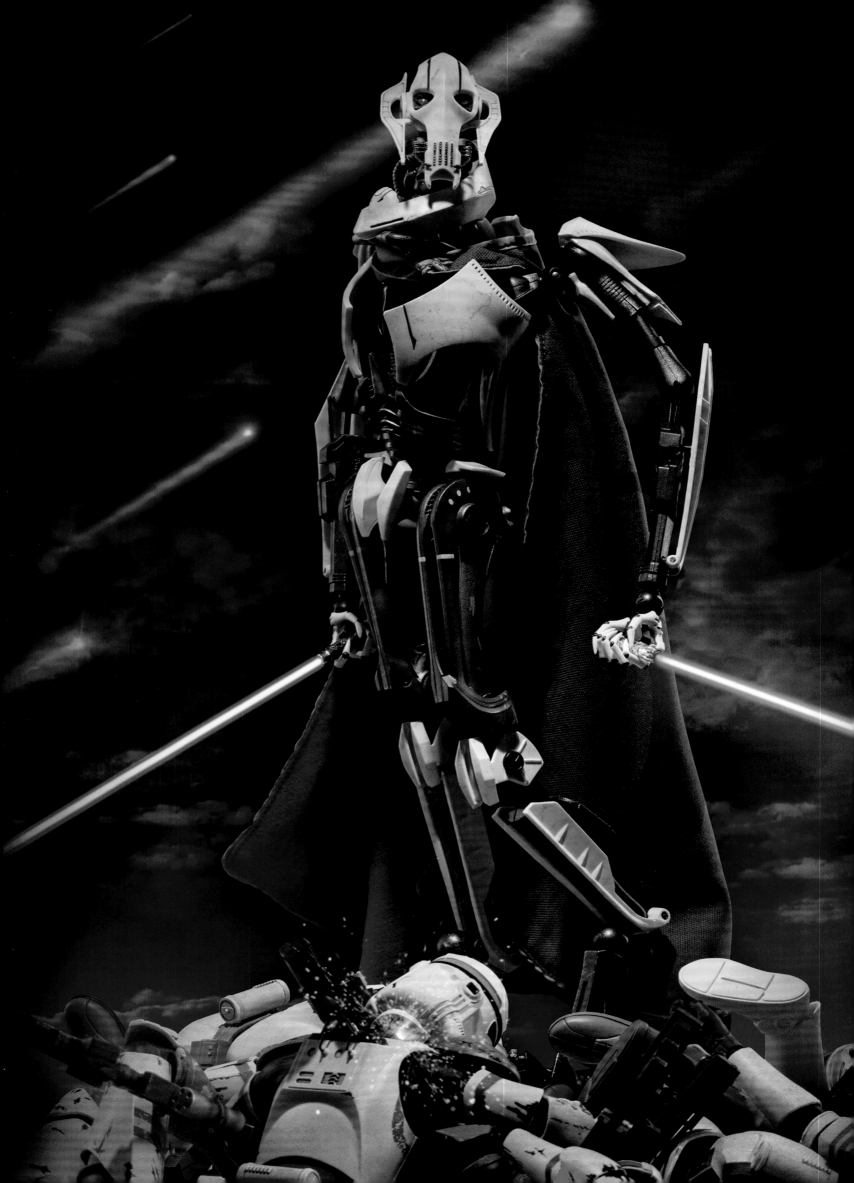

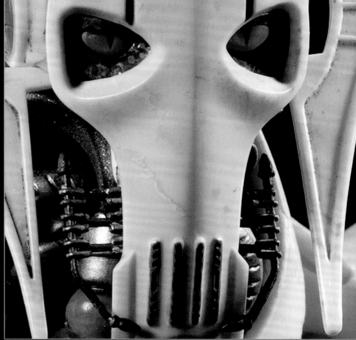

"Grievous is one of the strangest, most vicious icons in the *Star Wars* world. He's a deeply focused, tall and lanky alien, whose is robotic and cold. Grievous is very calculating and has no humanity. There's nothing redeeming about his character. He is trained in all Lightsaber combat forms to ensure the Jedi's destruction. He is a real killing machine. He actually takes pleasure in the kill. When you see him coming, your first instinct is to run for cover."

David Igo, Art Dire

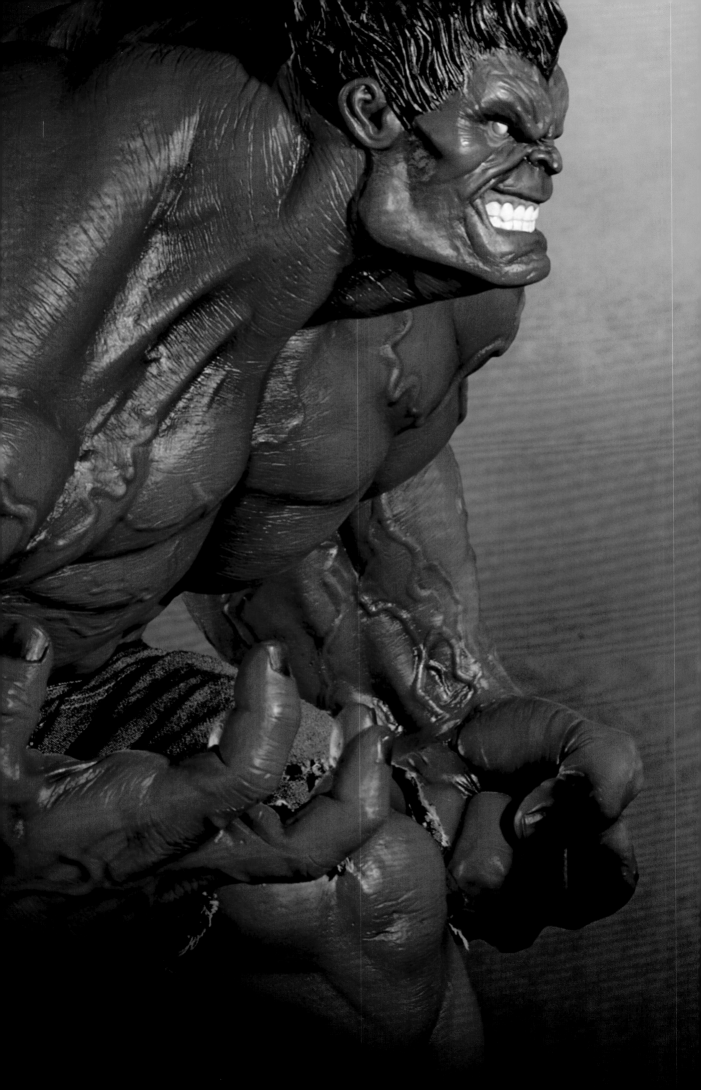

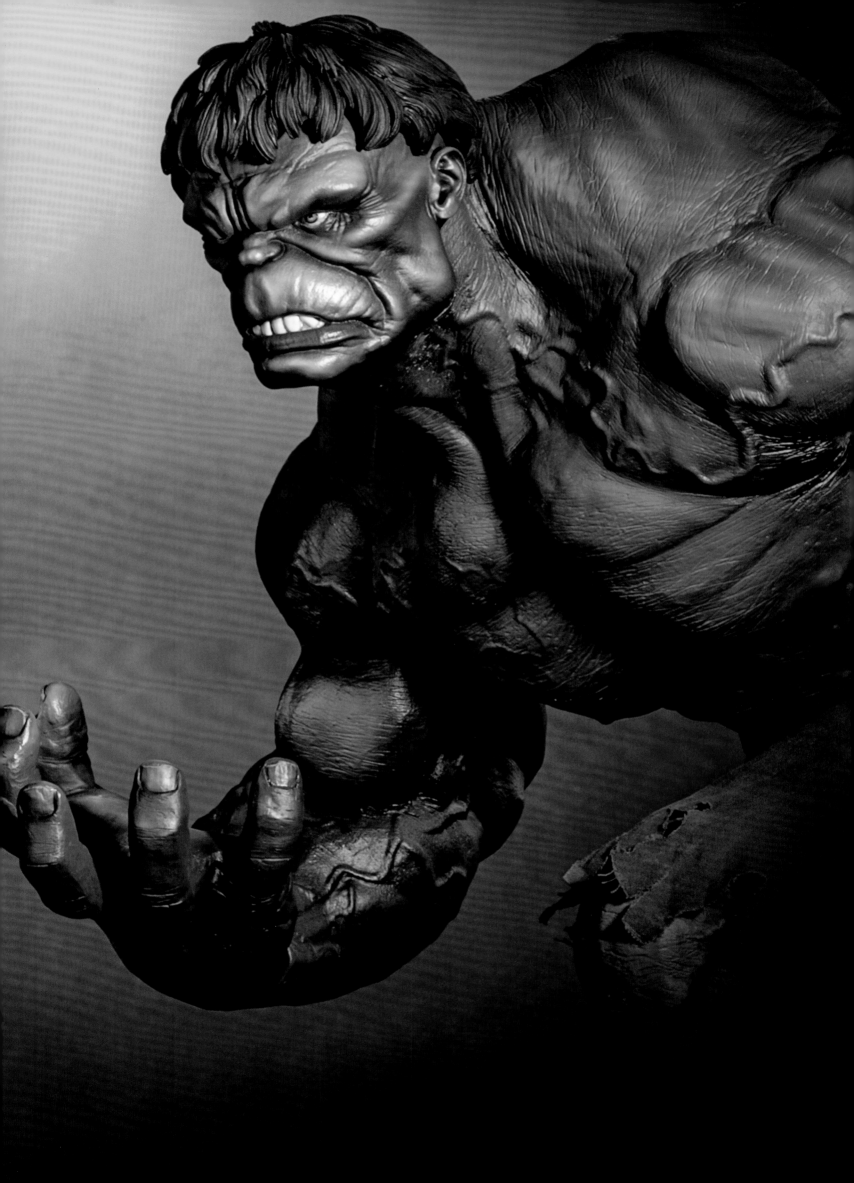

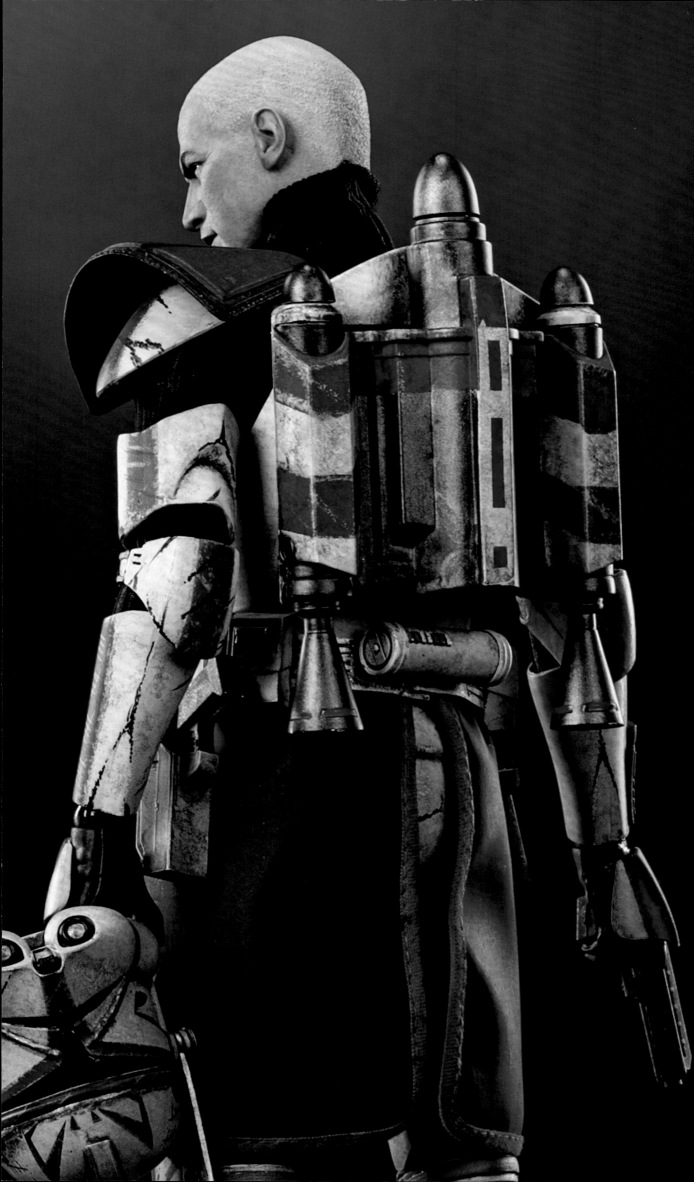

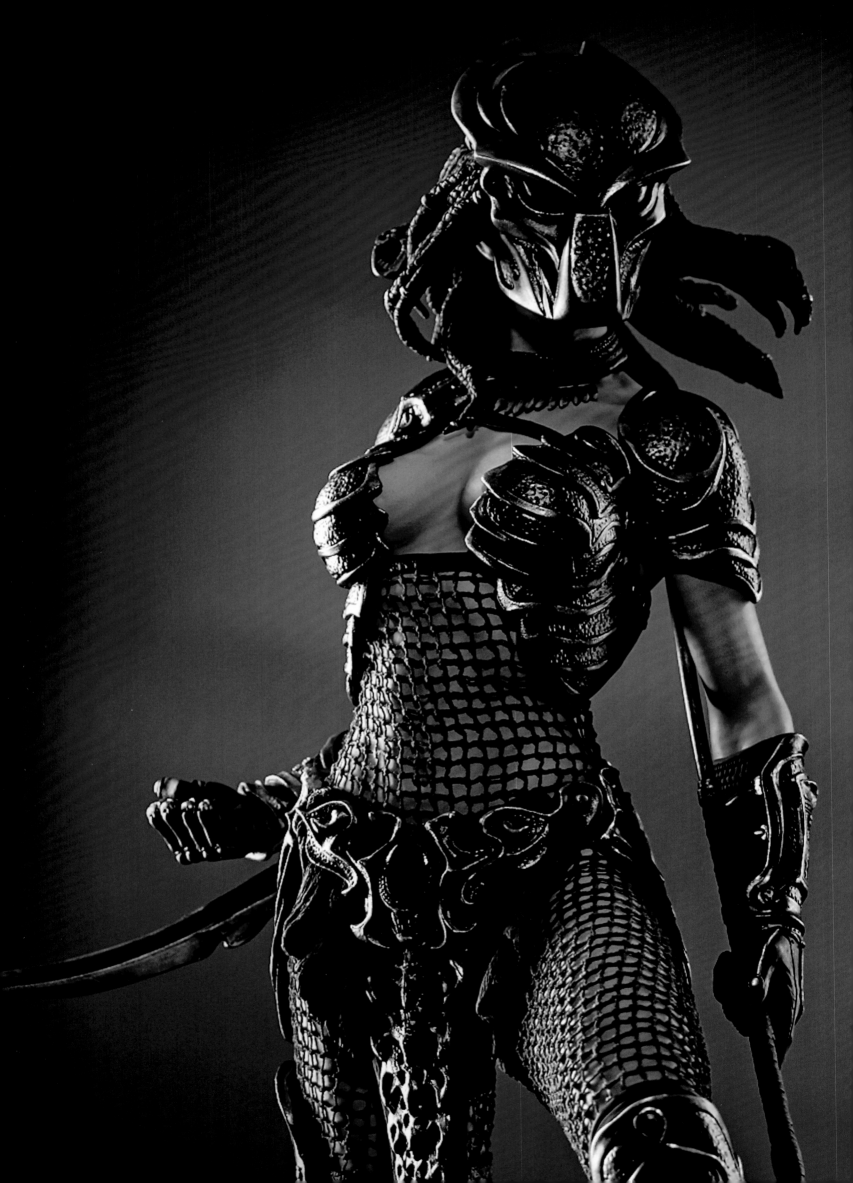

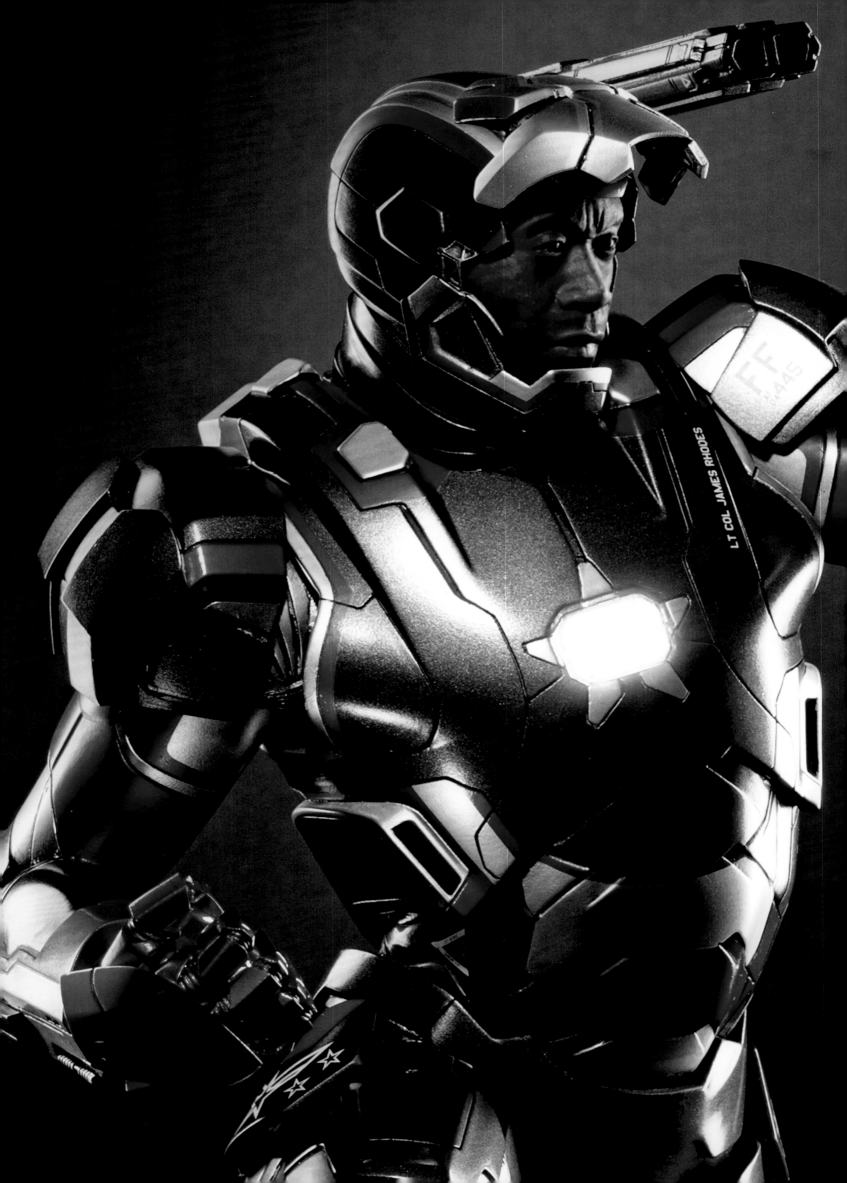

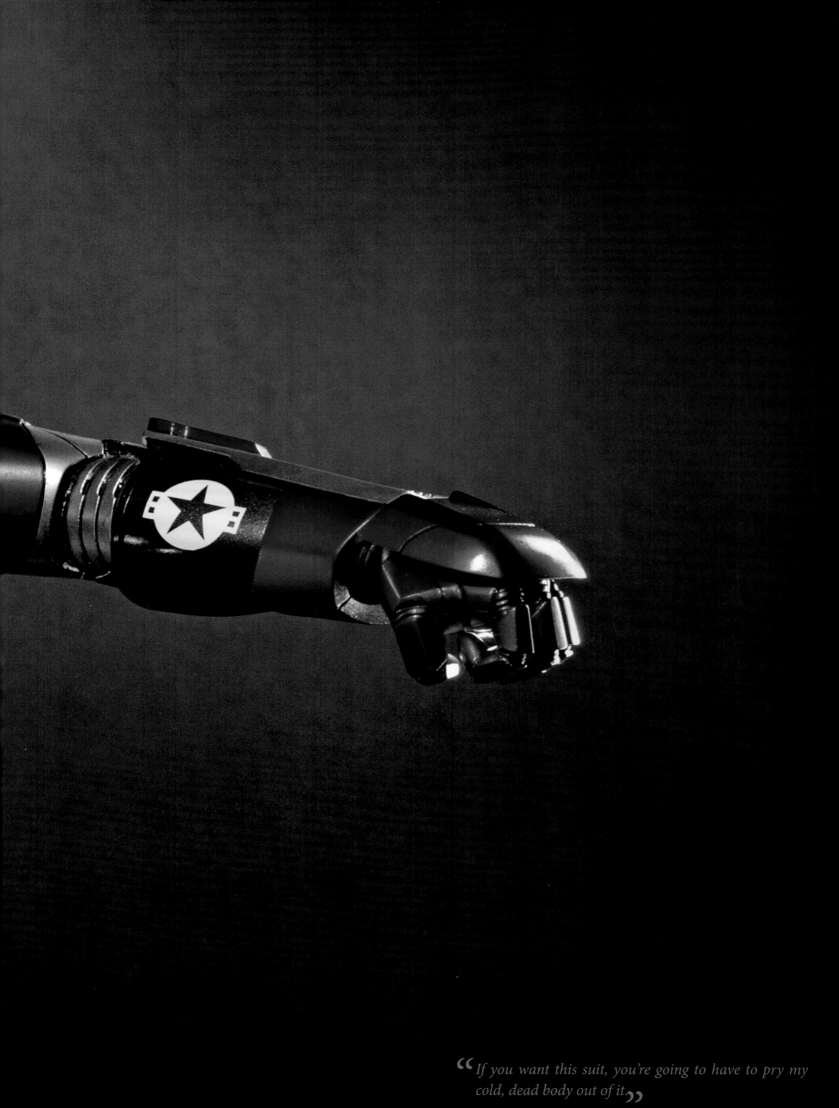

> **"** *If you want this suit, you're going to have to pry my cold, dead body out of it.* **"**

—James Rhodes, Iron Man 3

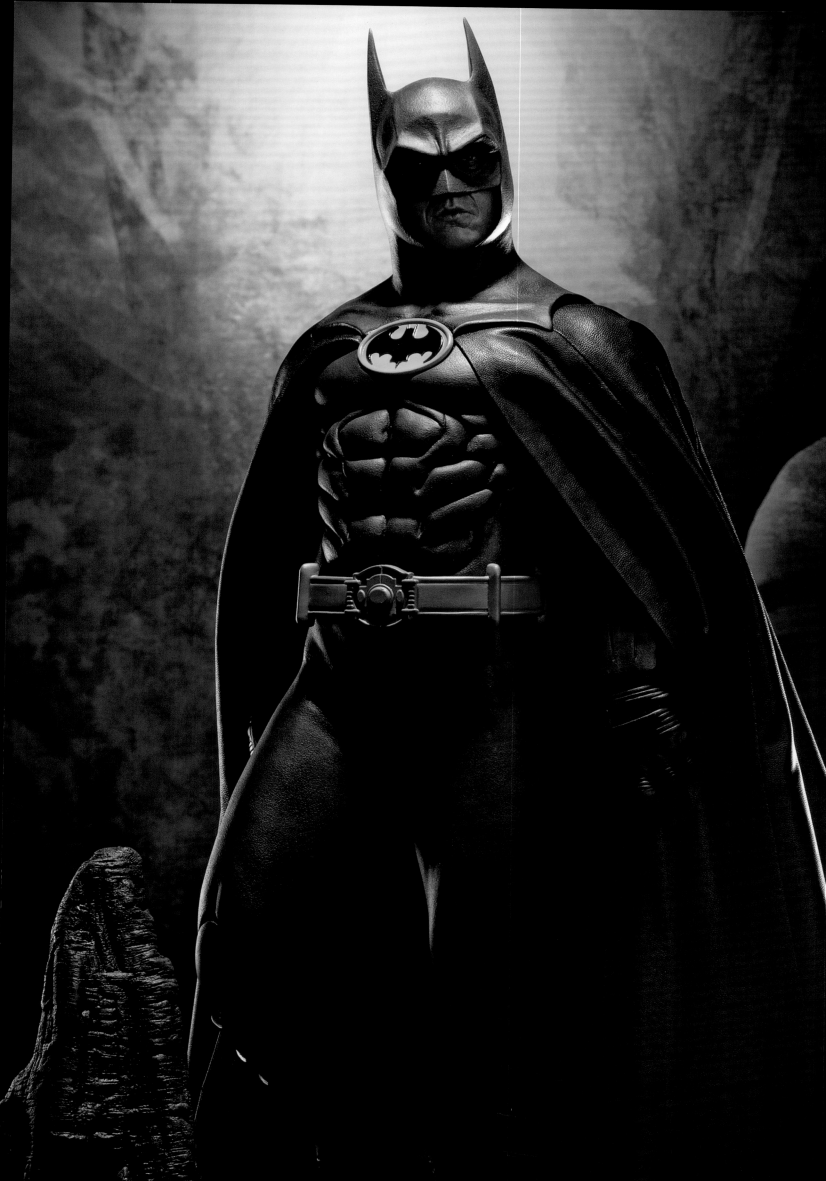

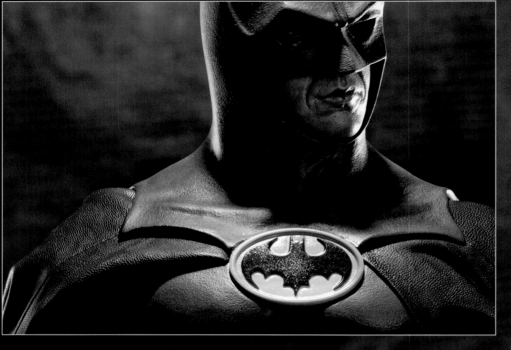

"Batman was one of the biggest forces in my life and is my favorite character in the entire comic universe. The Tim Burton film with Michael Keaton really redefined the character and created this world reminiscent of Edward Gorey's illustrated books with their quirky and macabre images. The 1990s animated Batman series also had a huge impact on revamping the character, which is the perfect combination of darkness and light. Unlike Superman, who just shows up and knocks everyone over and wins the game, Batman has to figure out how to deal with all these villains who get worse and more maniacal every time."

—Nathan Mansfield, Sculptor & 3D Key Artist

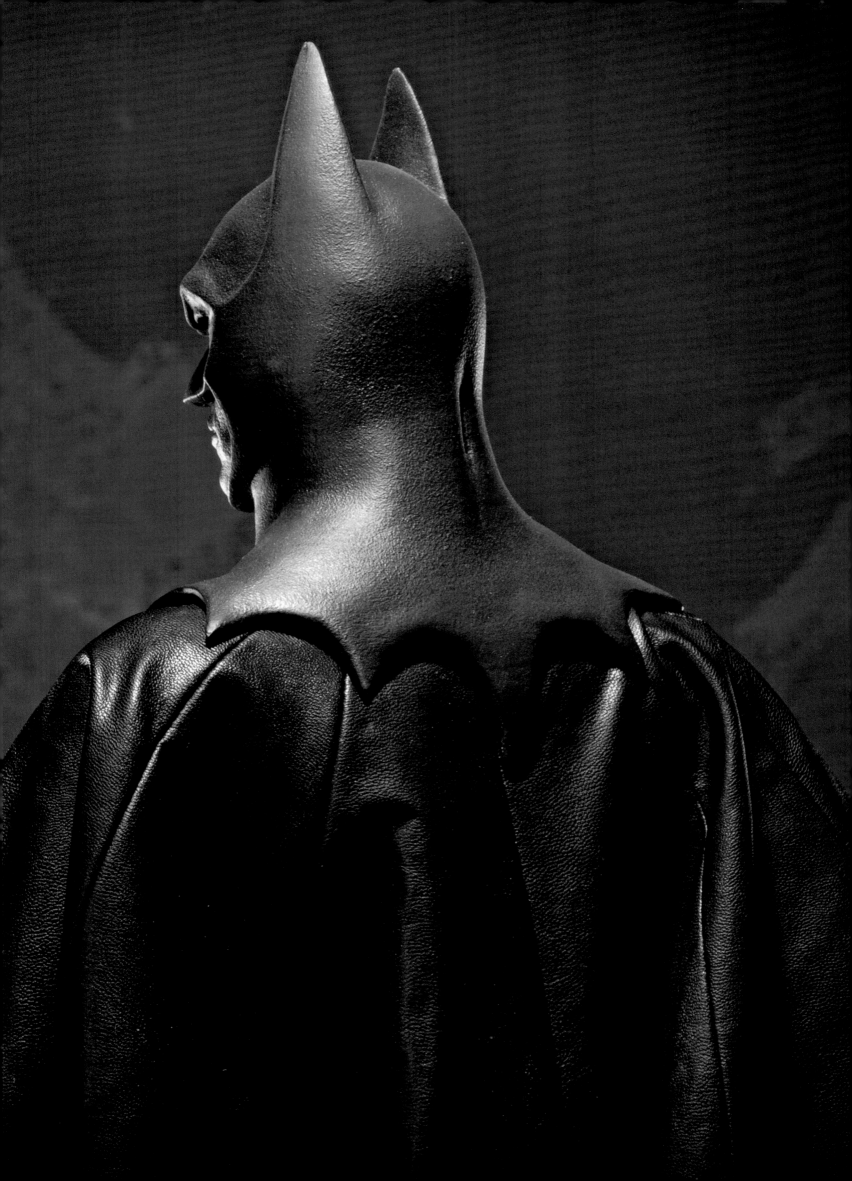

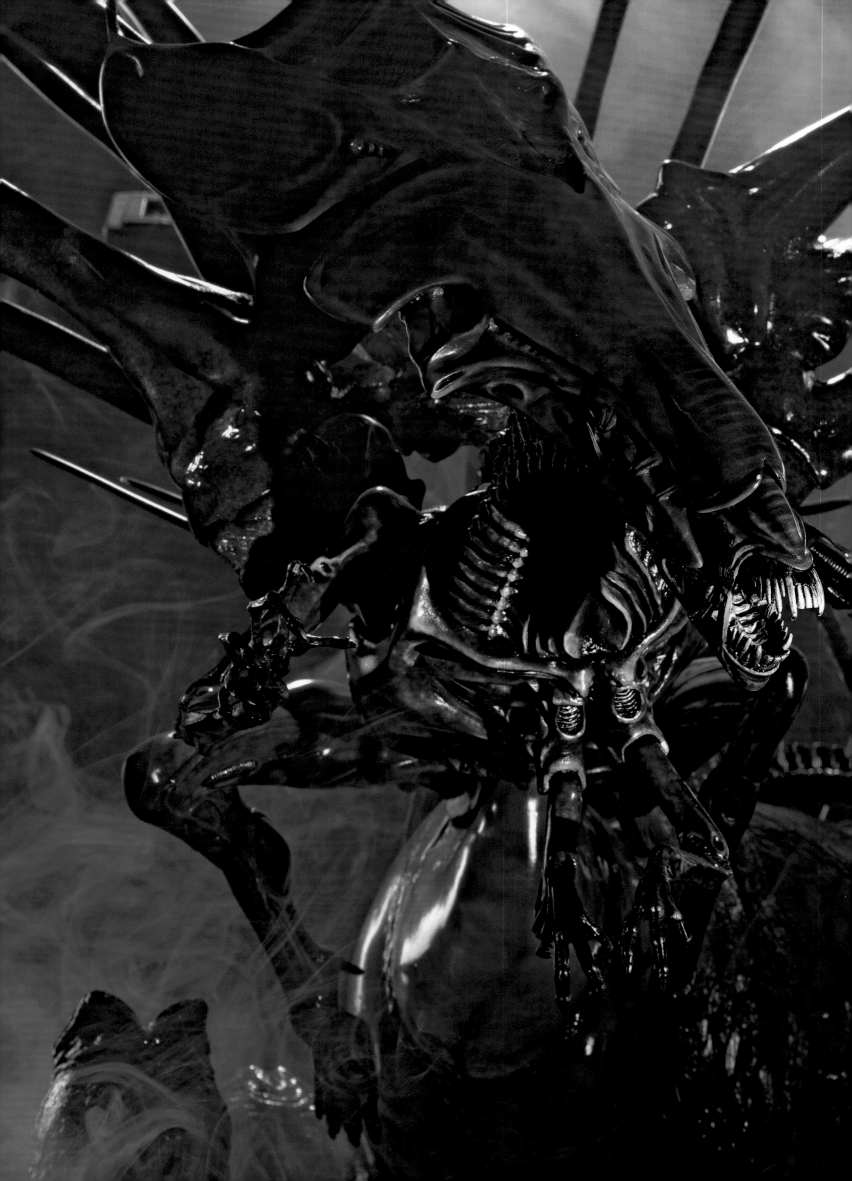

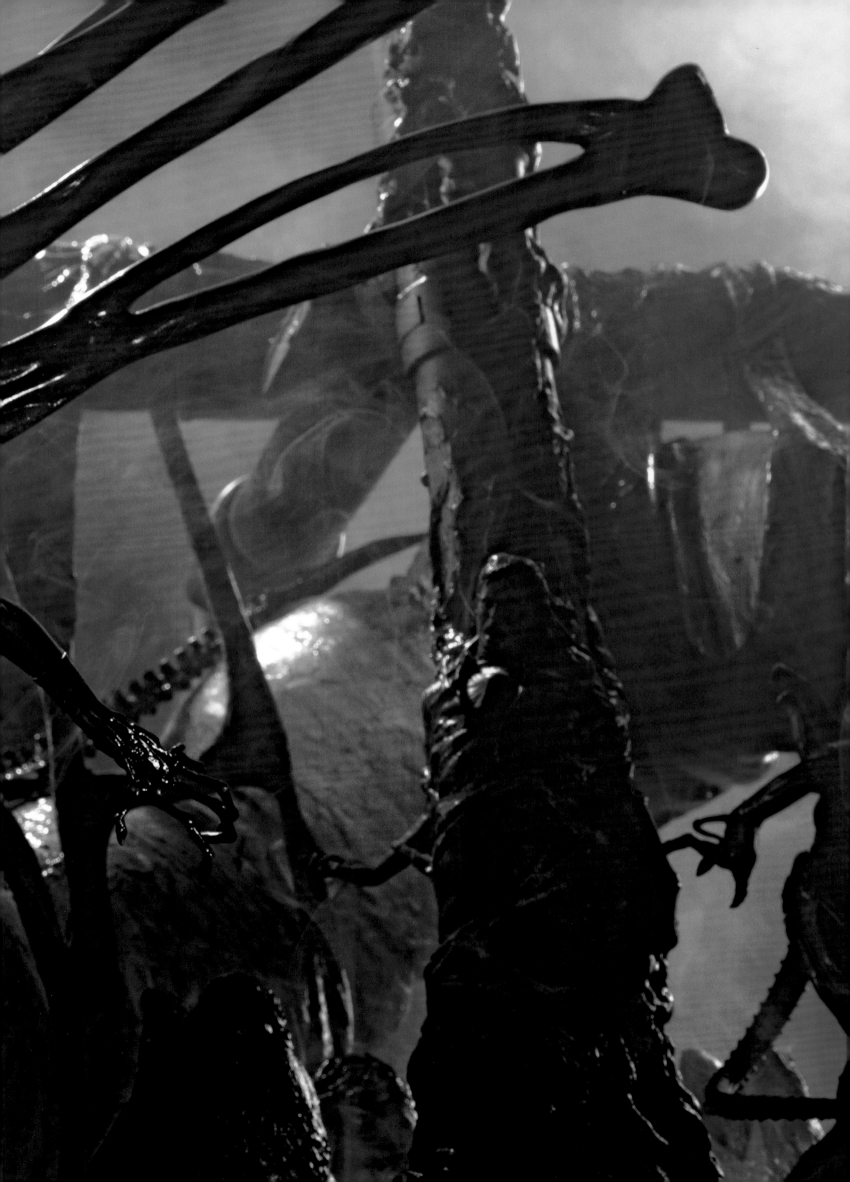

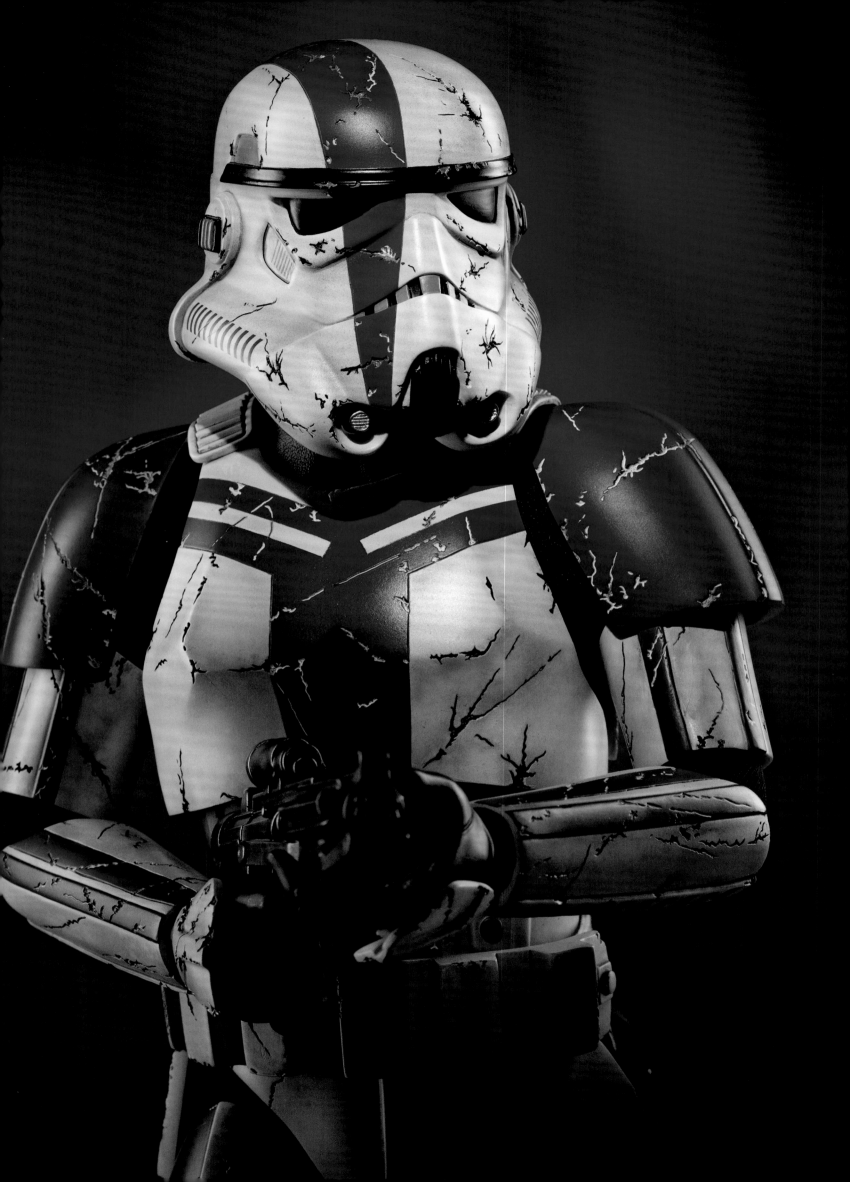

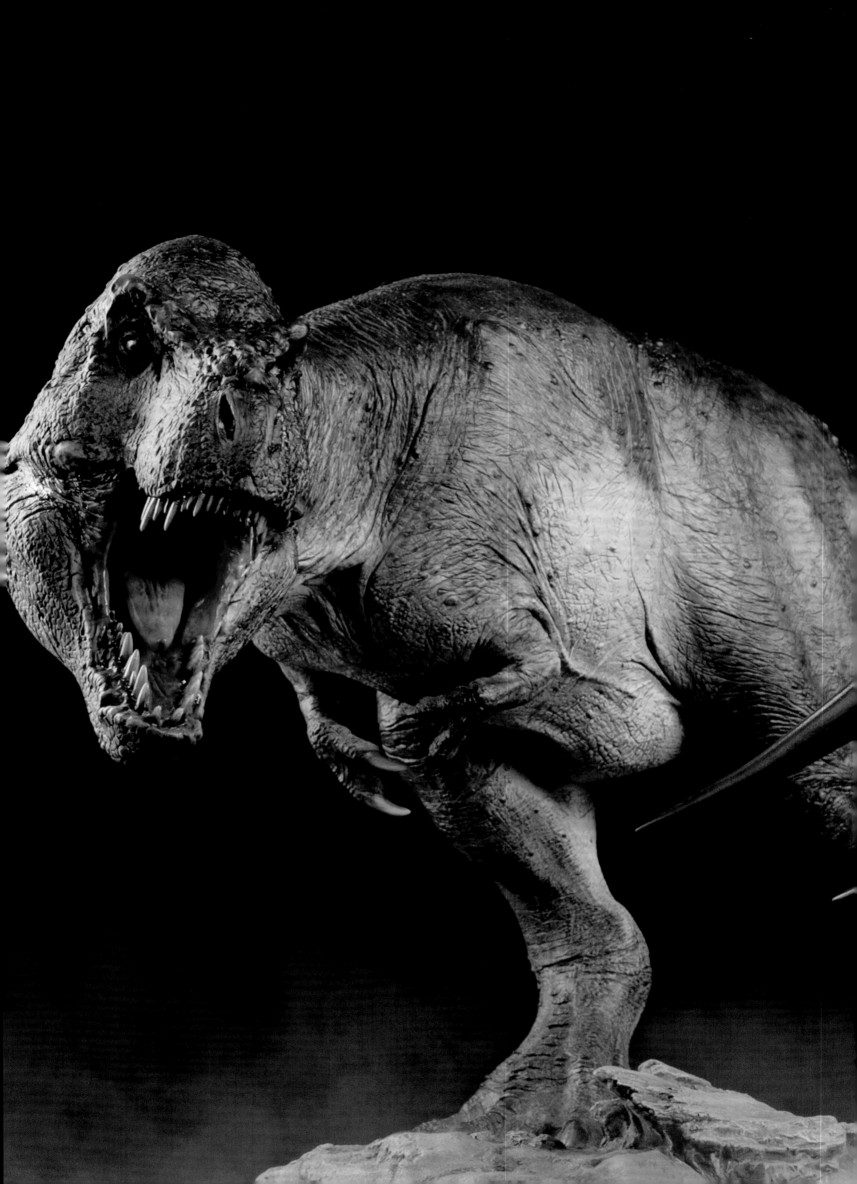

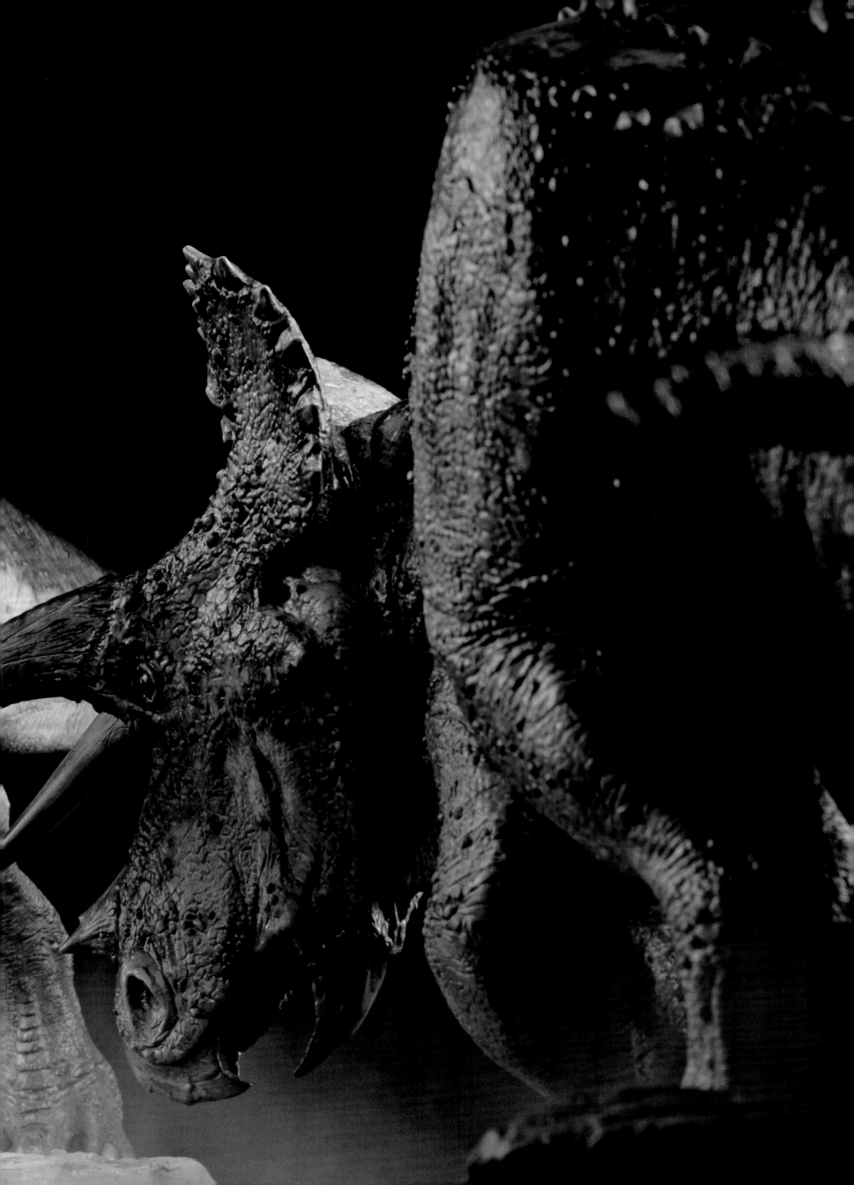

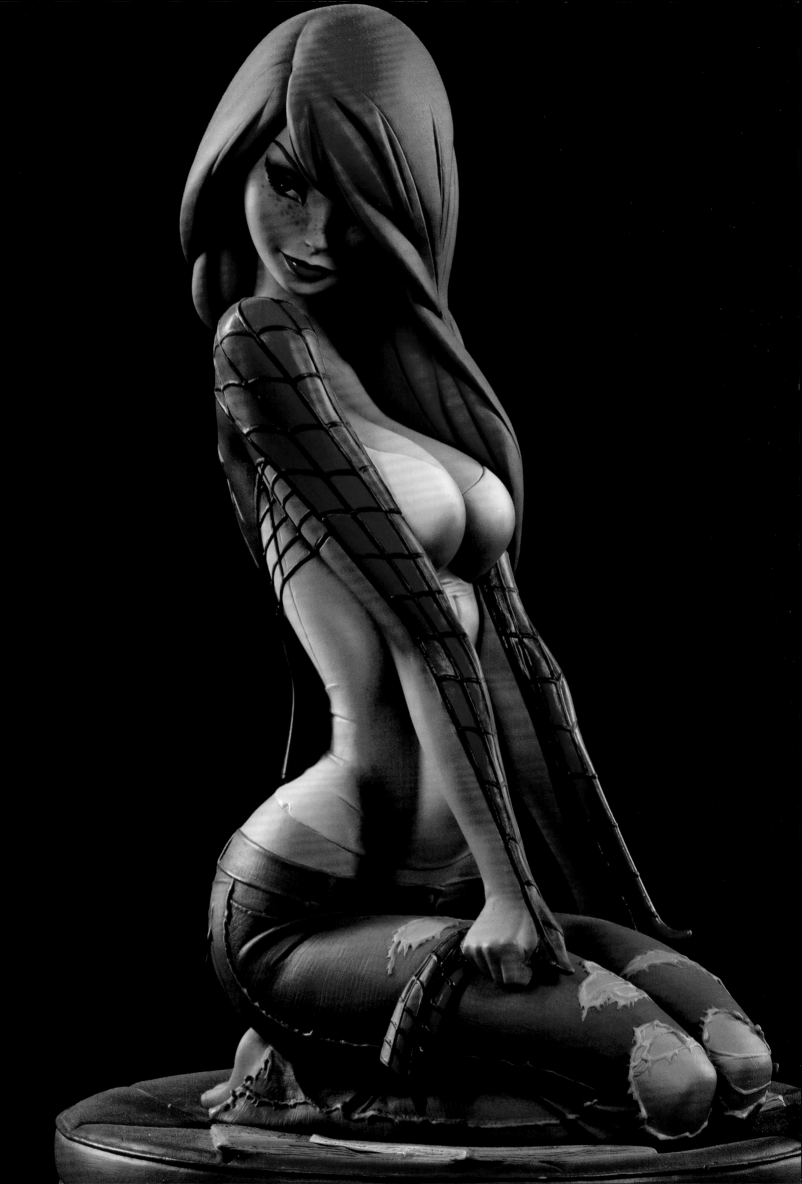

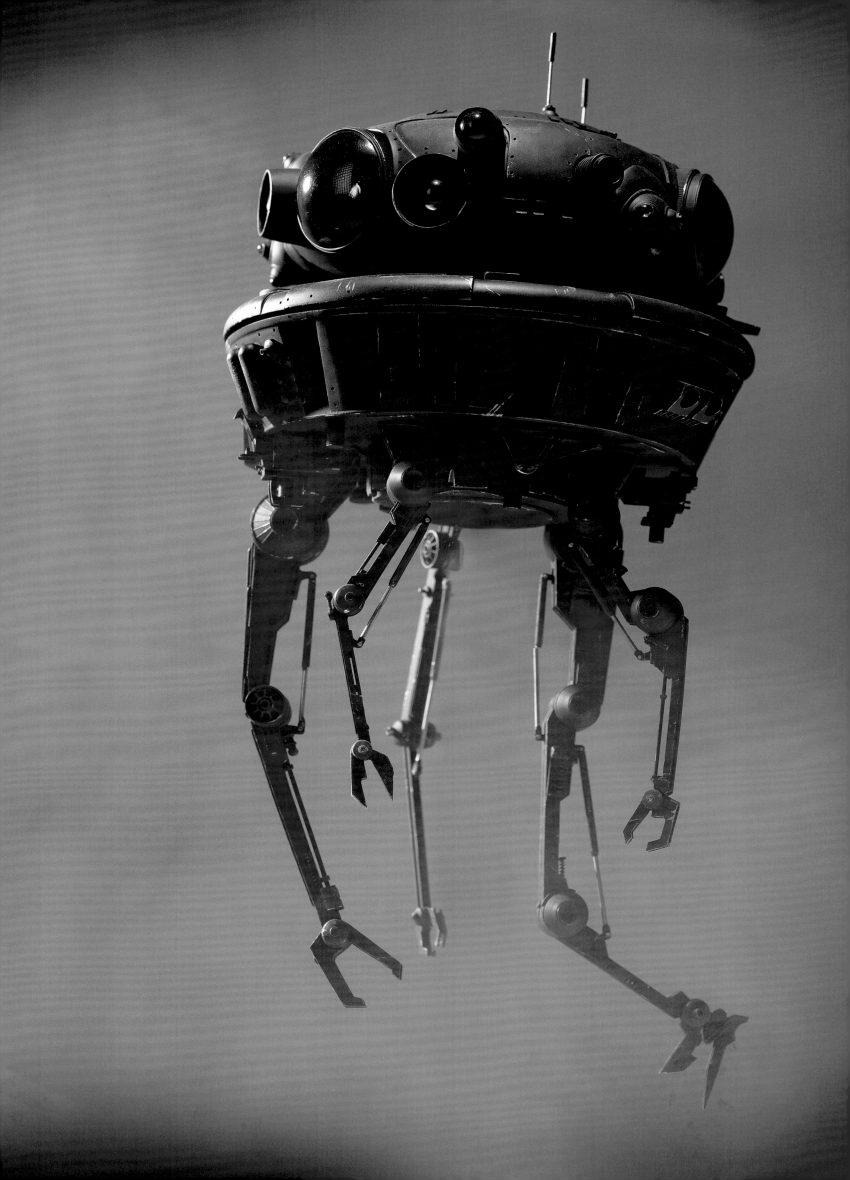

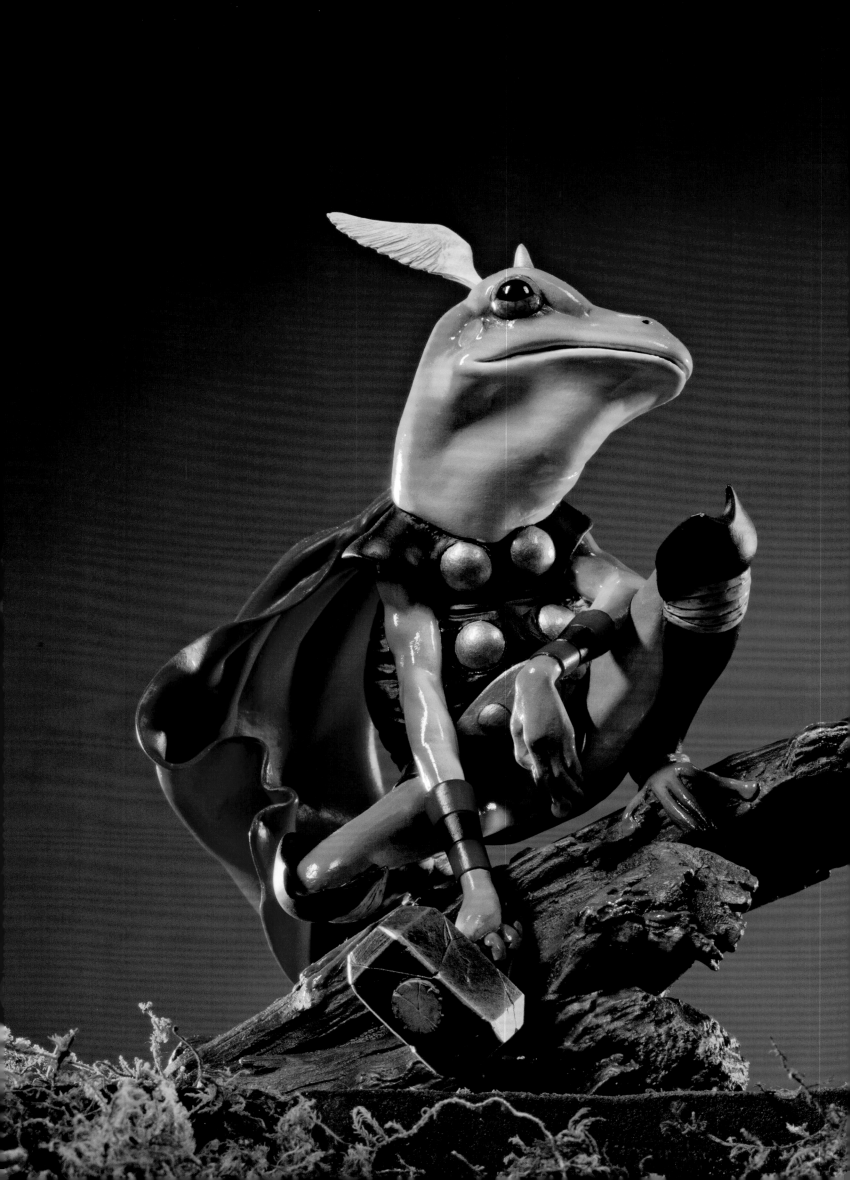

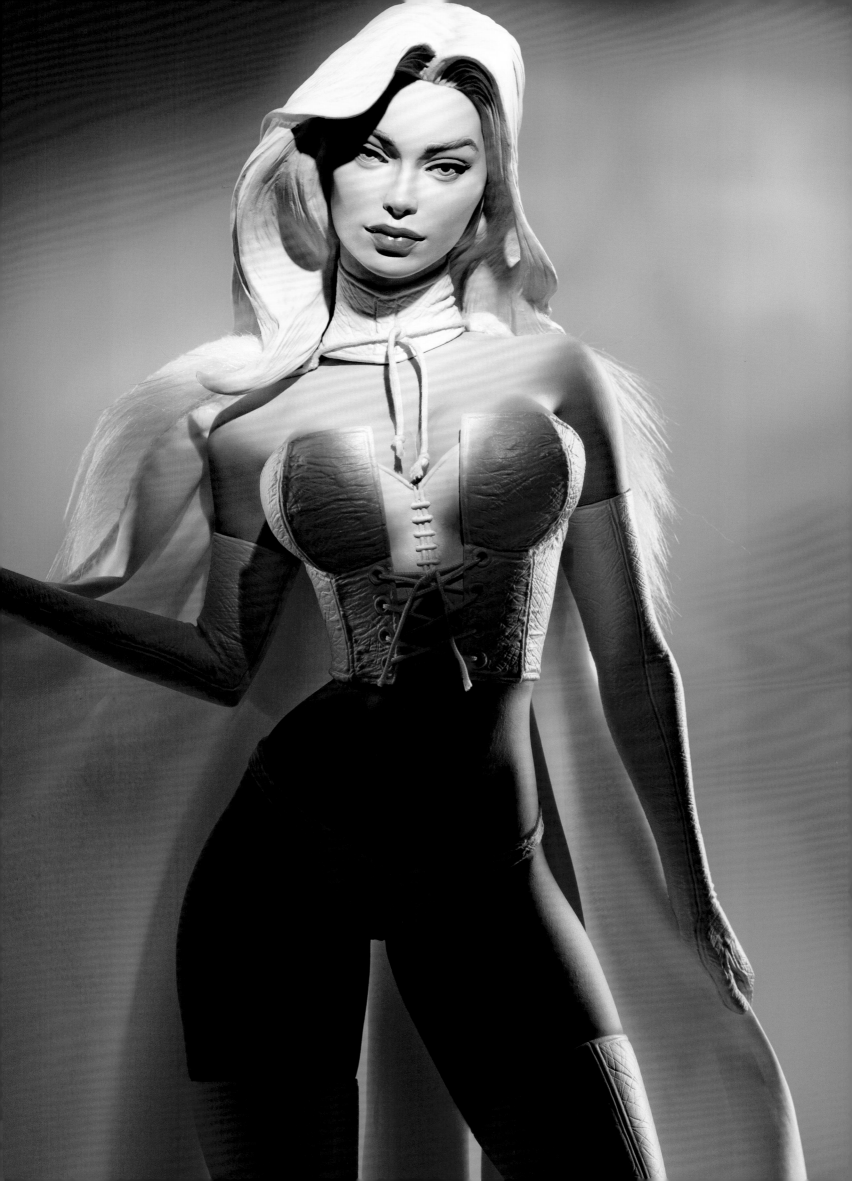

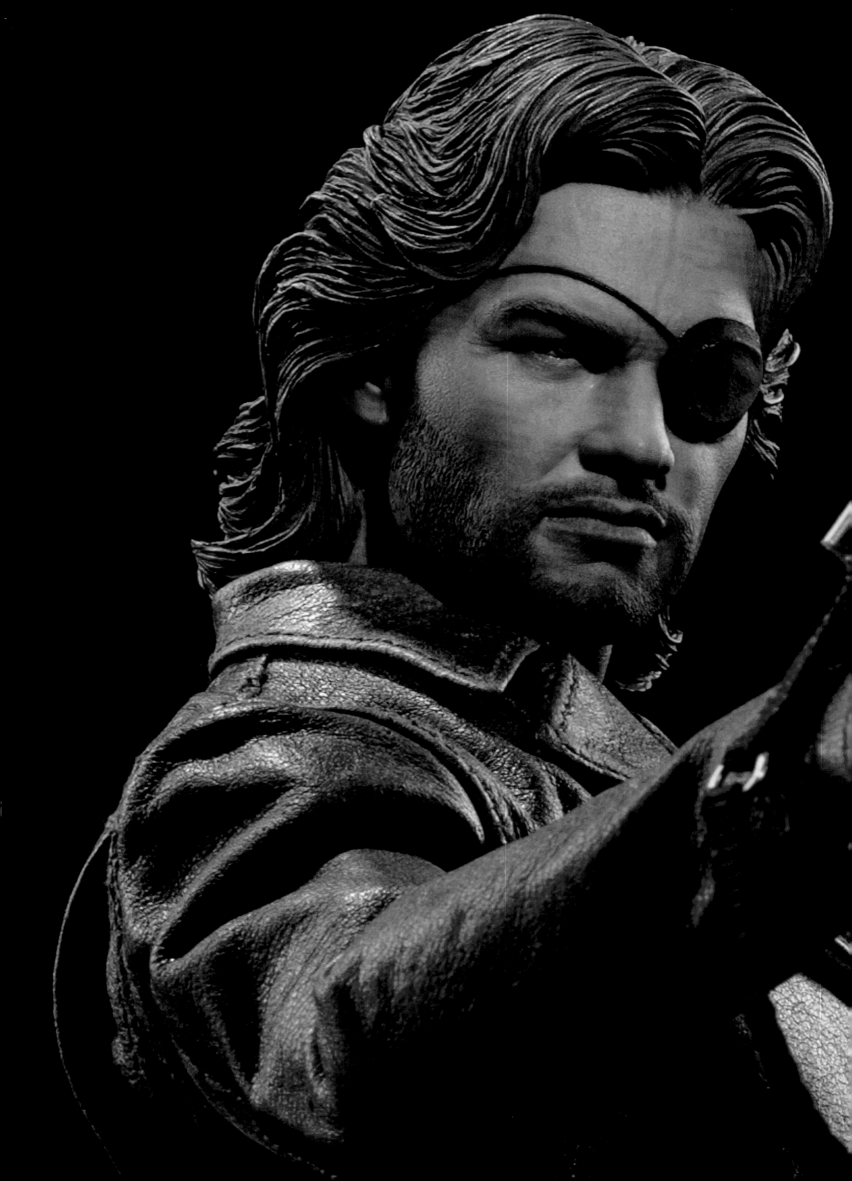

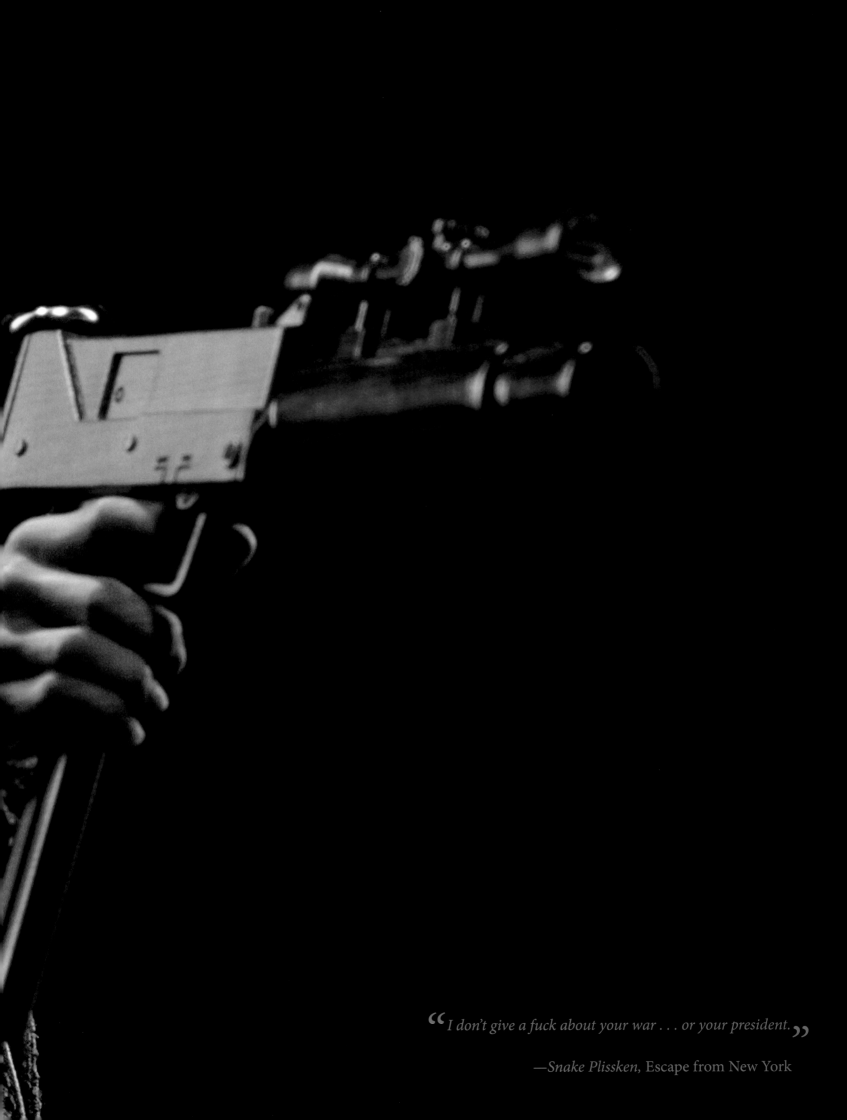

**"** *I don't give a fuck about your war . . . or your president.* **"**

—*Snake Plissken,* Escape from New York

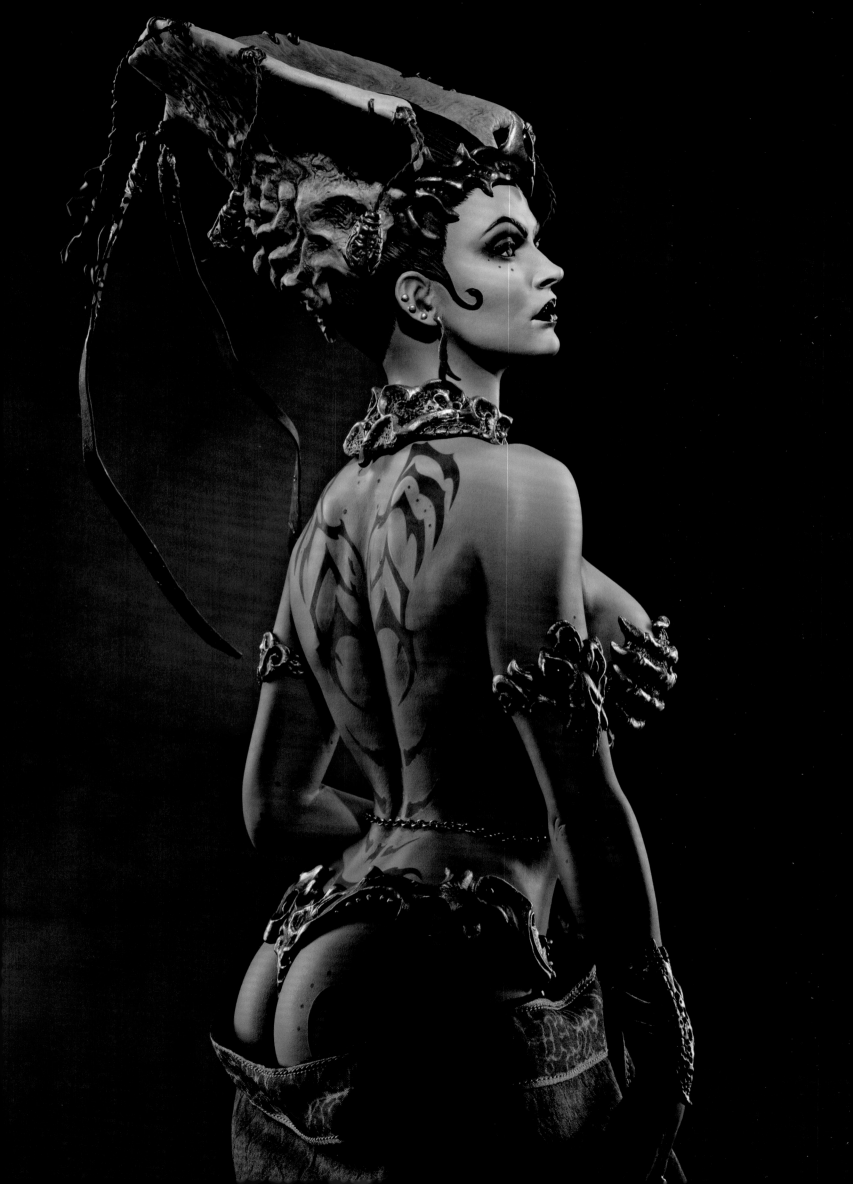

*" This is my domain, and everything within it—from the lowest of lost souls to the most powerful of lords—serves me. "*

—*Gethsemoni*, Court of the Dead: The Chronicle of the Underworld

One of the central themes of Sideshow's Court of the Dead world is the dichotomy of the beatific and the horrific. The Queen is Death's appointed regent in the Underworld, and she is the representation of the ultimate human beauty and ugliness at the same time. Based on a design by Walter O'Neal, the Queen is a throwback to Frank Frazetta's high-fantasy creations from the 1970s. She is a mixture of thousands of human souls, and her disarming beauty crowns the court."

—Tom Gilliland, Vice President | Creative Director & CCO
Creator of Court of the Dead

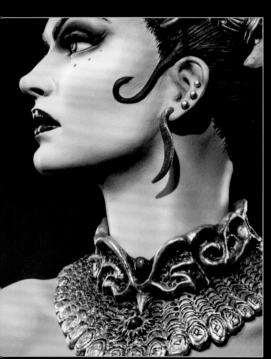
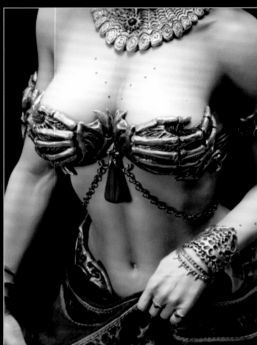
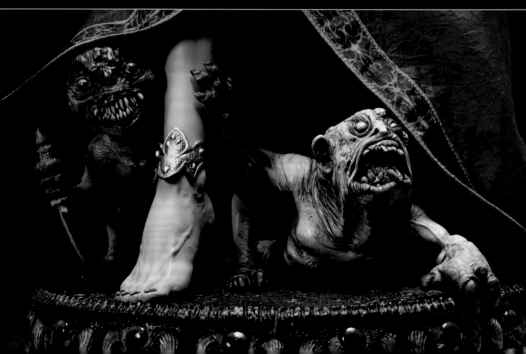

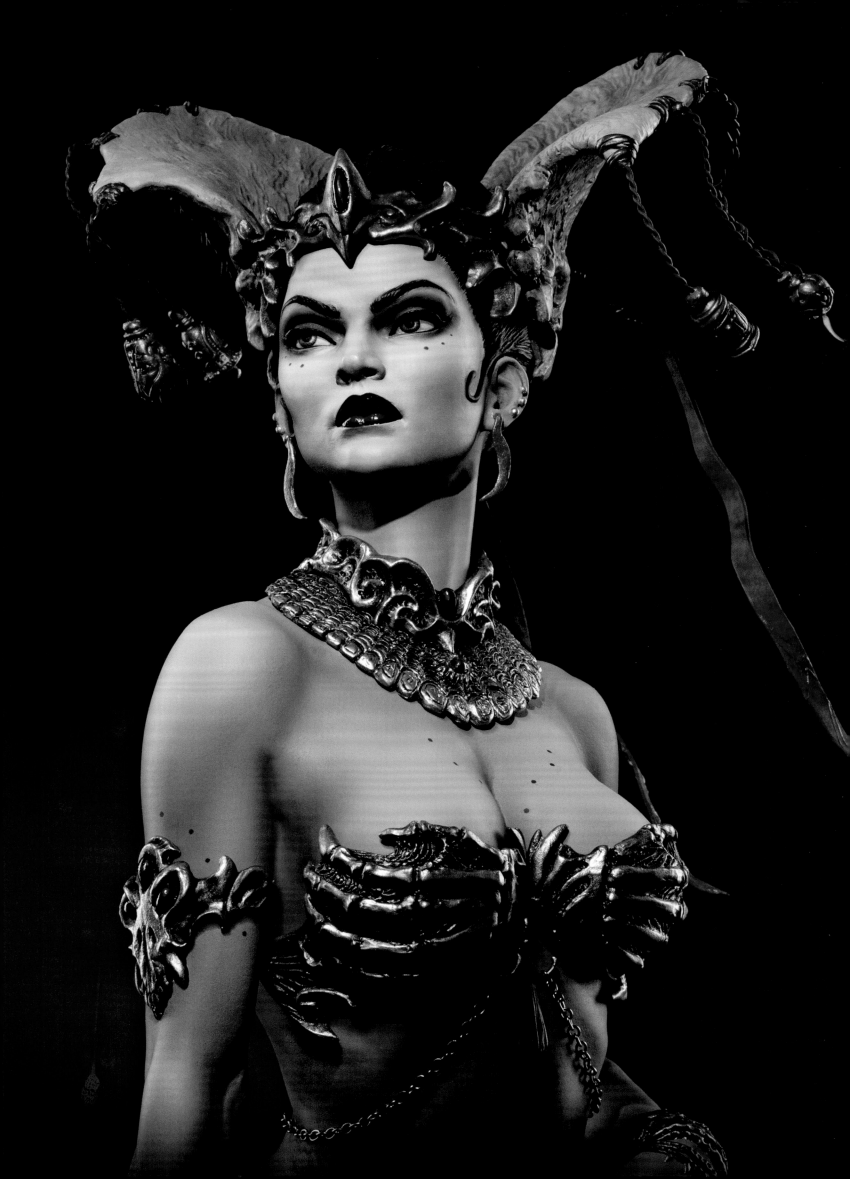

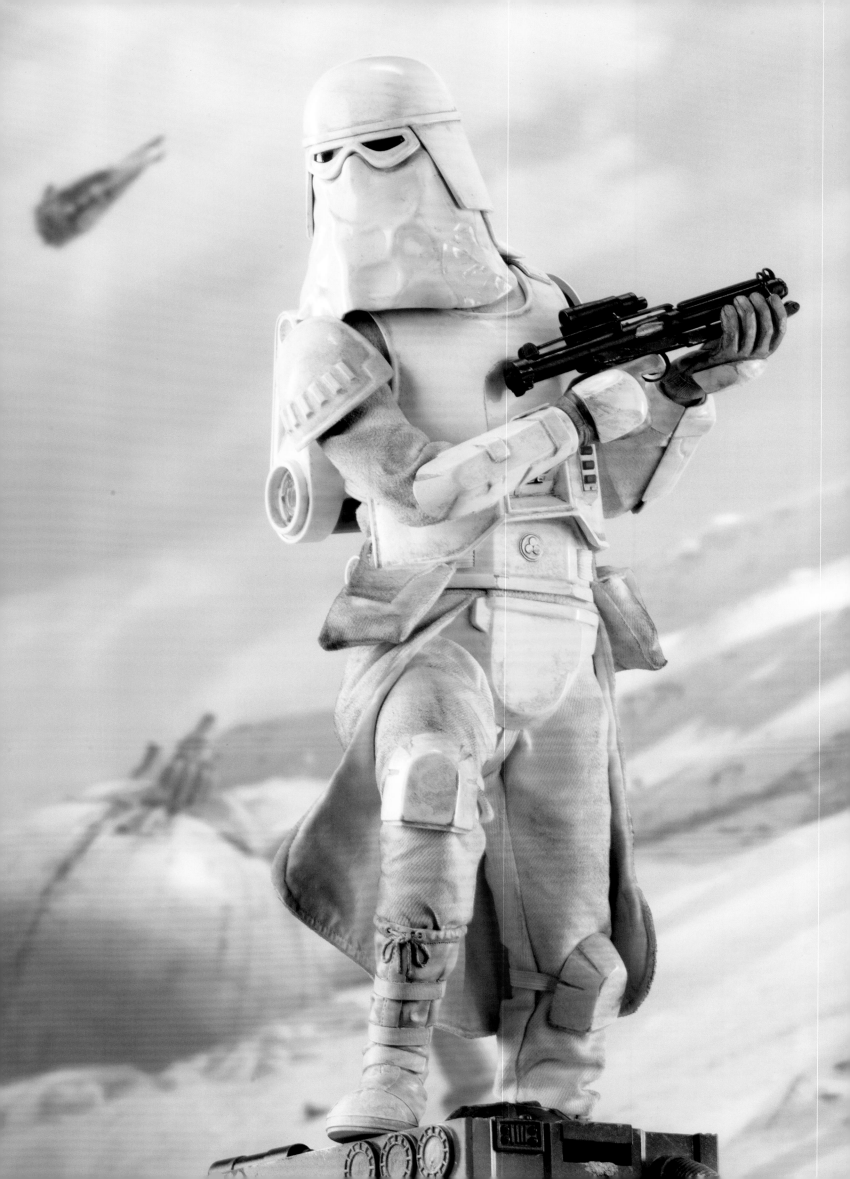

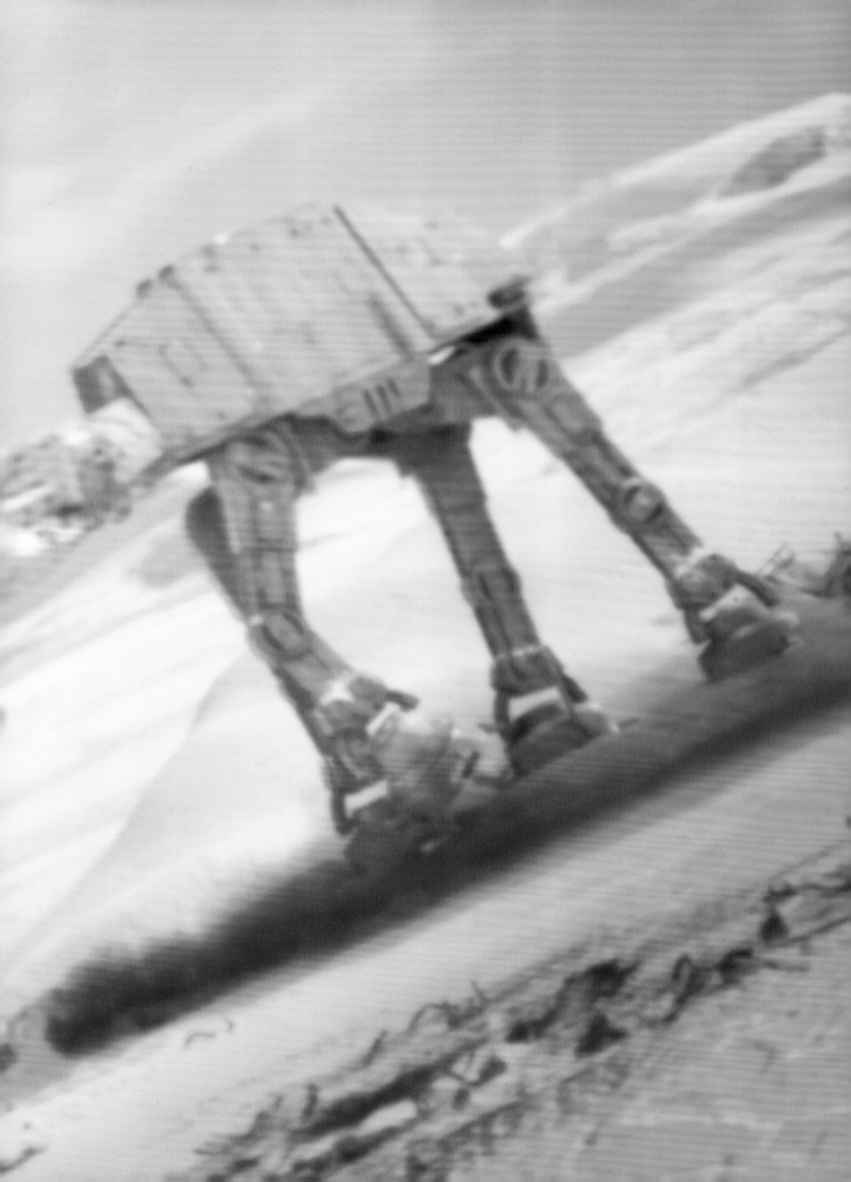

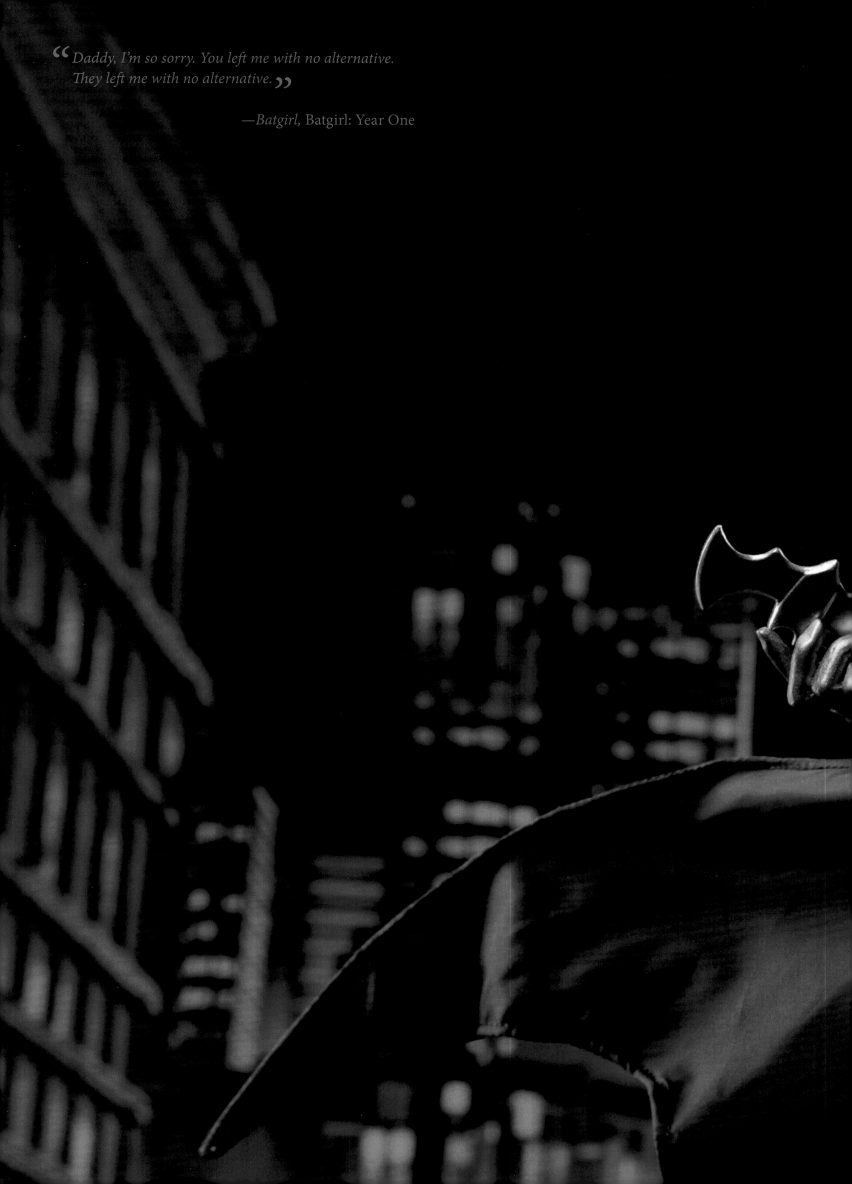

*"Daddy, I'm so sorry. You left me with no alternative. They left me with no alternative."*

—*Batgirl*, Batgirl: Year One

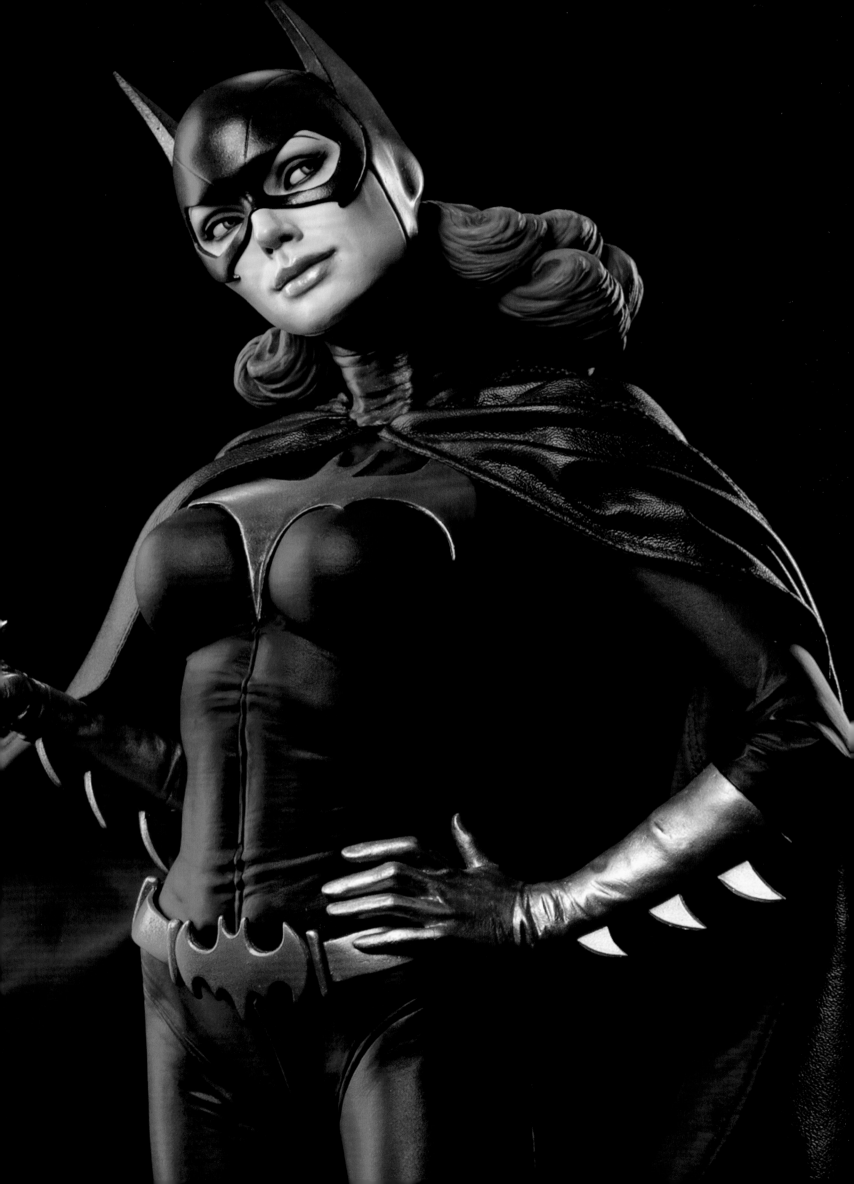

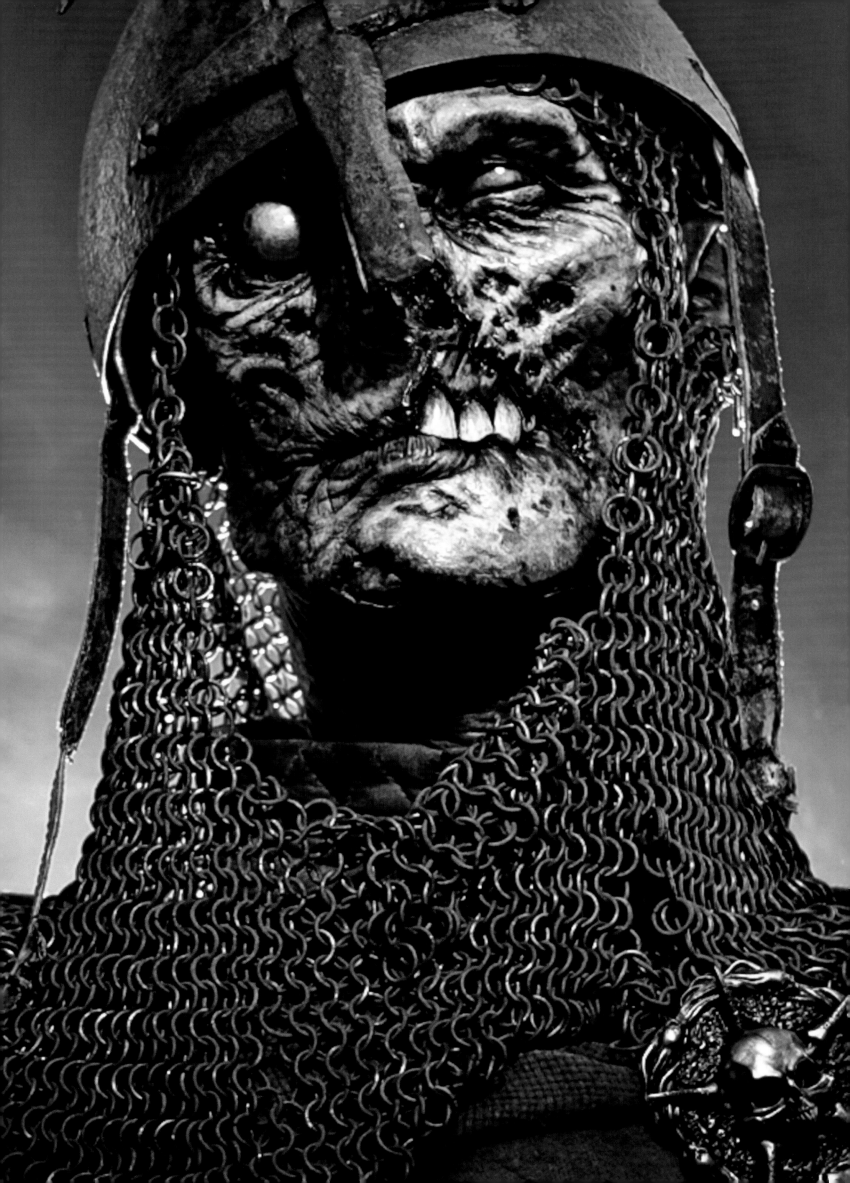

> "At last I have met Count Dracula. It only remains for me now to await the daylight hours when, with God's help, I will forever end this man's reign of terror."

—*Jonathan Harker,* Horror of Dracula

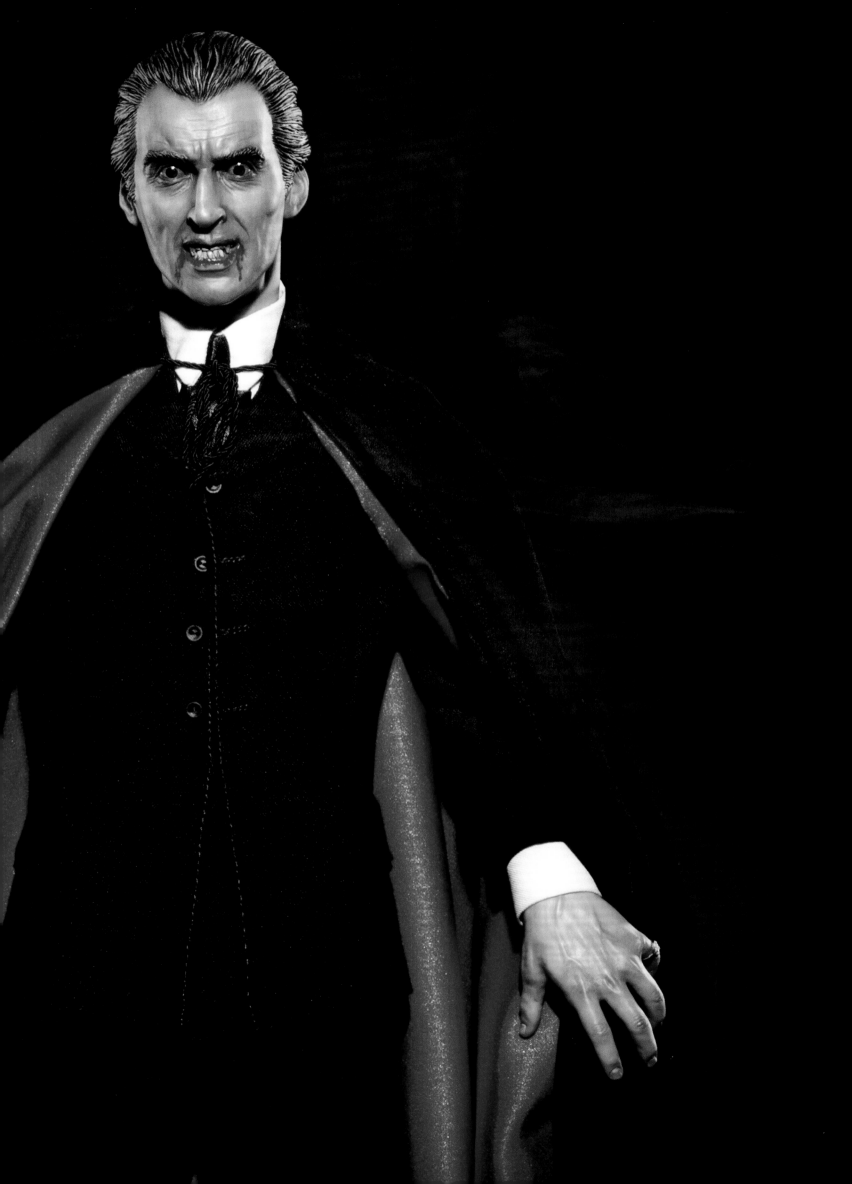

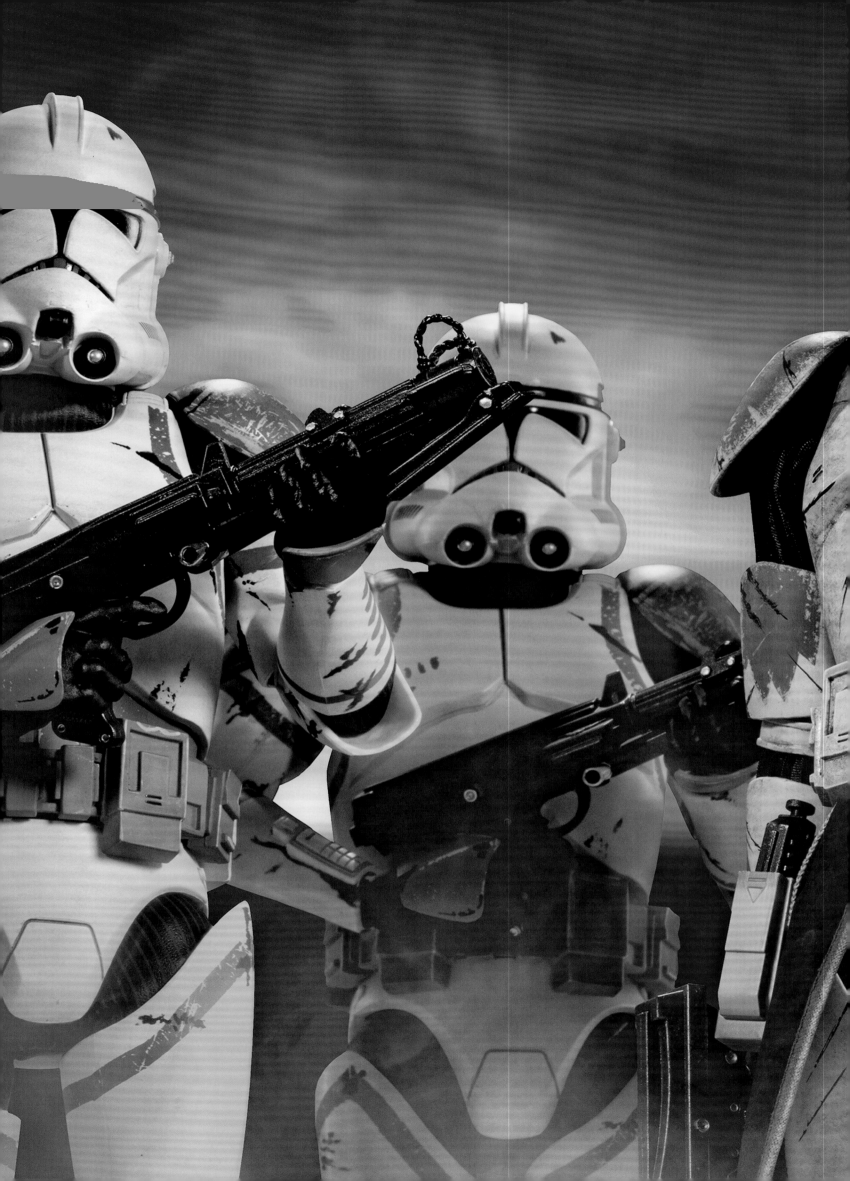

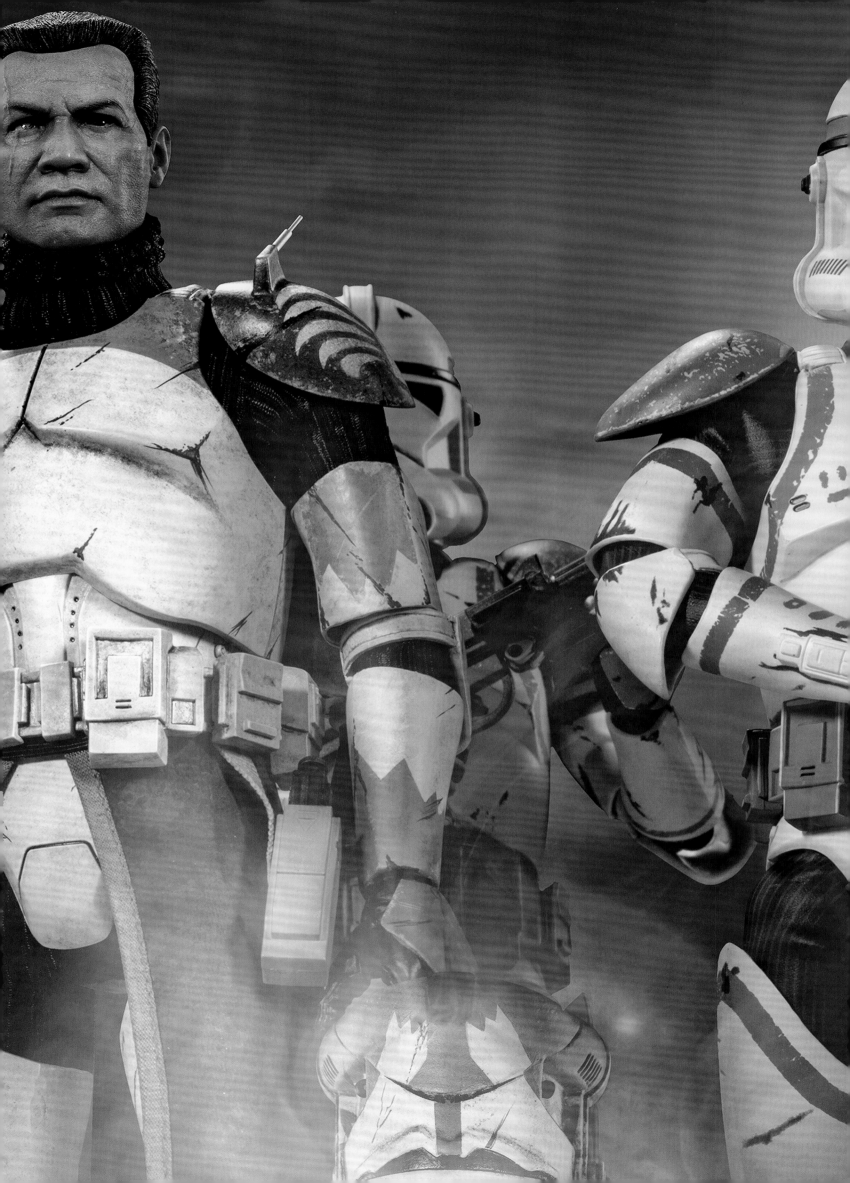

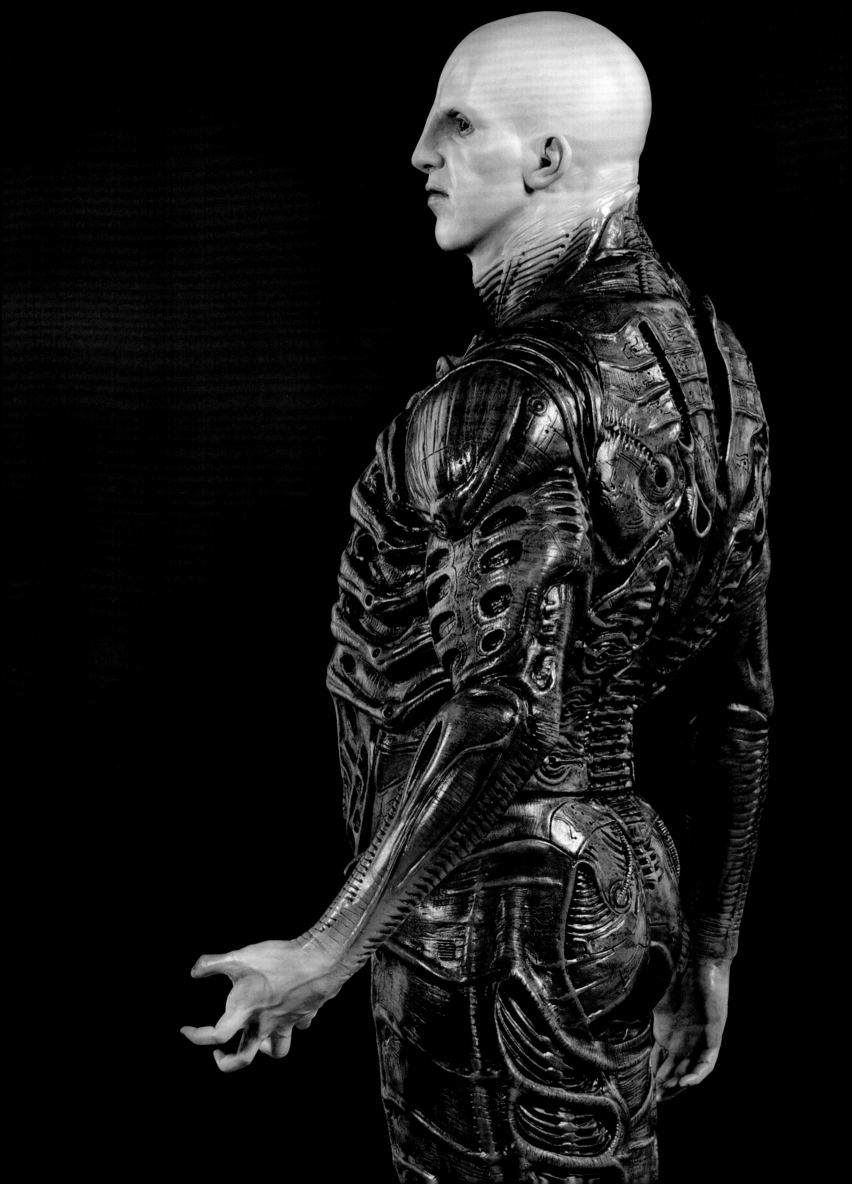

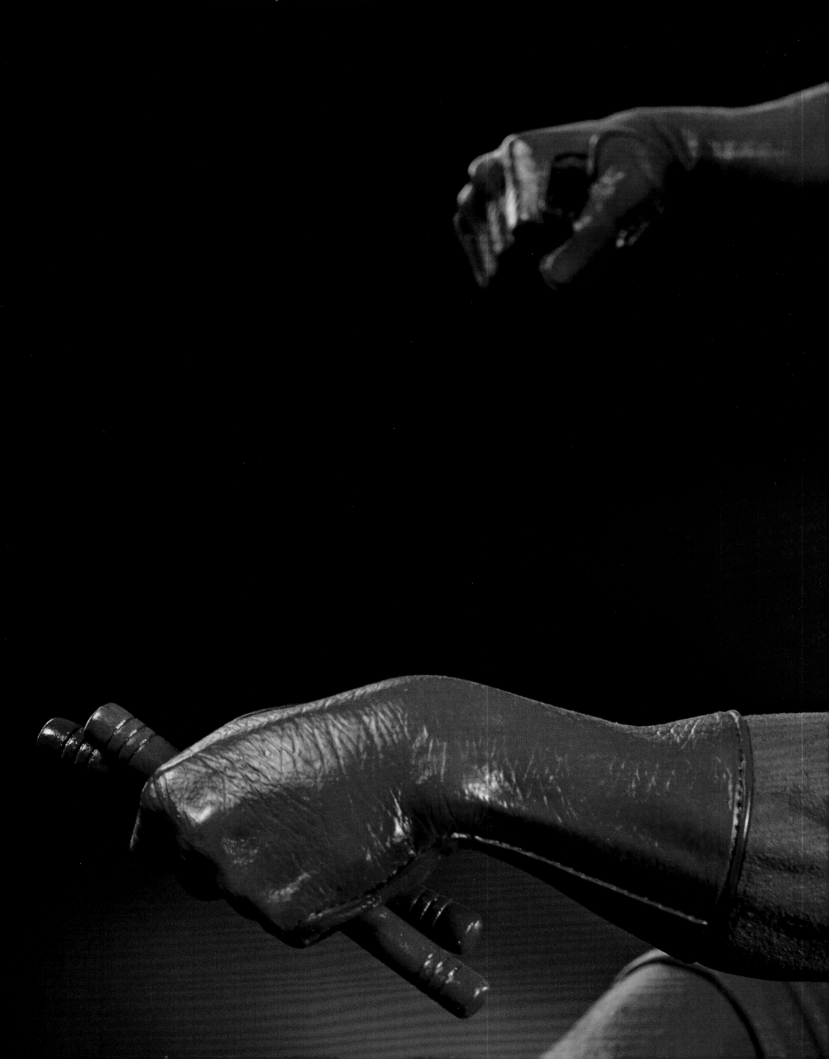

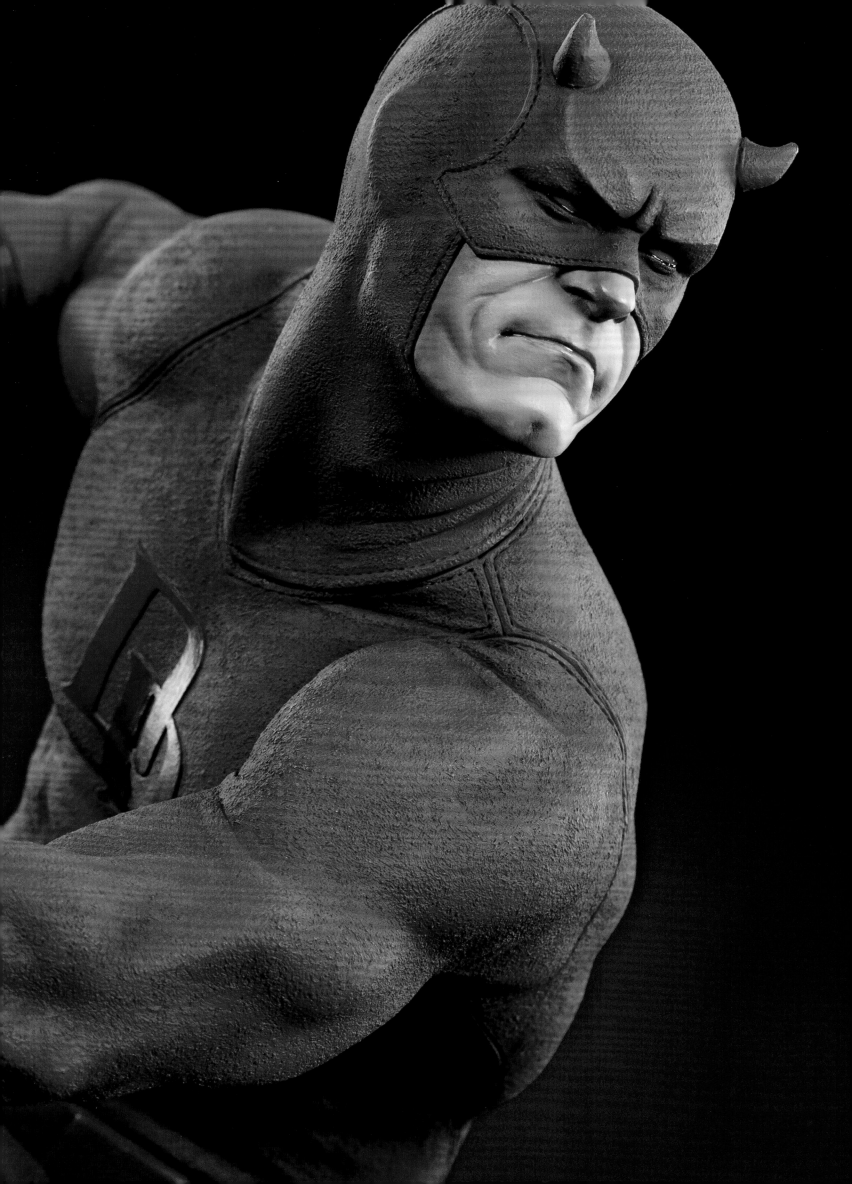

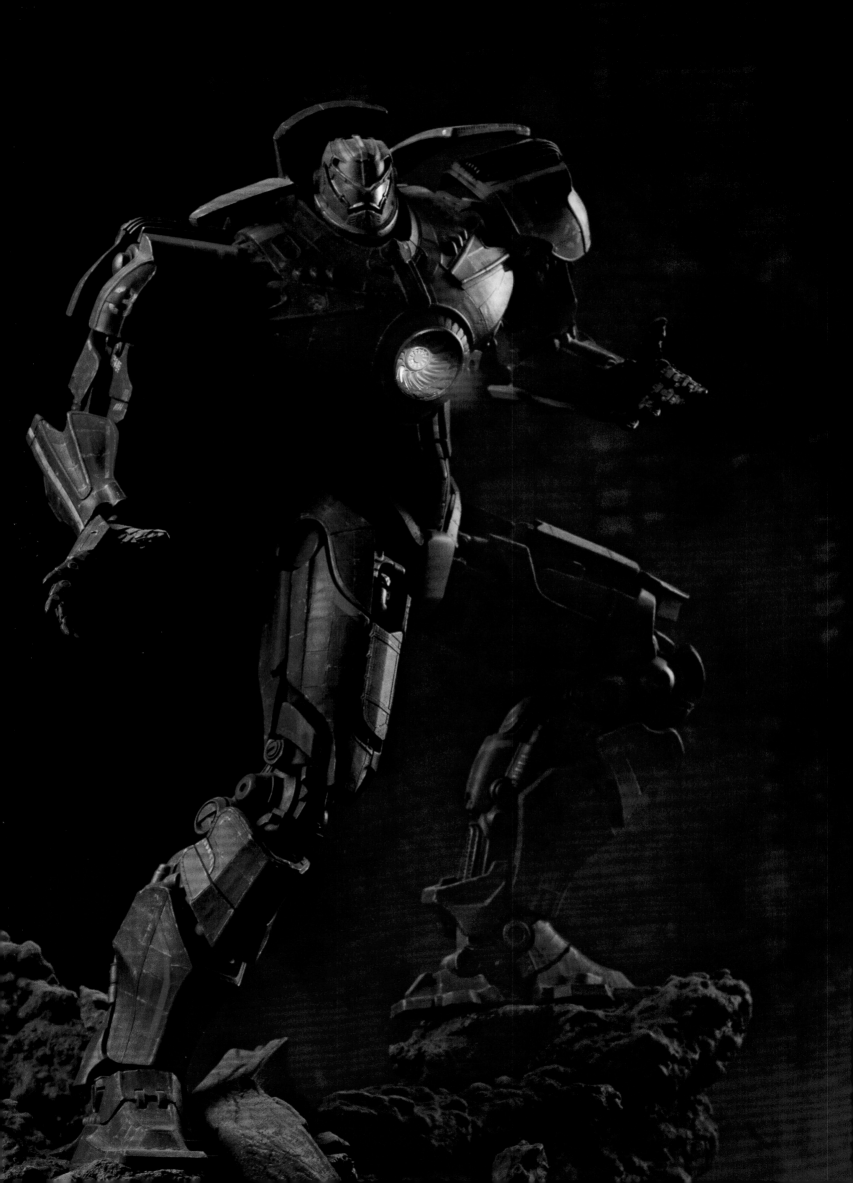

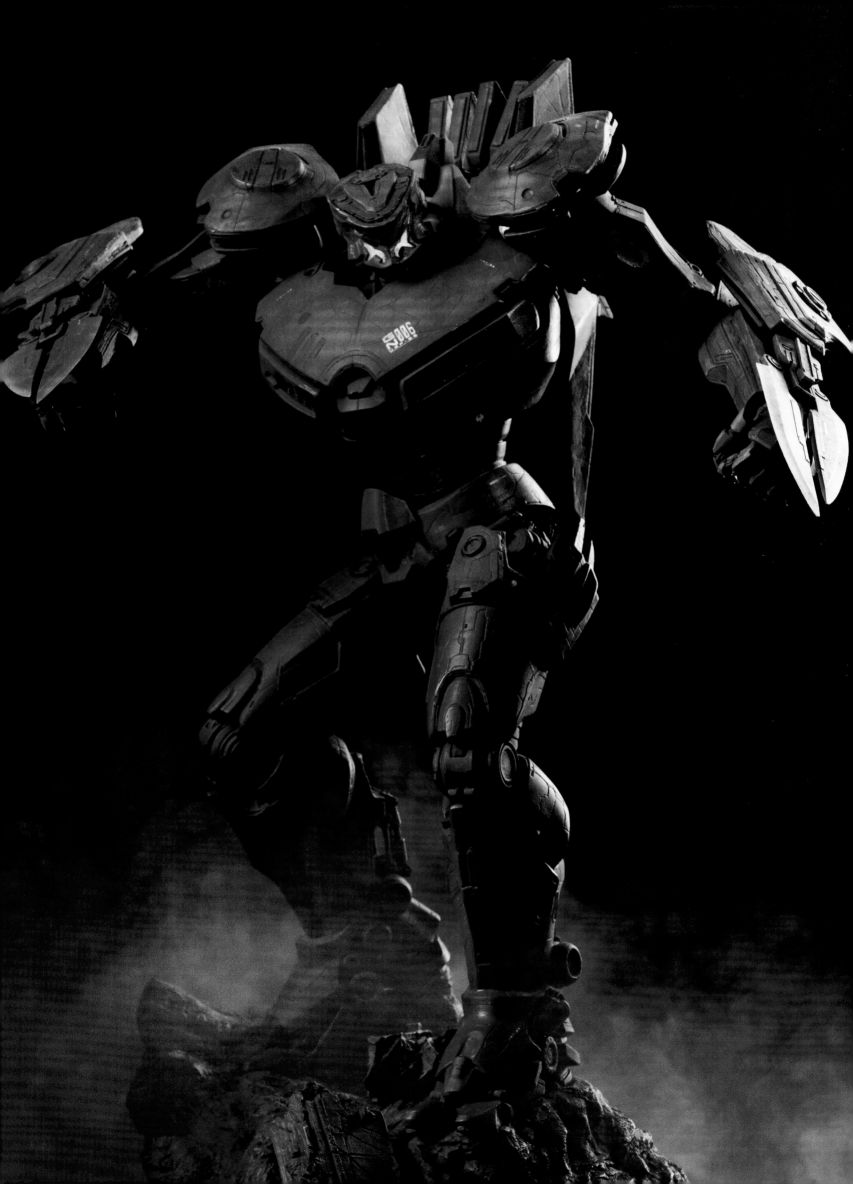

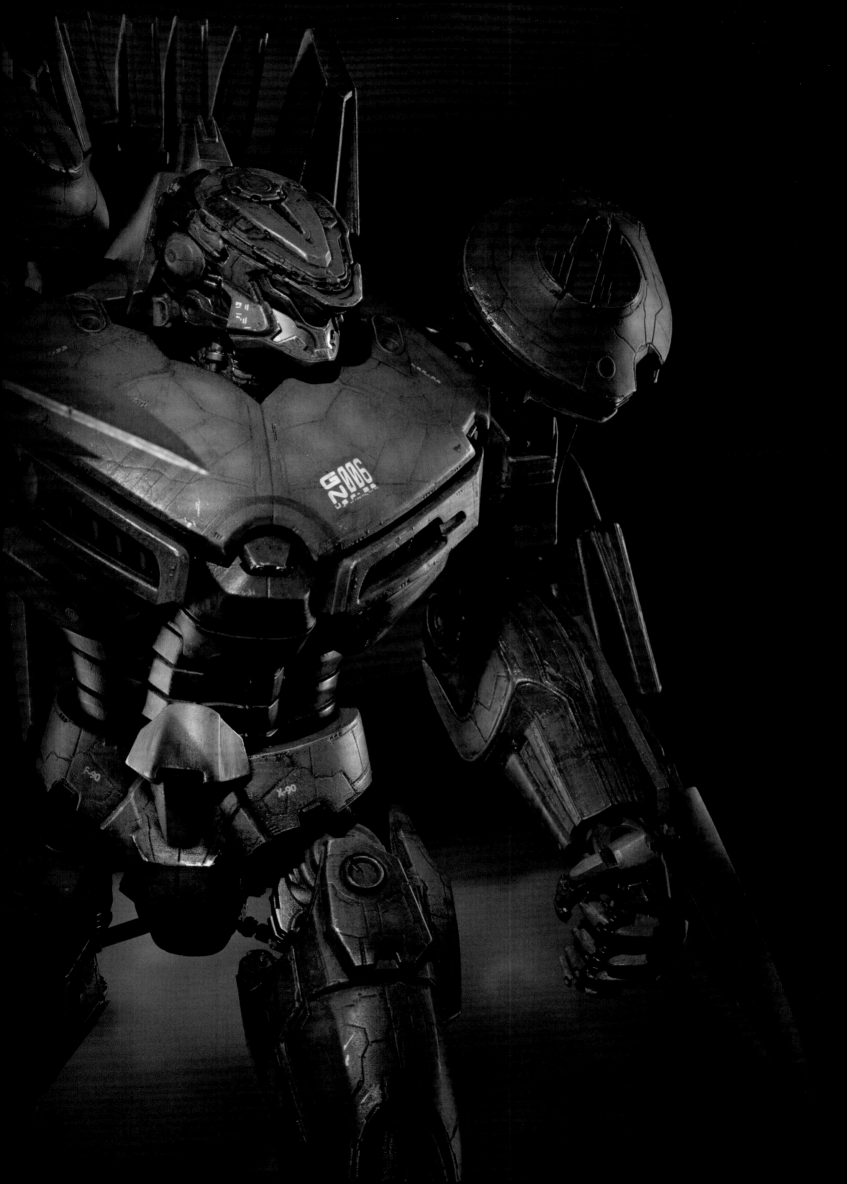

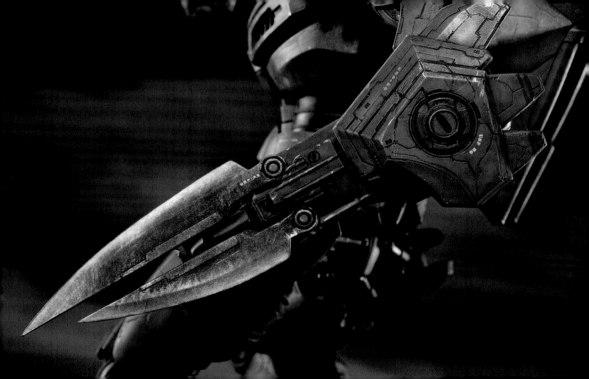

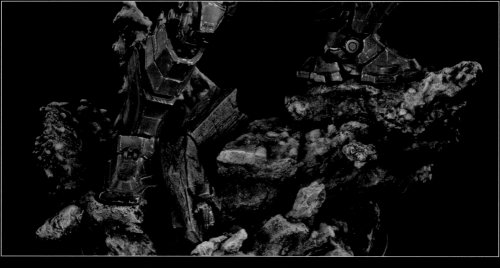

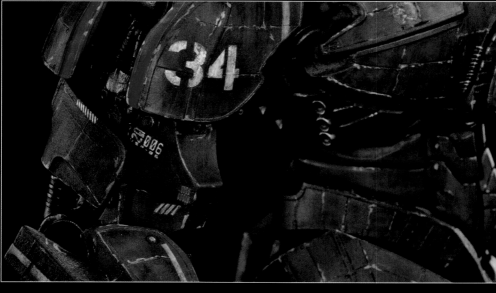

"Pacific Rim *was the movie that I've been wanting to see since I was in junior high and high school. It really had the best of Japanese and U.S.-style genre filmmaking: action, storytelling, and great visual details. If you're a fan of robots and kaijus, then you immediately get this film. Many of us got into collecting and model building because of movies like* King Kong *and* Godzilla. *The models allowed me to admire these detailed characters after the credits rolled, and Guillermo del Toro captured that in his film."*

—Anthony Mestas, Paint Department Manager

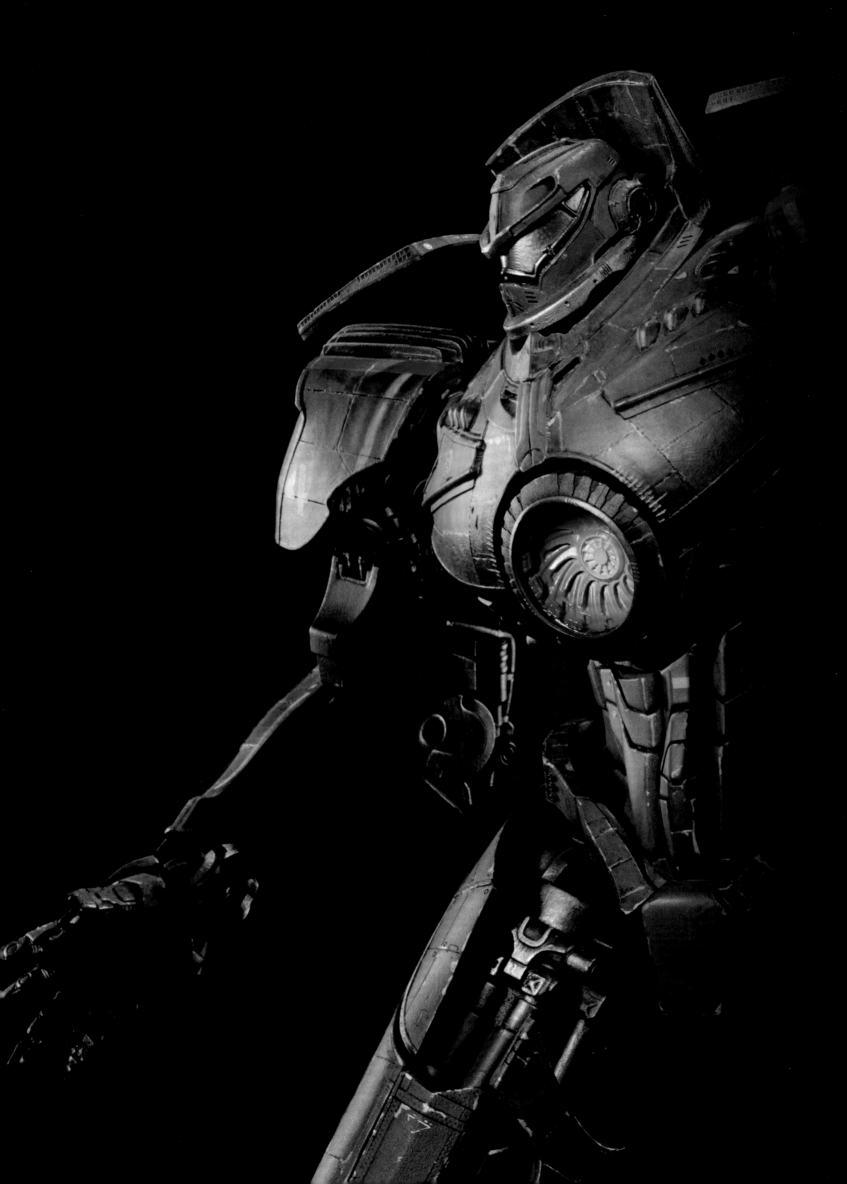

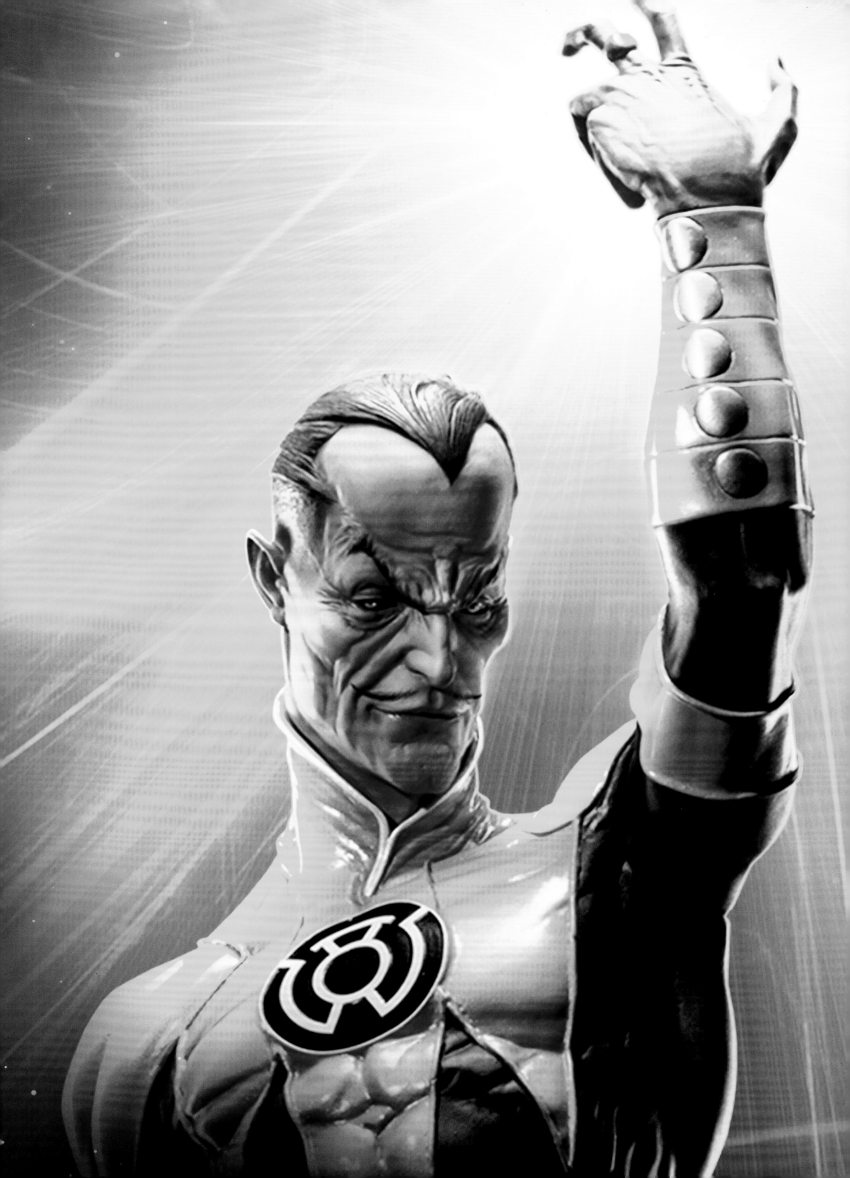

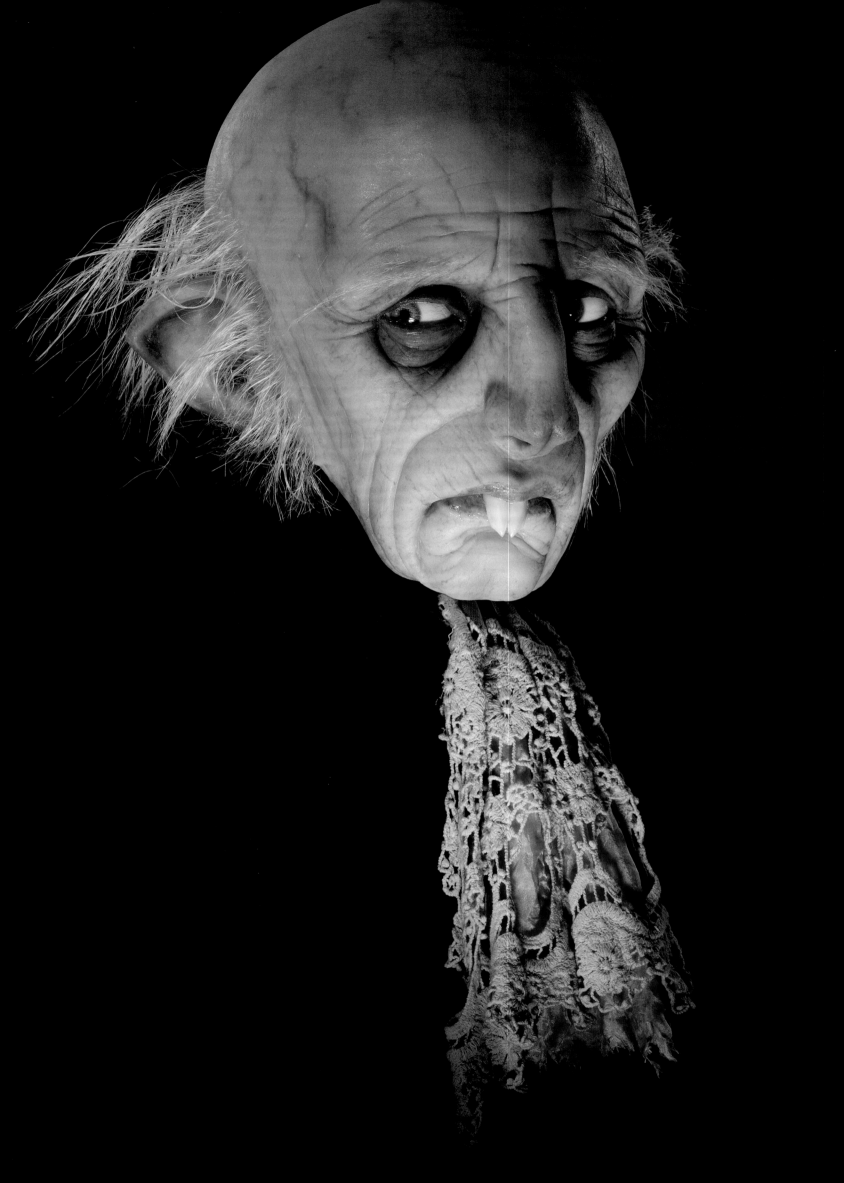

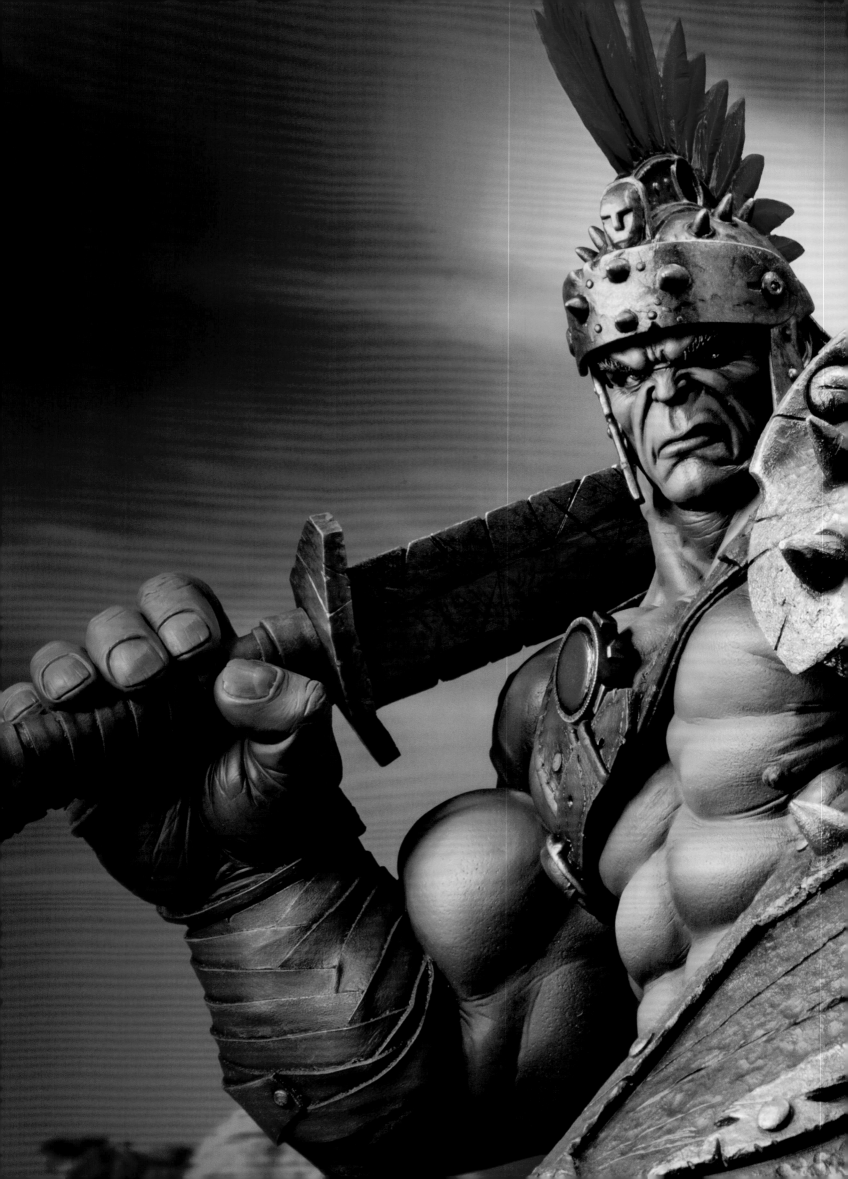

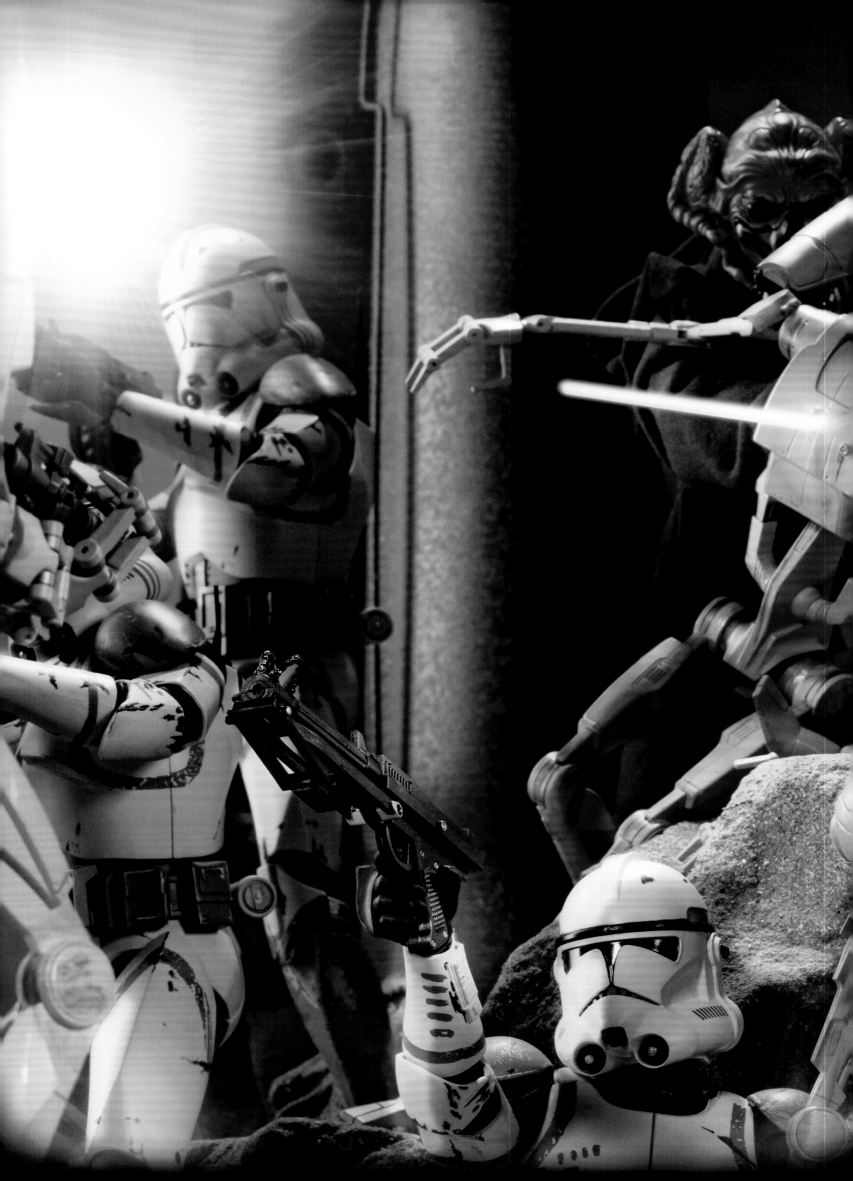

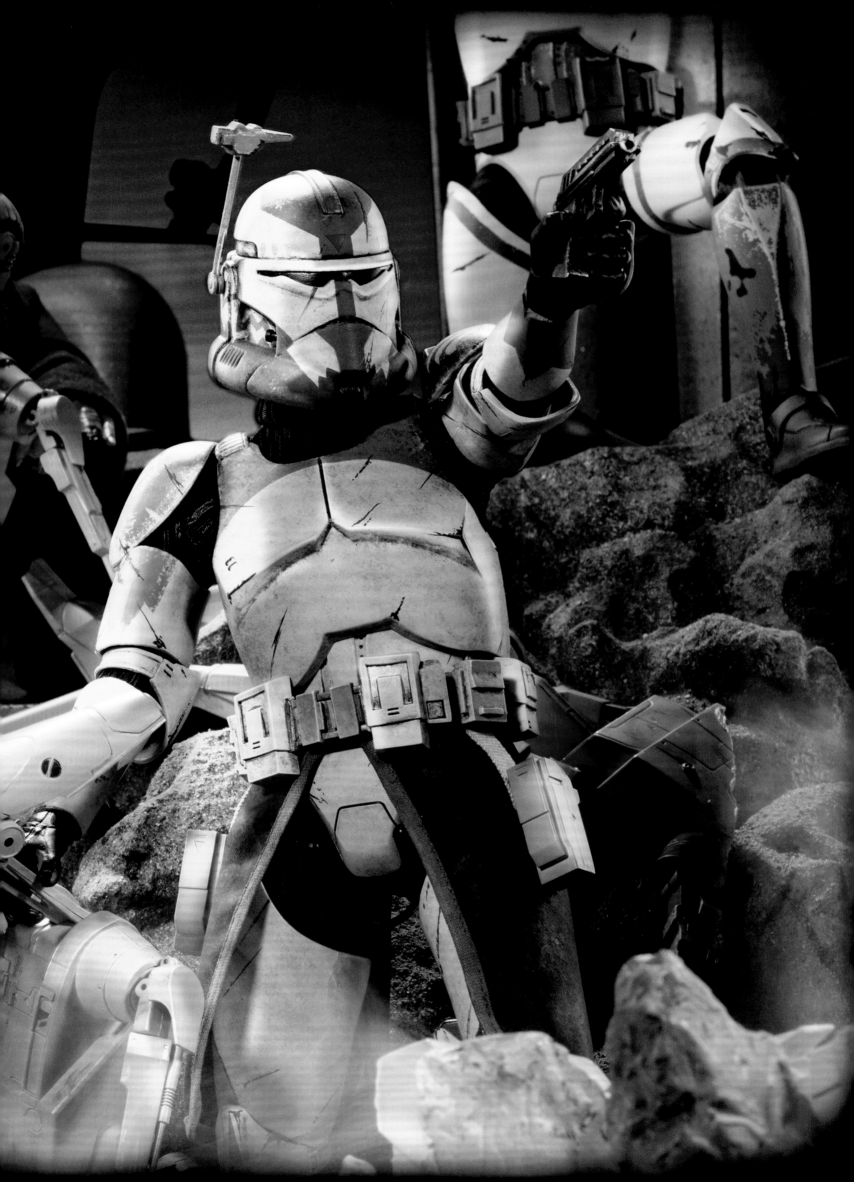

*beyond death.* **"**

—Kerrigan, StarCraft II

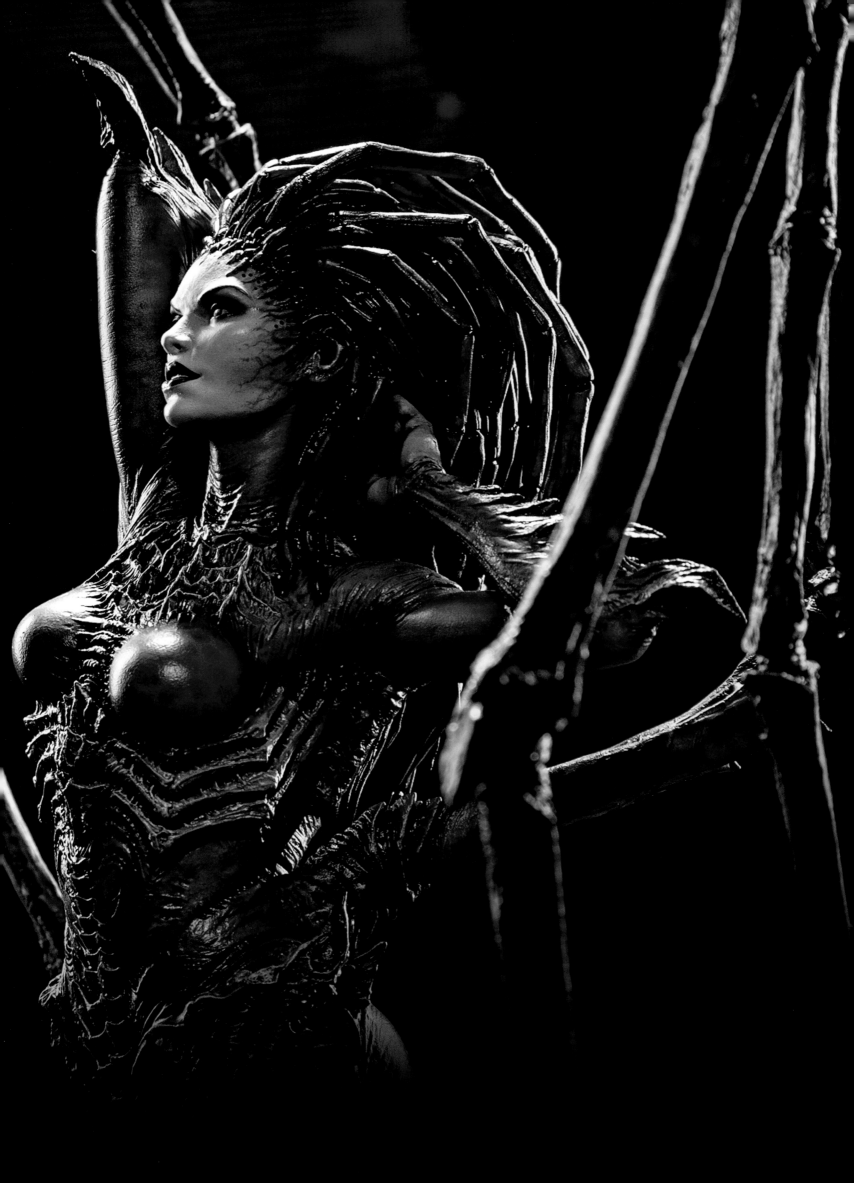

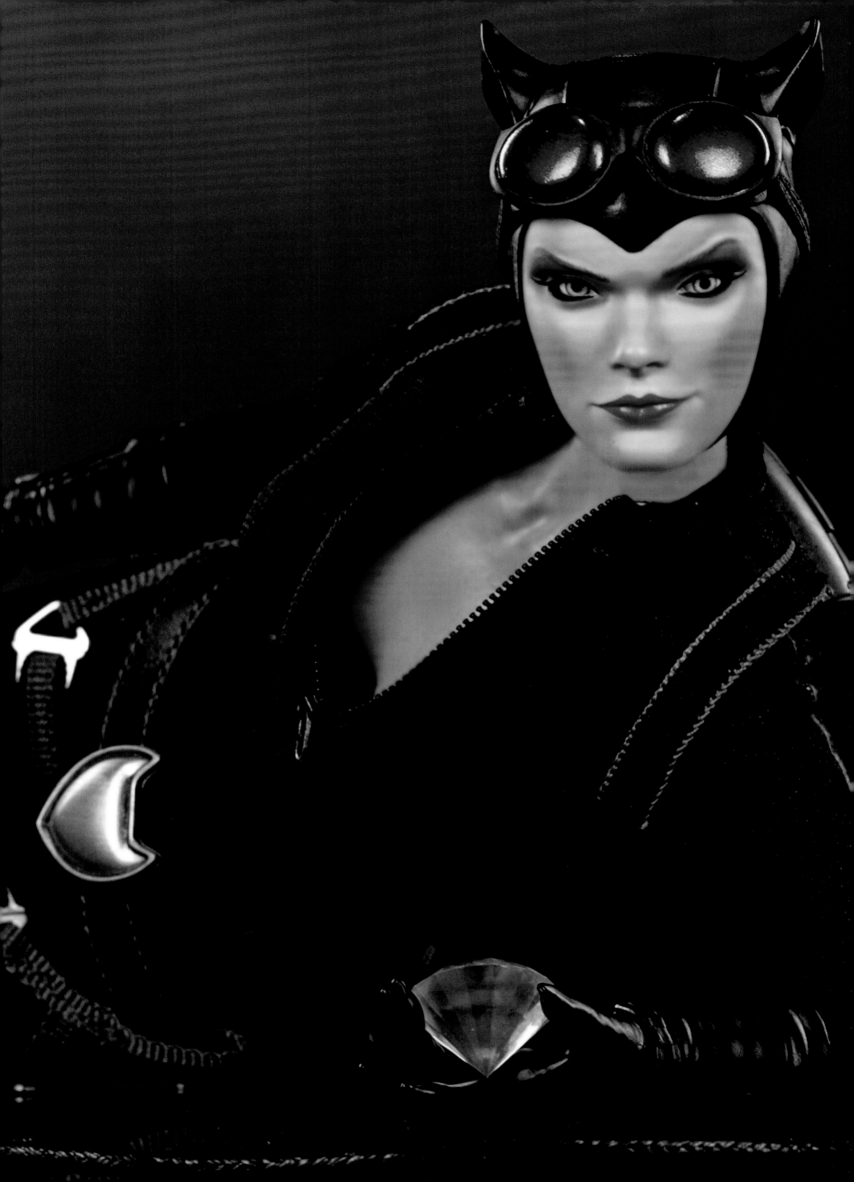

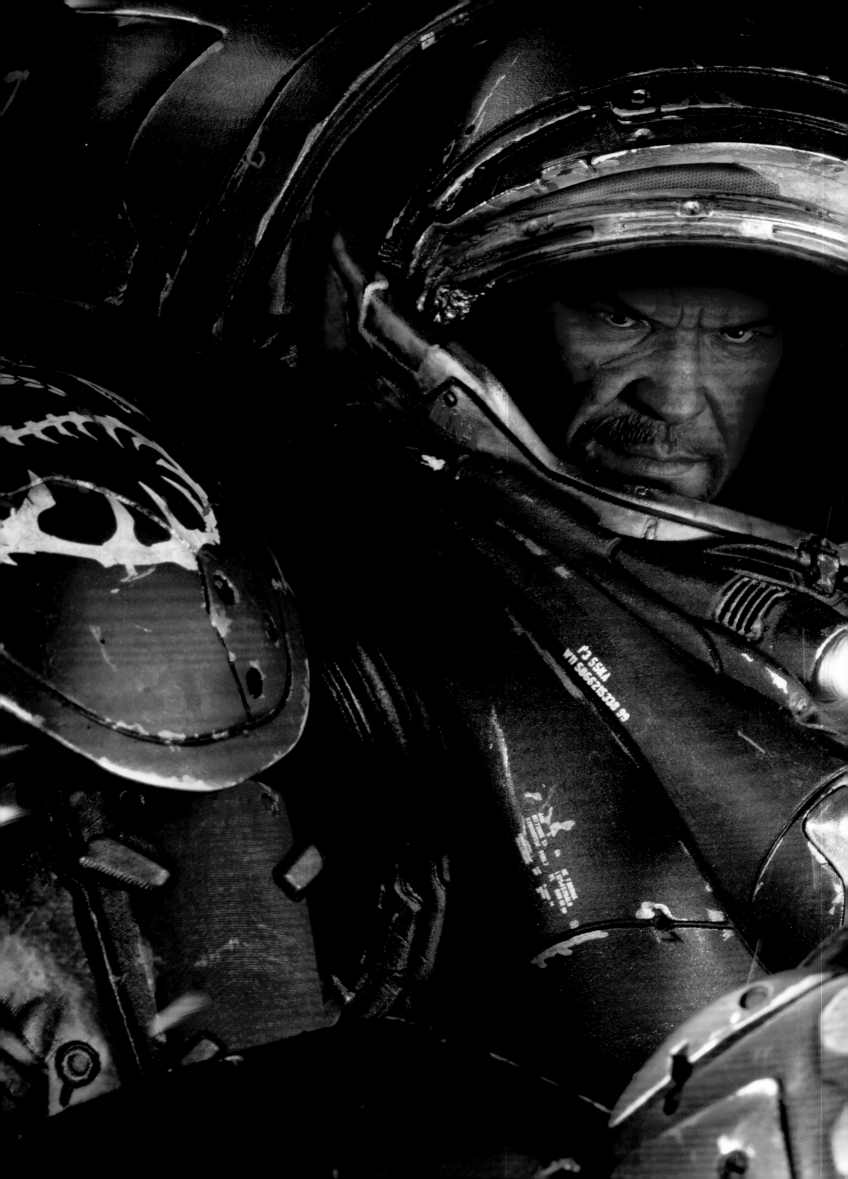

"Raynor's weathered space marine suit and the way he represents himself immediately tells you that he's an outlaw. He's a Western gunslinger at heart. Raynor's the original space marine cowboy from Blizzard's StarCraft series. Although he lives way into the future and travels across different planets, you just know he'd feel comfortable in an old Clint Eastwood spaghetti western movie. He wears this higher-caliber black marine suit, which is customized especially for him, because he's not part of the current outfit anymore. He's

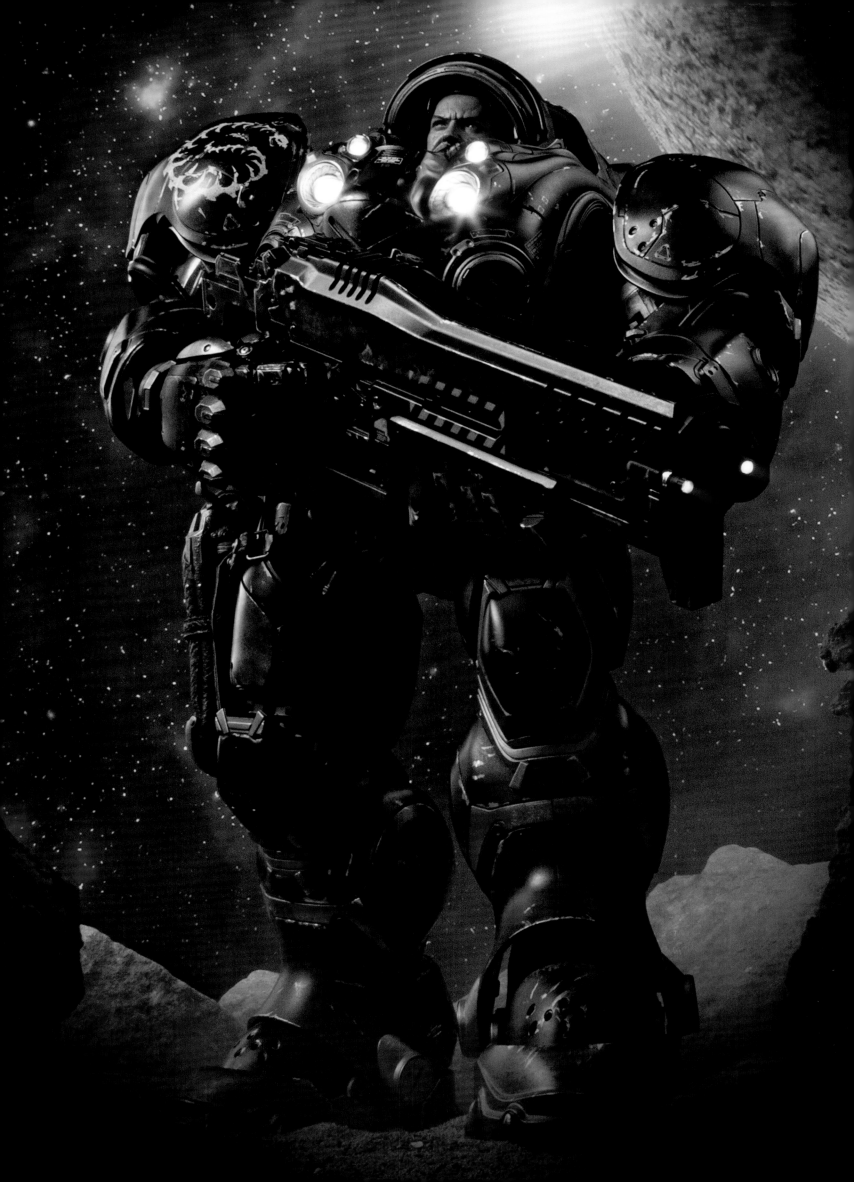

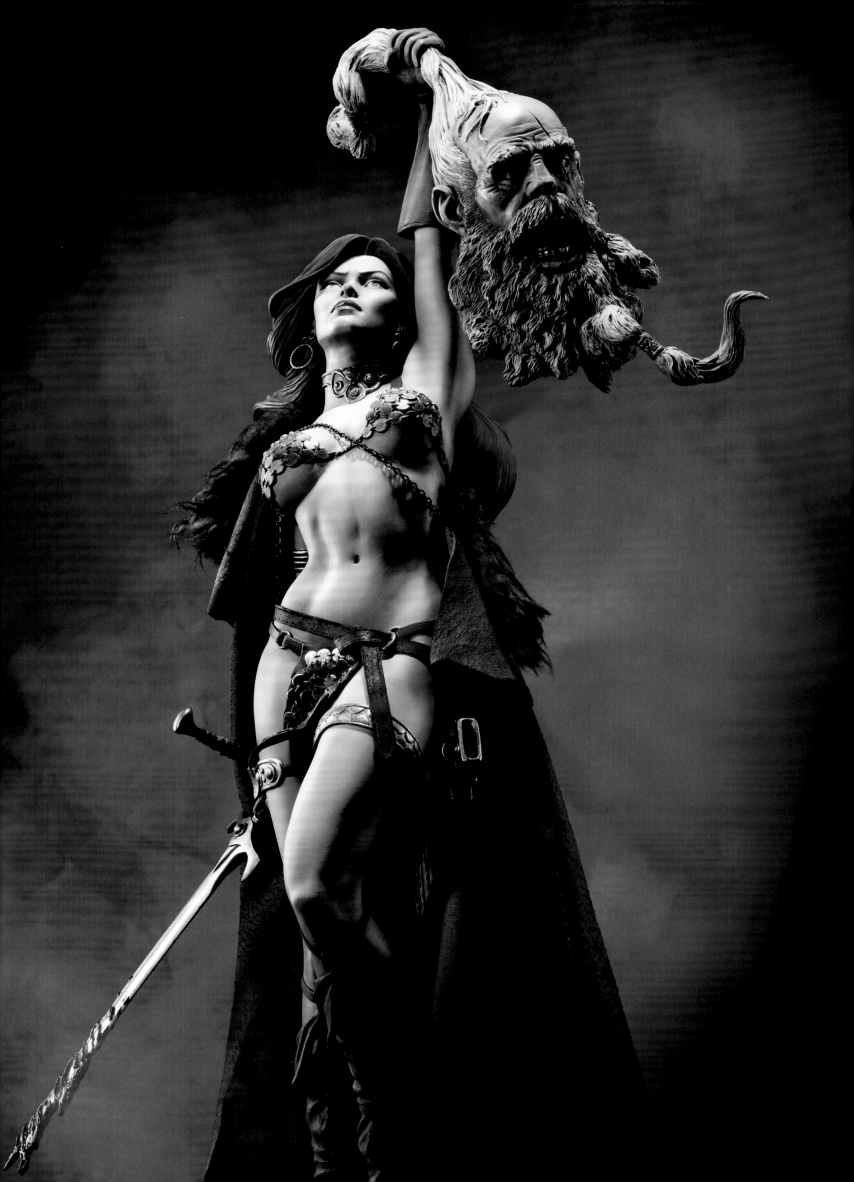

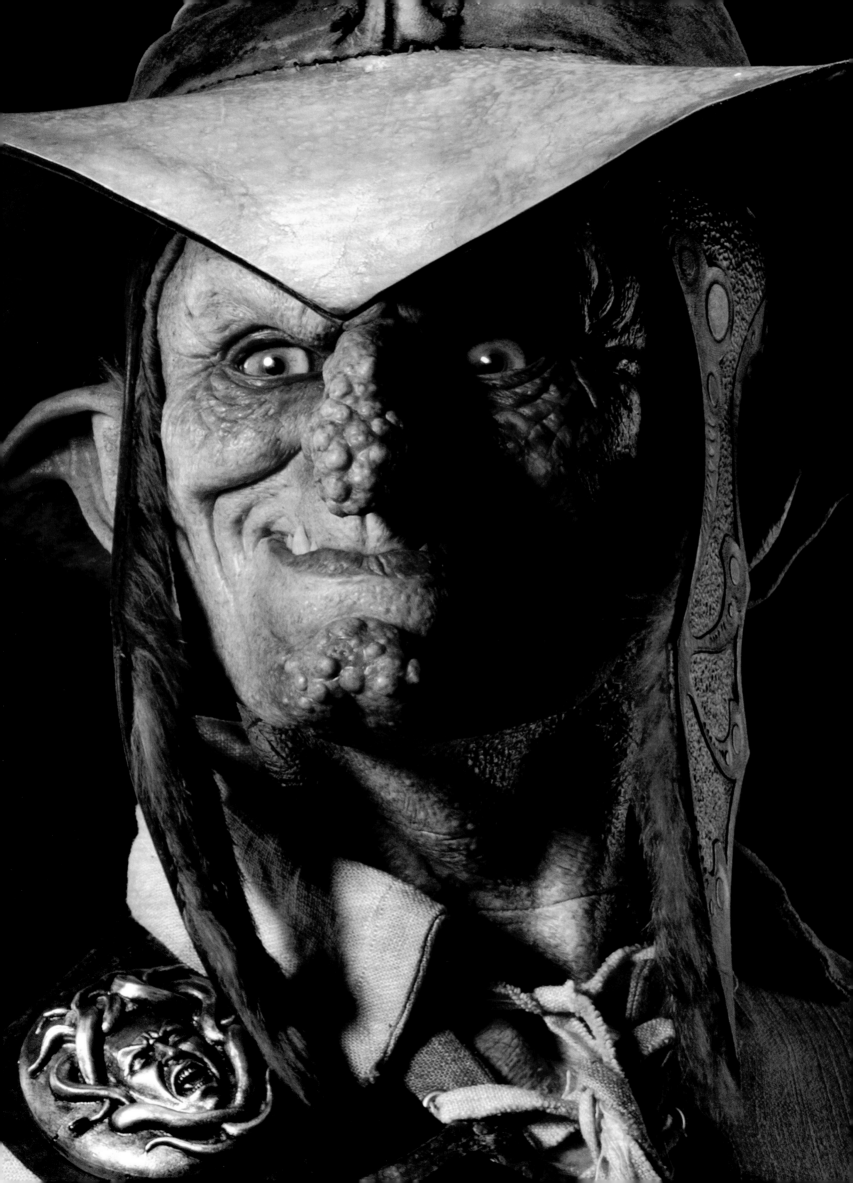

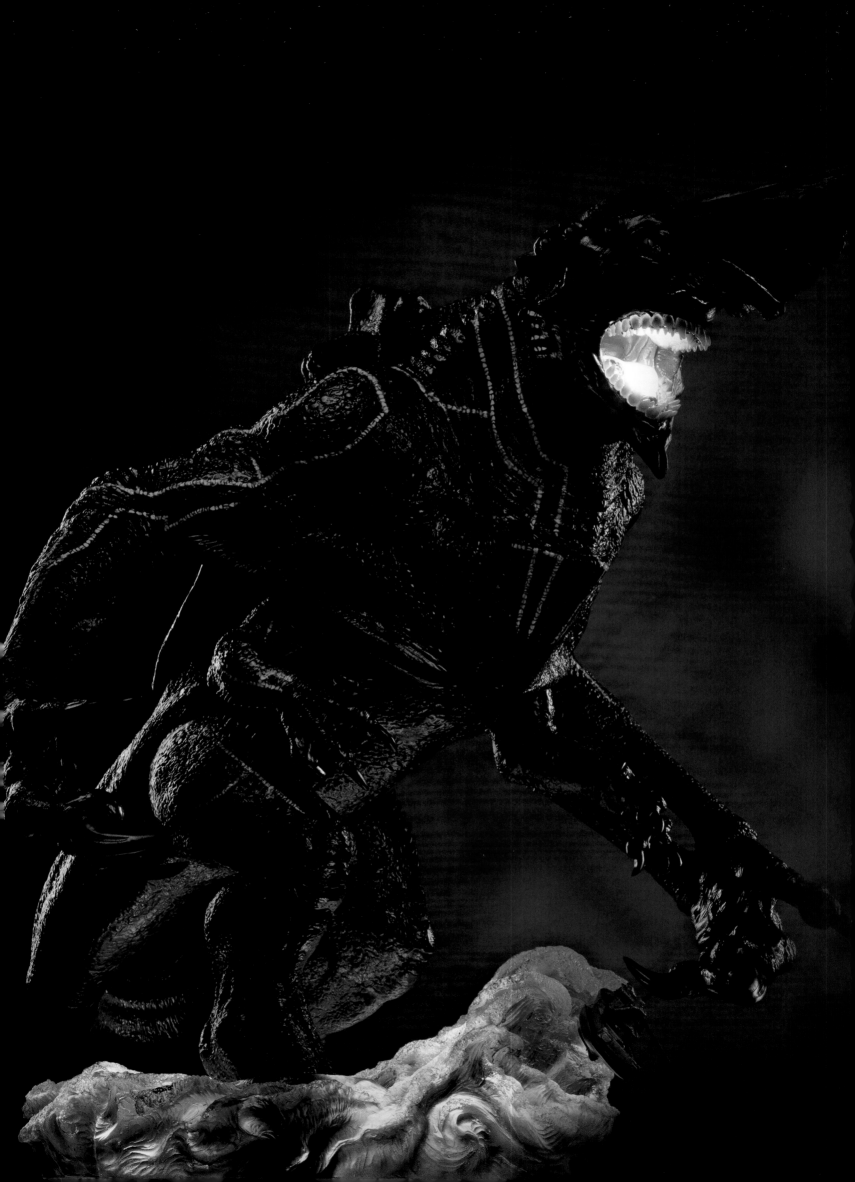

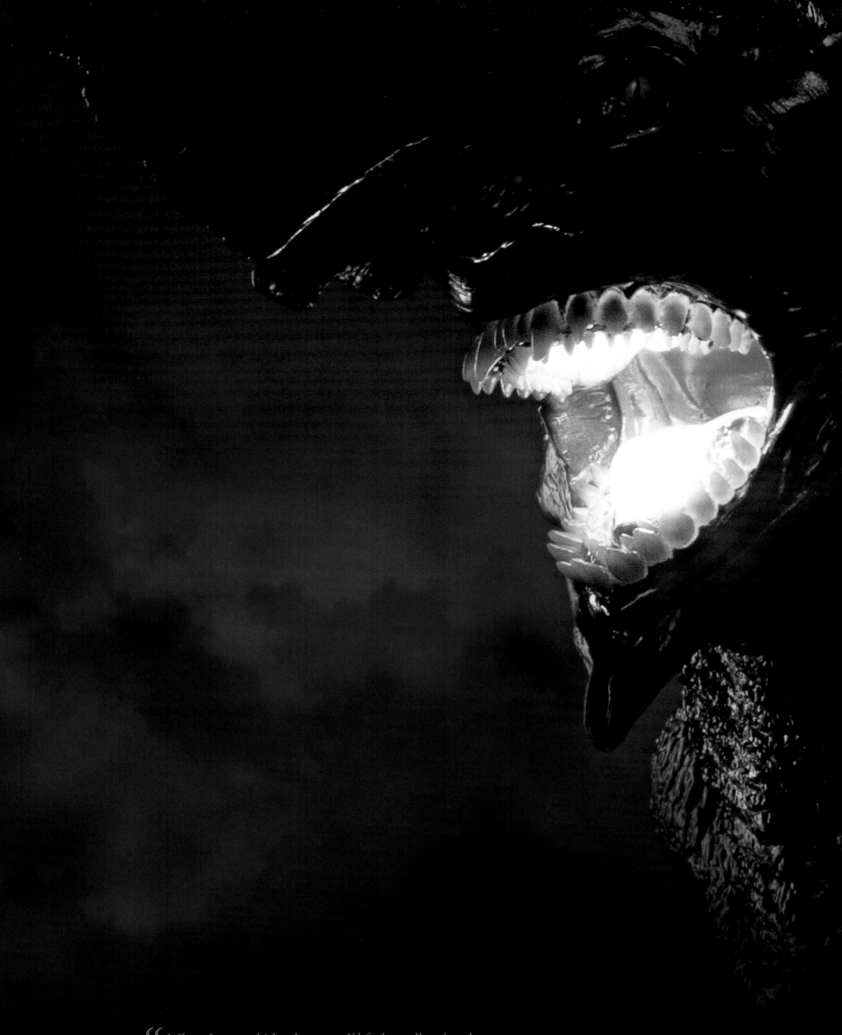

*When I was a kid, whenever I'd feel small or lonely, I'd look up at the stars. Wondered if there was life up there. Turns out I was looking in the wrong direction.*

—Raleigh Becket, Pacific Rim

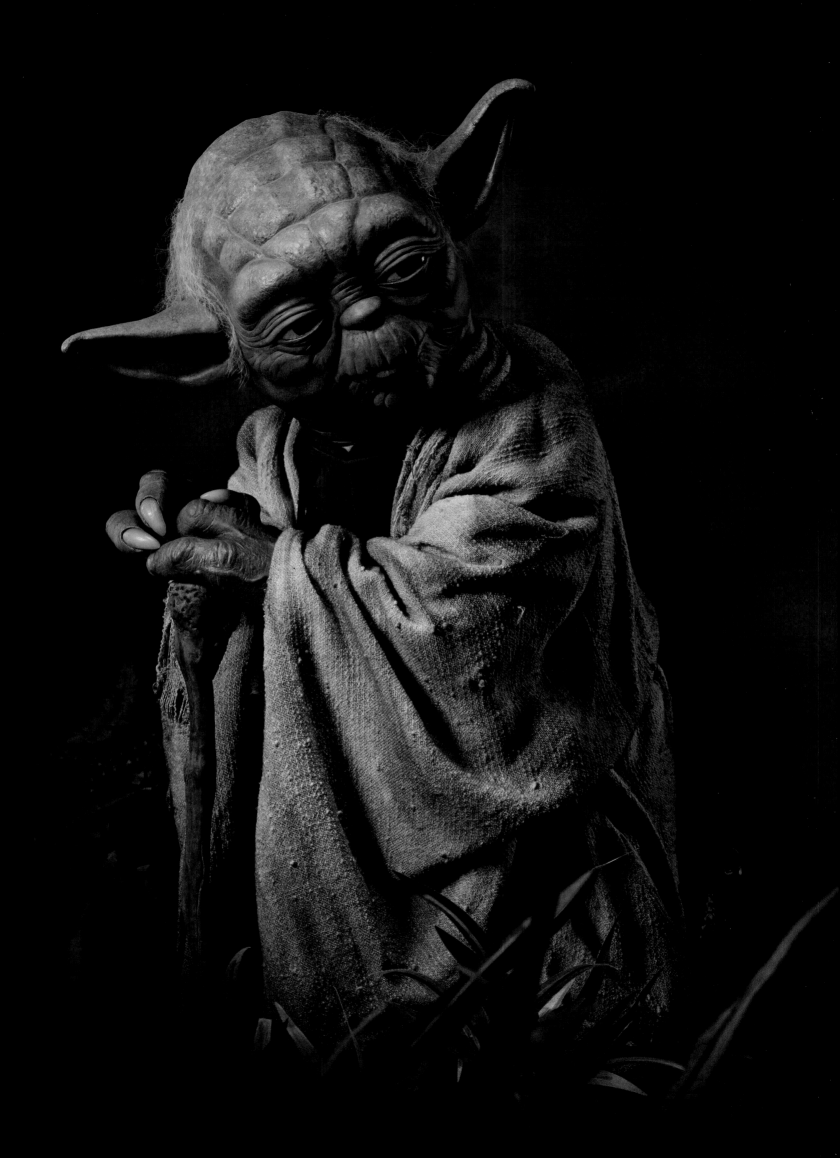

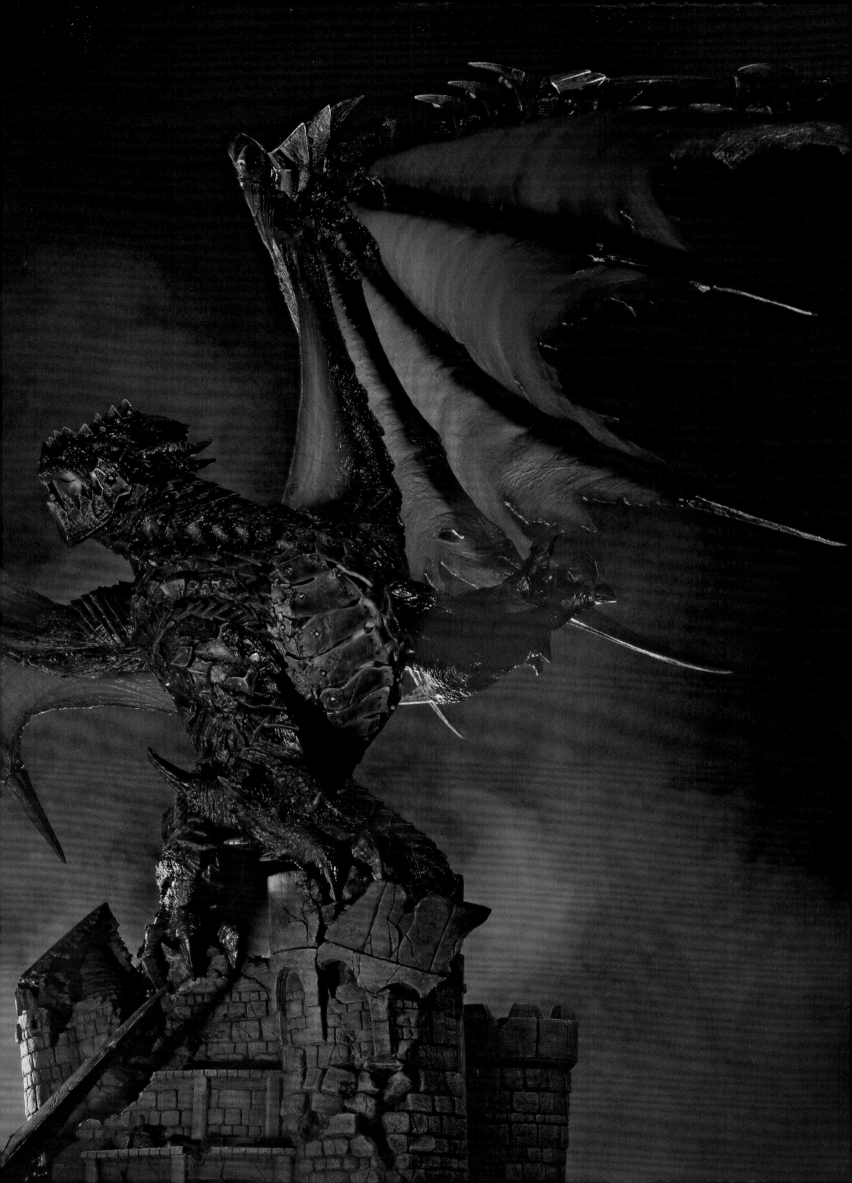

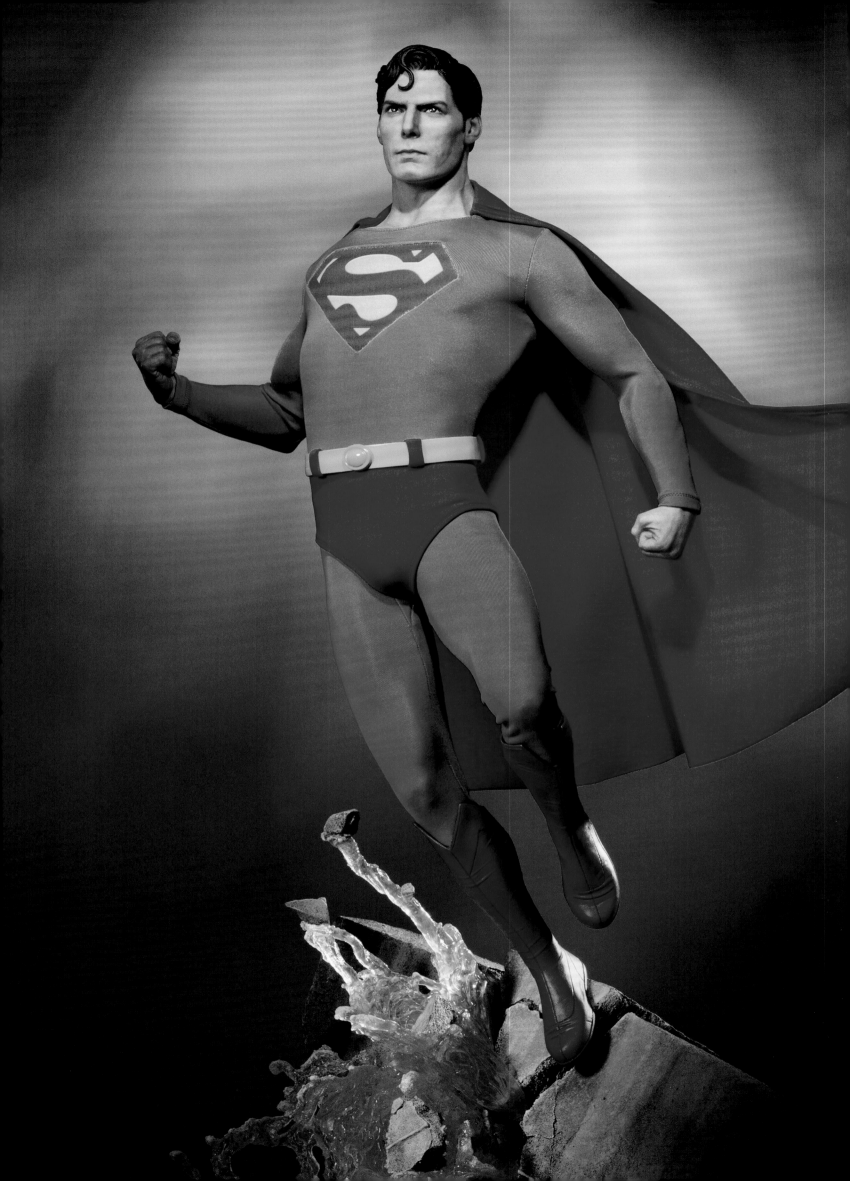

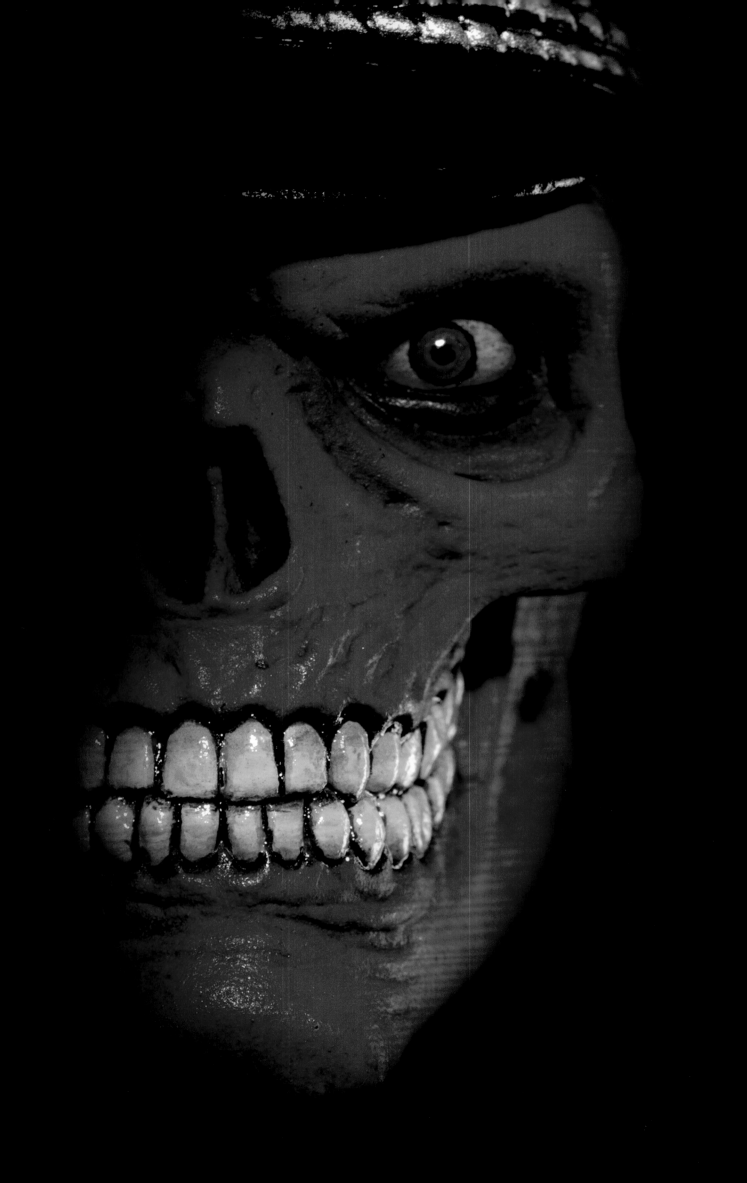

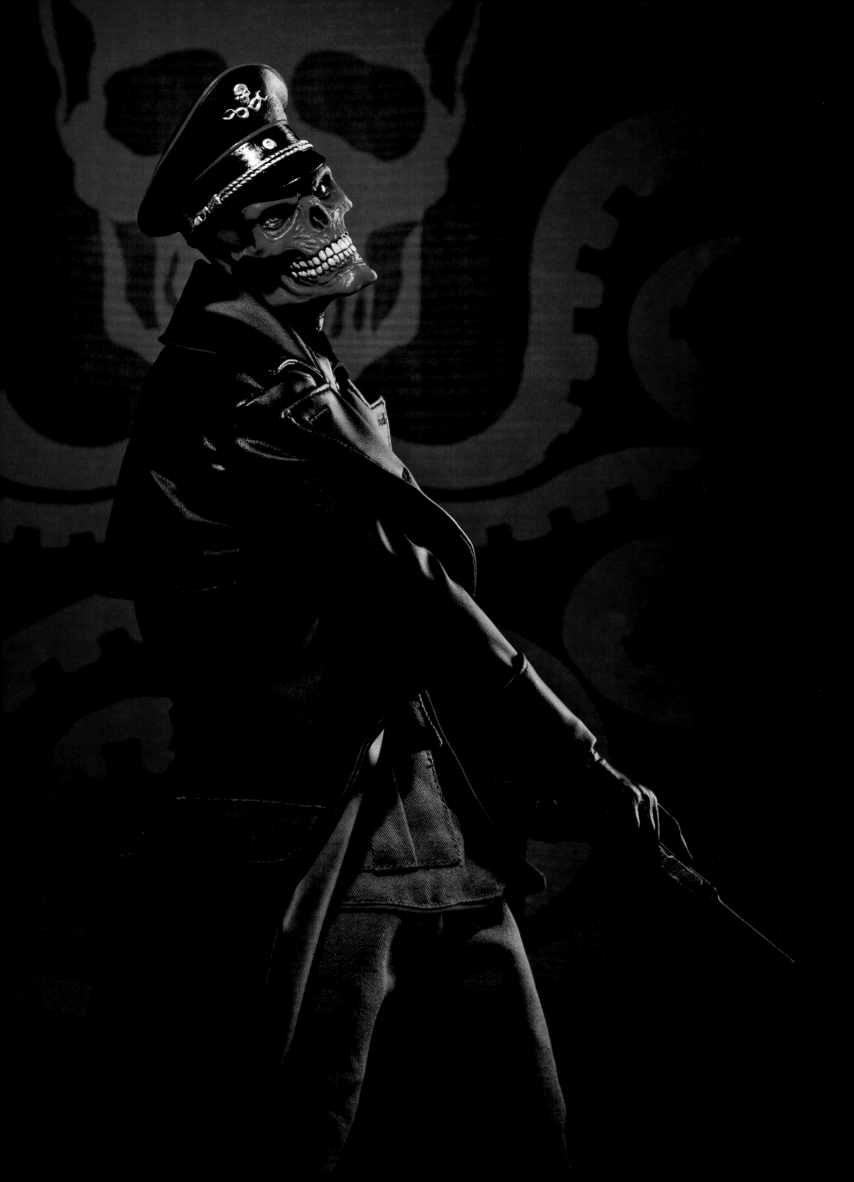

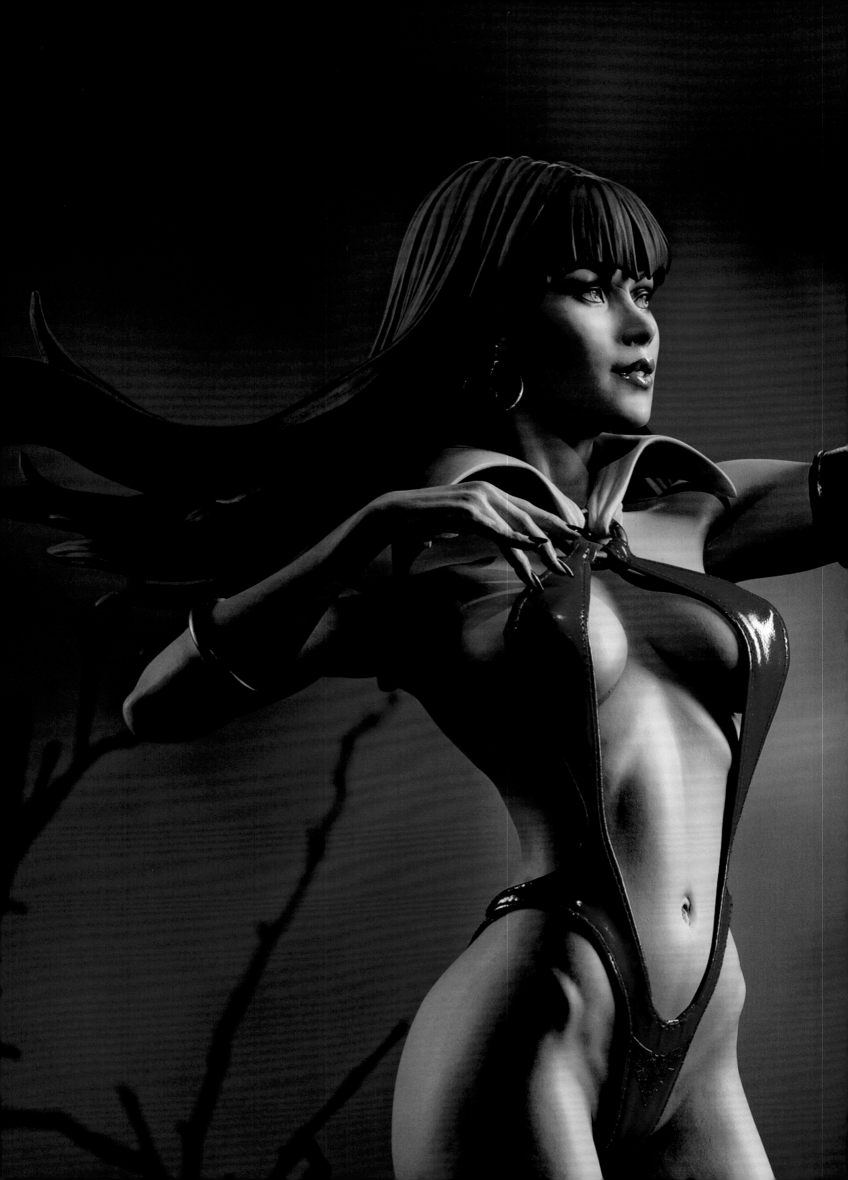

"*My first reaction to Vampirella: I was shocked at the minimal amount of clothing she was wearing, a red sling suit with a white collar and shiny, black knee-high boots. It's very interesting to think that Vampirella has always been this very sexy, strong, dominant female heroine in revealing clothing since her inception in the late 1960s. For me, the ultimate iconic Vampirella is the one drawn by Frank Frazetta. He always illustrated his women with these feline pointy noses and slanted eyes. She is a space vampire from the planet Drakulon, but most people don't even know her story. Vampirella is a heroine vampire; she survives on blood but tries not to kill people if she can while fighting evil. They just remember that she's a hot vampire and that she's one of those ancient creatures of the night.*"

—Anthony Mestas, Paint Department Manager

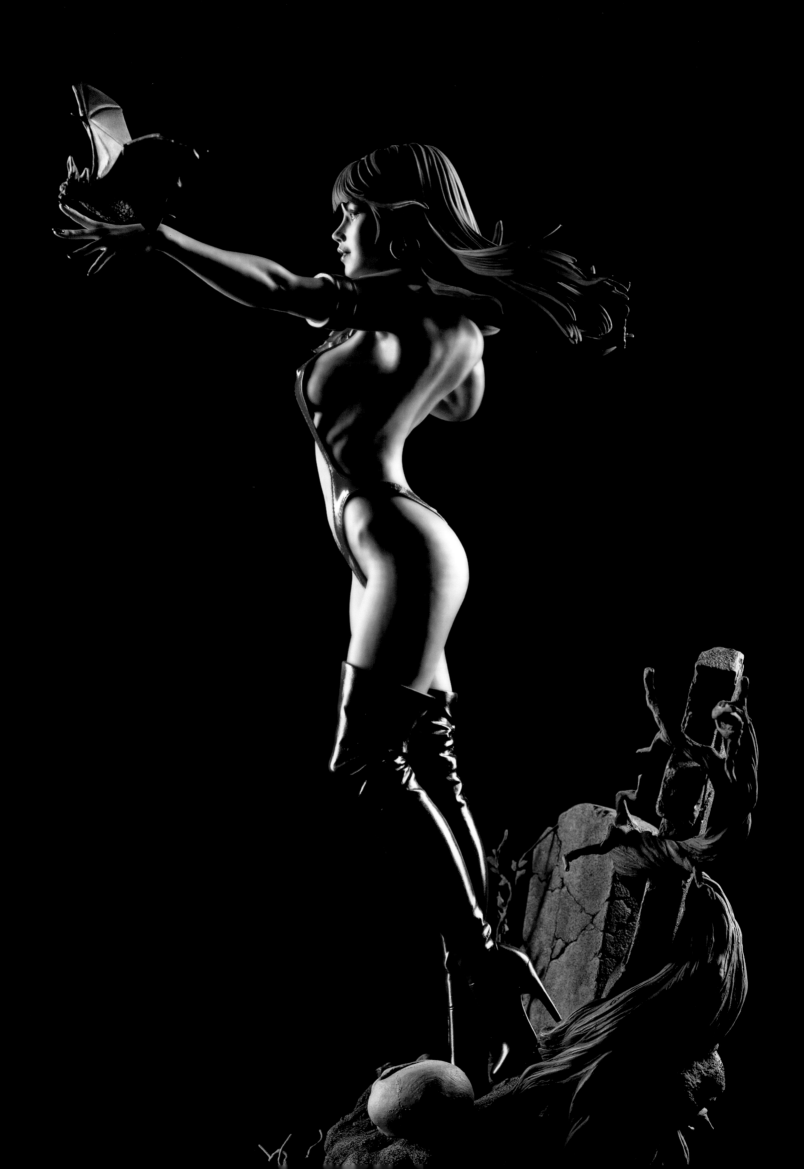

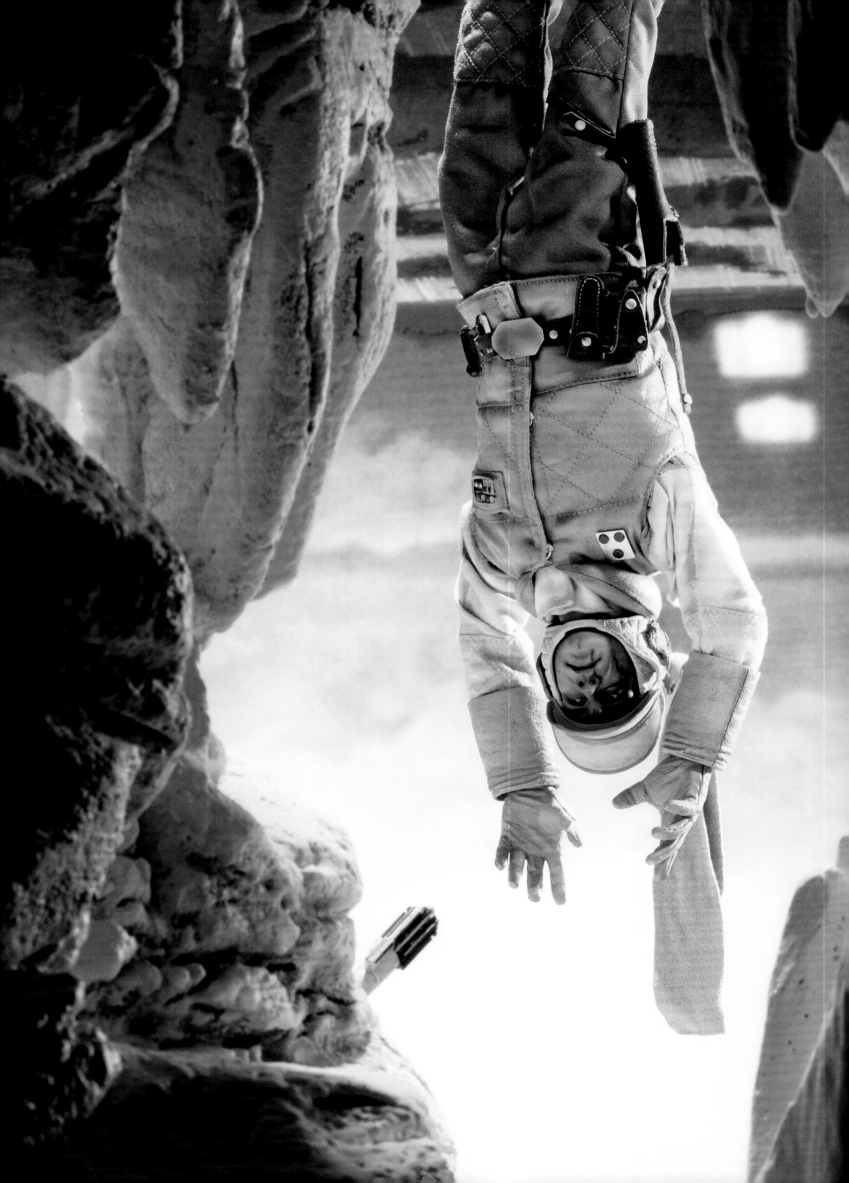

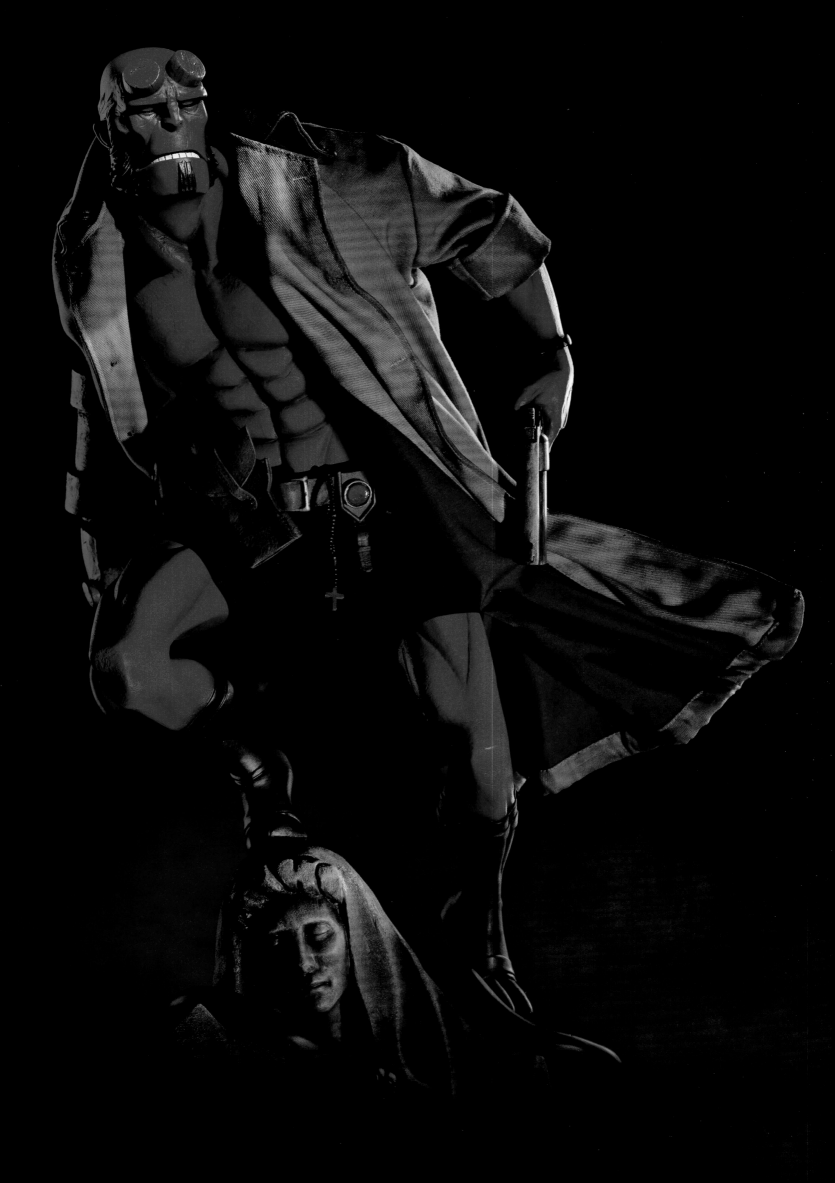

"*If there's anything left in you that can still talk, start now. Last chance.*"

—*Hellboy,* Hellboy: Seed of Destruction

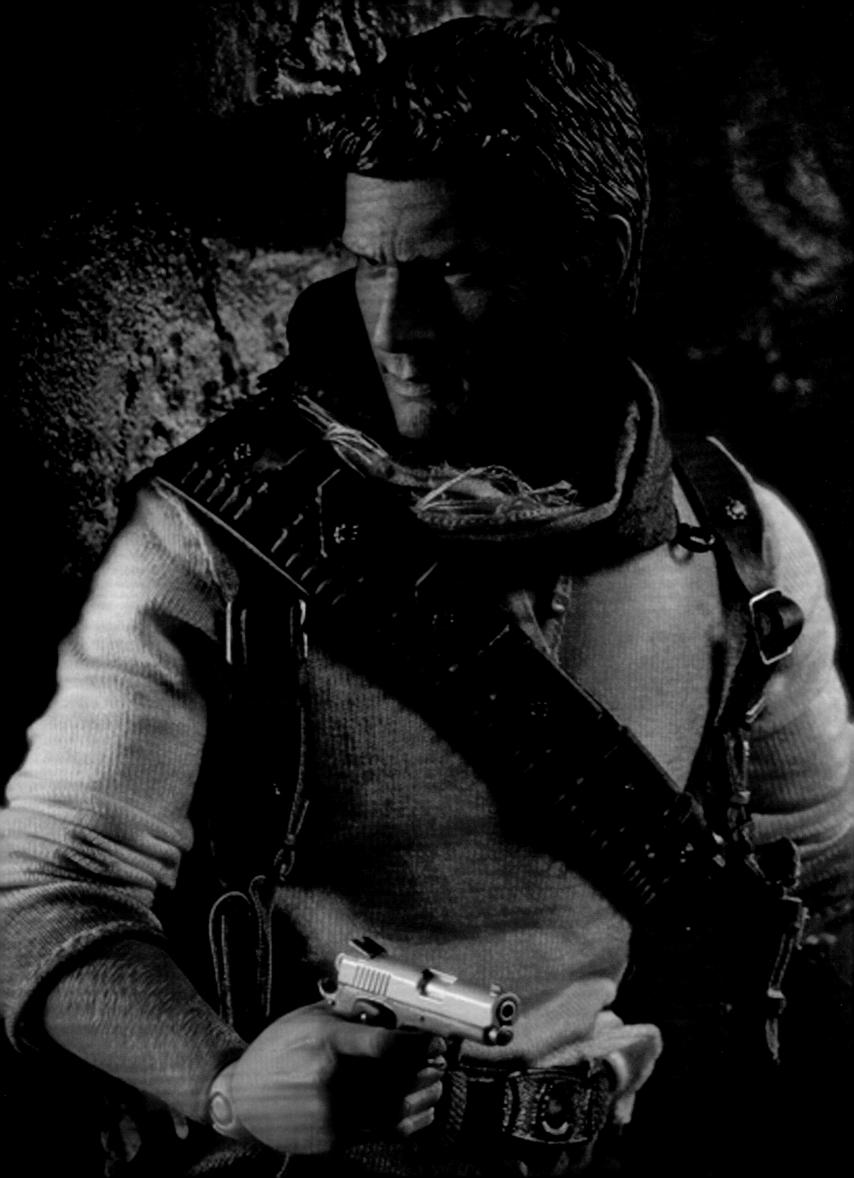

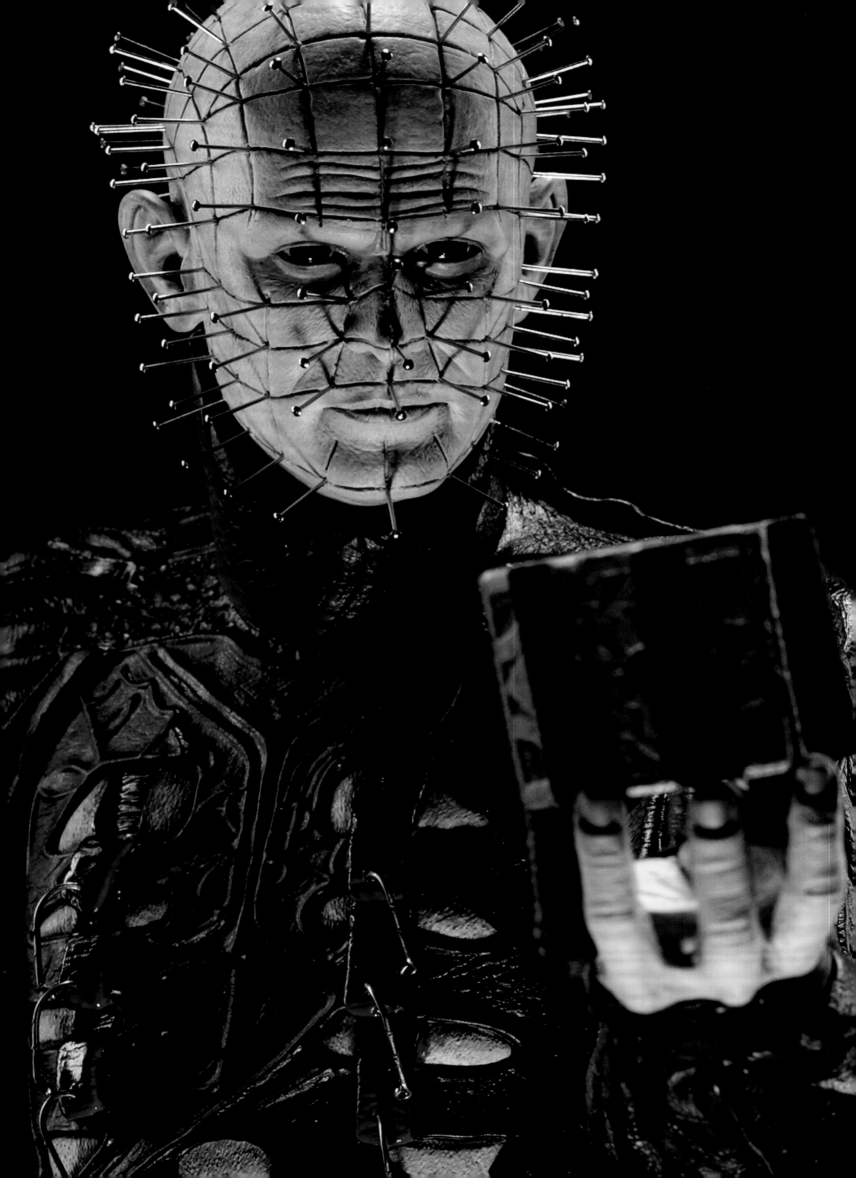

" *Human dreams . . . such fertile ground for the seeds of torment.* "

—*Pinhead,* Hellraiser III: Hell on Earth

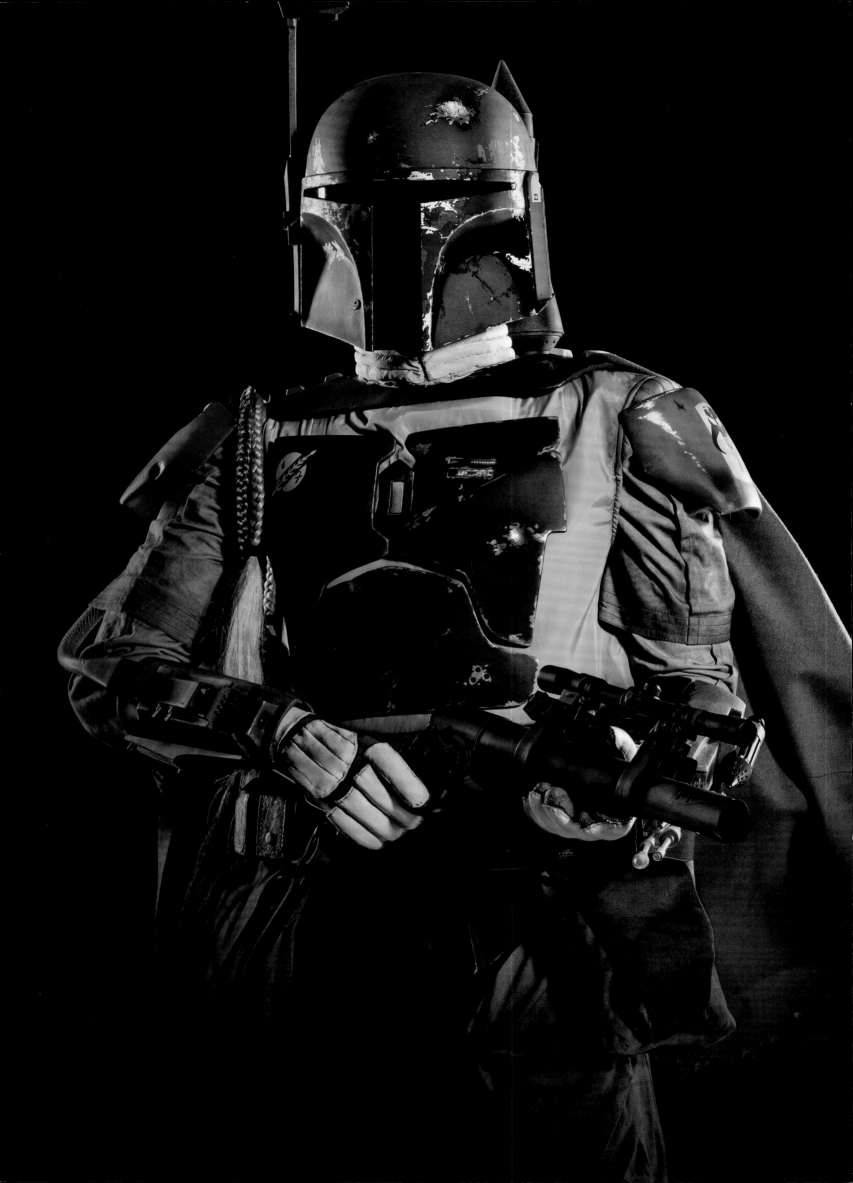

# CREDITS

Front Cover: BATMAN and all related characters and elements are trademarks of and © DC Comics. (s15)

Back Cover: Darth Vader Deluxe, Sixth Scale, © & ™ Lucasfilm Ltd.

2–3: Darth Vader Deluxe, Sixth Scale, © & ™ Lucasfilm Ltd.

4–5: Darth Vader Lord of the Sith Premium Format Figure™, © & ™ Lucasfilm Ltd. Indiana Jones, Temple of Doom, Premium Format Figure™, © & ™ Lucasfilm Ltd. Hellboy, Premium Format Figure™; Hellboy II The Golden Army Movie is a © & ™ of Universal Studios Licensing LLLP. All Rights Reserved.

8–11: Captain America, Premium Format™ Figure, © MARVEL

12–13: Batman: Modern Age, Life-Size Bust, BATMAN and all related characters and elements are trademarks of and © DC Comics. (s15)

14–15: Vampirella, Premium Format™ Figure, Dynamite logo & Vampirella is ® and © 2015 Dynamite. All rights reserved.

16–17: Iron-Man Mark II, Maquette, © MARVEL

18–21: R2-D2 Deluxe, Sixth Scale, © & ™ Lucasfilm Ltd.

22–23: Storm Shadow, Sixth Scale Figure, © 2015 Hasbro. All Rights Reserved.

24–25: Predator 2, Maquette, Predator 2 TM & © 2015 Twentieth Century Fox Film Corporation. All Rights Reserved.

26–27: Deadpool, Sixth Scale, © MARVEL

28–29: Captain Han Solo - Hoth, Sixth Scale, © & ™ Lucasfilm Ltd.

30–31: Gallevarbe: Death's Siren, Premium Format™ Figure, © 2015 Sideshow Inc.

32–33: Saruman, Premium Format™ Figure, © NLP ™ Middle-earth Ent. Lic. to New Line. (s15)

34–35: Godzilla, Maquette, TM & © Toho Co., Ltd. © Warner Bros. Entertainment Inc. (s15)

36–39: Wonder Woman, Premium Format™ Figure, WONDER WOMAN and all related characters and elements are trademarks of and © DC Comics. (s15)

40–41: Black Widow: Natasha Romanova, Premium Format™ Figure, © MARVEL

42–43: Conan the Barbarian: Rage of the Undying, Premium Format™ Figure, © 2015 Conan Properties International LLC («CPI»). CONAN, CONAN THE BARBARIAN, HYBORIA, and related logos, characters, names, and distinctive likenesses thereof are trademarks or registered trademarks of CPI unless otherwise noted. All Rights Reserved. ROBERT E. HOWARD is a trademark or registered trademark of Robert E. Howard Properties Inc. Used with permission. All Rights Reserved.

44–45: Goblin, Life-Size Bust, Custom Creation by Nathan Mansfield.

46–47: Superman (Comic), Premium Format™ Figure, SUPERMAN and all related characters and elements are trademarks of and © DC Comics. (s15)

48–49: Gwen Stacy, Comiquette, © MARVEL

50–53: Lobo, Premium Format™ Figure, LOBO and all related characters and elements are trademarks of and © DC Comics. (s15)

54–55: Boba Fett (Prototype Armor), Sixth Scale, © & ™ Lucasfilm Ltd.

56–57: Kier: Valkyrie of the Dead, Premium Format™ Figure, © 2015 Sideshow Inc.

58–59: Master Chief, Premium Format™ Figure, © 2015 Microsoft Corporation. All Rights Reserved.

60–61: Predator 2, Legendary Scale™ Bust, Predator 2 TM & © 2015 Twentieth Century Fox Film Corporation. All Rights Reserved.

62–63: Catwoman, Premium Format™ Figure, BATMAN and all related characters and elements are trademarks of and © DC Comics. (s15)

64–65: Nosferatu, Life-Size Bust, Custom Creation by Nathan Mansfield.

66–69: Thor, Premium Format™ Figure, © MARVEL

70–71: Man of Steel: Superman, Premium Format™ Figure, SUPERMAN and all related characters and elements are trademarks of and © DC Comics. (s15)

72–73: The Red Death, Premium Format™ Figure, © 2015 Sideshow Inc.

74–75: Geonosis Infantry Battle Droids, Phase 1 Commander, Phase 1 Lieutenant, Phase 1 Sergeant, Sixth Scale, © & ™ Lucasfilm Ltd.

76–79: The Joker, Life-Size Bust, Figure, BATMAN and all related characters and elements are trademarks of and © DC Comics. (s15)

80–81: T-800 Terminator Battle Damaged, Premium Format™ Figure, Terminator 2: Judgment Day, T2, THE TERMINATOR, ENDOSKELETON, and any depiction of Endoskeleton are trademarks of Studiocanal S.A. ® ©2015 Studiocanal S.A. ® All Rights Reserved.

82–83: Punisher, Premium Format™ Figure, © MARVEL

84–85: Deadpool, Sixth Scale, © MARVEL

86–87: Batman: The Dark Knight, Life-Size Bust, BATMAN and all related characters and elements are trademarks of and © DC Comics. (s15)

88–89: Apocalypse, Premium Format™ Figure, © MARVEL

90–93: Darth Vader Deluxe, Sixth Scale, © & ™ Lucasfilm Ltd.

94–95: Alien Warrior, Legendary Scale™ Bust, Aliens™ & © 2015 Twentieth Century Fox Film Corporation. All Rights Reserved.

96–97: Batman, The Joker, and Harley Quinn, Sixth Scale, BATMAN and all related characters and elements are trademarks of and © DC Comics. (s15)

98–99: Savage Opress, Premium Format™ Figure, © & ™ Lucasfilm Ltd.

100–101: Wolfpack Clone Trooper: 104th Battalion & Battle Droids, Sixth Scale, © & ™ Lucasfilm Ltd.

102–103: Thor: The Dark World, Premium Format™ Figure, © MARVEL

104–105: Dr. Doom, Legendary Scale Figure™, © MARVEL

106–111: Poison Ivy, Premium Format™ Figure, BATMAN and all related characters and elements are trademarks of and © DC Comics. (s15)

112–113: Scout Trooper, Sixth Scale, © & ™ Lucasfilm Ltd.

114–117: Superman, Sixth Scale, SUPERMAN and all related characters and elements are trademarks of and © DC Comics. (s15)

118–119: Oglavaeil the Executioner, Premium Format™ Figure, © 2015 Sideshow Inc.

120–121: Commander Cody, Premium Format™ Figure, © & ™ Lucasfilm Ltd.

122–123: Power Girl, Premium Format™ Figure, SUPERMAN and all related characters and elements are trademarks of and © DC Comics. (s15)

124–125: Sentinel, Maquette, © MARVEL

126–127: Spider-Man: Classic, Comiquette, © MARVEL

128–131: General Grievous, Sixth Scale, © & ™ Lucasfilm Ltd.

132–133: The Incredible Hulk & Red Hulk, Premium Format™ Figure, © MARVEL

134–135: Captain Rex, Sixth Scale, © & ™ Lucasfilm Ltd.

136–137: Machiko Noguchi, Premium Format™ Figure, Alien VS Predator TM & © 2015 Twentieth Century Fox Film Corporation. All Rights Reserved.

138–139: Iron Patriot, Maquette, © MARVEL

140–143: Batman, Premium Format™ Figure, BATMAN and all related characters and elements are trademarks of and © DC Comics. (s15)

144–145: Alien Queen, Diorama, Aliens™ & © 2015 Twentieth Century Fox Film Corporation. All Rights Reserved.

146–147: Stormtrooper Commander, Premium Format™ Figure, © & ™ Lucasfilm Ltd.

148–149: T-rex: 'The Tyrant King' & Triceratops, Statue, © 2015 Sideshow Inc.

150–151: Mary Jane, Comiquette, © MARVEL

152–153: Imperial Probe Droid, Sixth Scale, © & ™ Lucasfilm Ltd.

154–155: Thor Frog, Diorama, © MARVEL

156–157: Emma Frost: Hellfire Club, Premium Format™ Figure, © MARVEL

158–159: Snake Plissken, Sixth Scale, Escape from New York is a trademark of Studiocanal S.A. © 2015 Studiocanal S.A. ® All Rights Reserved.

160–163: Queen of the Dead, Premium Format™ Figure, © 2015 Sideshow Inc.

164–165: Snowtrooper, Premium Format™ Figure, © & ™ Lucasfilm Ltd.

166–167: Batgirl, Premium Format™ Figure, BATMAN and all related characters and elements are trademarks of and © DC Comics. (s15)

168–169: Templar Knight, Life-Size Bust, © 2015 Sideshow Inc.

170–171: Christopher Lee, Premium Format™ Figure, ©2015 Hammer Film Productions Ltd. All rights Reserved.

172–173: Wolfpack Clone Trooper: 104th Battalion, Coruscant Clone Trooper, Sixth Scale, © & ™ Lucasfilm Ltd.

174–175: Engineer, Statue, © 2015 Twentieth Century Fox Film Corporation. All Rights Reserved.

176–177: Daredevil, Premium Format™ Figure, © MARVEL

178–183: Gipsy Danger & Striker Eureka, Statue, © Warner Bros. Entertainment Inc. © Legendary

184–185: Sinestro, Premium Format™ Figure, GREEN LANTERN and all related characters and elements are trademarks of and © DC Comics. (s15)

186–187: Nosferatu, Original Life-Size Bust, Custom Creation by Matthew Black.

188–189: Gladiator Hulk, Premium Format™ Figure, © MARVEL

190–191: Wolfpack Clone Trooper: 104th Battalion, Coruscant Clone Trooper & Security Battle Droids & Plo Koon, Sixth Scale, © & ™ Lucasfilm Ltd.

192–193: Kerrigan, Statue, © 2015 Blizzard Entertainment, Inc. All Rights Reserved.

194–195: Catwoman, Sixth Scale, BATMAN and all related characters and elements are trademarks of and © DC Comics. (s15)

196–199: Raynor, Sixth Scale, © 2015 Blizzard Entertainment, Inc. All Rights Reserved.

200–201: Red Sonja, Premium Format™ Figure, Red Sonja ® & © 2014 Red Sonja, LLC.

202–203: Goblin, Life-Size Bust, Custom Creation by Nathan Mansfield.

204–205: Knifehead, Statue, © Warner Bros. Entertainment Inc.© Legendary

206–207: Yoda, Life-Size Figure, © & ™ Lucasfilm Ltd.

208–209: Deathwing, Statue, © 2015 Blizzard Entertainment, Inc. All Rights Reserved.

210–211: Superman (Christopher Reeve), Premium Format™ Figure, SUPERMAN and all related characters and elements are trademarks of and © DC Comics. (s15)

212–213: Red Skull, Premium Format™ Figure, © MARVEL

214–217: Vampirella, Premium Format™ Figure, Dynamite logo & Vampirella is ® and © 2015 Dynamite. All rights reserved.

218–219: Commander Luke Skywalker – Hoth, Sixth Scale, © & ™ Lucasfilm Ltd.

220–221: Hellboy, Premium Format™ Figure, Copyright © 2015 Mike Mignola.

222–223: Nathan Drake, Sixth Scale, UNCHARTED © 2015/™ SCEA Created and developed by Naughty Dog, Inc. Licensed for manufacture by SCEA.

224–225: Pinhead, Premium Format™ Figure, © 2014 Miramax, LLC. All Rights Reserved.

226: Boba Fett, Life-Size Figure, © & ™ Lucasfilm Ltd.

# INSIGHT EDITIONS

PO Box 3088
San Rafael, CA 94912
www.insighteditions.com

**INSIGHT EDITIONS:**
PUBLISHER: Raoul Goff
ART DIRECTOR: Chrissy Kwasnik
EXECUTIVE EDITOR: Vanessa Lopez
SENIOR EDITOR: Ramin Zahed
PRODUCTION EDITOR: Elaine Ou
EDITORIAL ASSISTANT: Kathryn DeSandro
PRODUCTION MANAGER: Anna Wan

Library of Congress Cataloging-in-Publication Data available.

ISBN: 978-1-60887-685-3

Manufactured in China
10 9 8 7 6 5 4 3 2 1

2630 Conejo Spectrum Street
Thousand Oaks, CA 91320
www.sideshow.com

**SIDESHOW COLLECTIBLES:**
CREATIVE DIRECTOR: Tom Gilliland
BOOK CONCEPT: Greg Anzalone
PRINCIPLE PHOTOGRAPHY: Ginny Guzman,
Jeannette Villarreal, Terry Smith
DESIGN: Andrew McBride, Jennifer Garrett, Adam Codeus,
Margaux Pinero

**The Sideshow Orchestra:** The imagery in this publication
would not be possible without the creative ambition and
endless toil of the creative forces behind the Sideshow
Collectibles Development Teams. Spread far and wide the
world over, our teams consist of artisans from the United
States, Europe, Argentina, Canada, Singapore, China, and
Korea. It is with great pride and honor that we say thank you
to all those creative spirits that have played in our orchestra
over the last twenty years.

**Special thanks** to Drew Struzan and all of the extended
Sideshow Family.

All quotes included in this book appear in or are credited to the following sources:

12–13: Batman, *Batman: Hush*
18–19: EV-9D9, *Star Wars: Episode VI: Return of the Jedi*
28–29: Echo Base Officer and Han Solo, *Star Wars: Episode V: The Empire Strikes Back*
30–31: Gallevarbe, *Court of the Dead: The Chronicle of the Underworld*
34–35: Joe Brody, *Godzilla* (2014)
46–47: Superman, *Man of Steel #6*
50–51: Lobo, *Lobo #62*
56–57: Kier, *Court of the Dead: The Chronicle of the Underworld*
62–63: Catwoman, *Catwoman: Selina's Big Score*
70–71: Superman, *Man of Steel*
72–73: The Red Death, *Court of the Dead: The Chronicle of the Underworld*
76–77: The Joker, *Batman: The Killing Joke*
84–85: Deadpool, *Cable & Deadpool #49*

90–91: Darth Vader, *Star Wars: Episode V: The Empire Strikes Back*
96–97: Batman, *Batman: The Killing Joke*
98–99: Savage Opress, *Star Wars: The Clone Wars*
104–105: Doctor Doom, *Fantastic Four: The World's Greatest Comics Magazine #3*
120–121: Darth Sidious and Commander Cody, *Star Wars: Episode III: Revenge of the Sith*
122–123: Power Girl, *All-Star Comics #58*
128–129: General Grievous, *Star Wars: The Clone Wars*
134–135: Captain Rex, *Star Wars: The Clone Wars*
138–139: James Rhodes, *Iron Man 3*
140–141: Batman, *Batman* (1989)
152–153: C-3PO, *Star Wars: Episode V: The Empire Strikes Back*
158–159: Snake Plissken, *Escape from New York*
160–161: Gethsemoni, *Court of the Dead: The Chronicle of the Underworld*

166–167: Batgirl, *Batgirl: Year One*
168–169: General Demithyle, *Court of the Dead: The Chronicle of the Underworld*
170–171: Jonathan Harker, *Horror of Dracula*
174–175: David, *Prometheus*
176–177: Daredevil, *Daredevil #139*
180–181: Stacker Pentecost, *Pacific Rim*
184–185: Sinestro, *Green Lantern #24*
192–193: Kerrigan, *StarCraft II*
194–195: Catwoman, *Batman: Hush*
200–201: Red Sonja, *Marvel Feature #4*
204–205: Raleigh Becket, *Pacific Rim*
208–209: Deathwing, *World of Warcraft*
220–221: Hellboy, *Hellboy: Seed of Destruction*
224–225: Pinhead, *Hellraiser III: Hell on Earth*

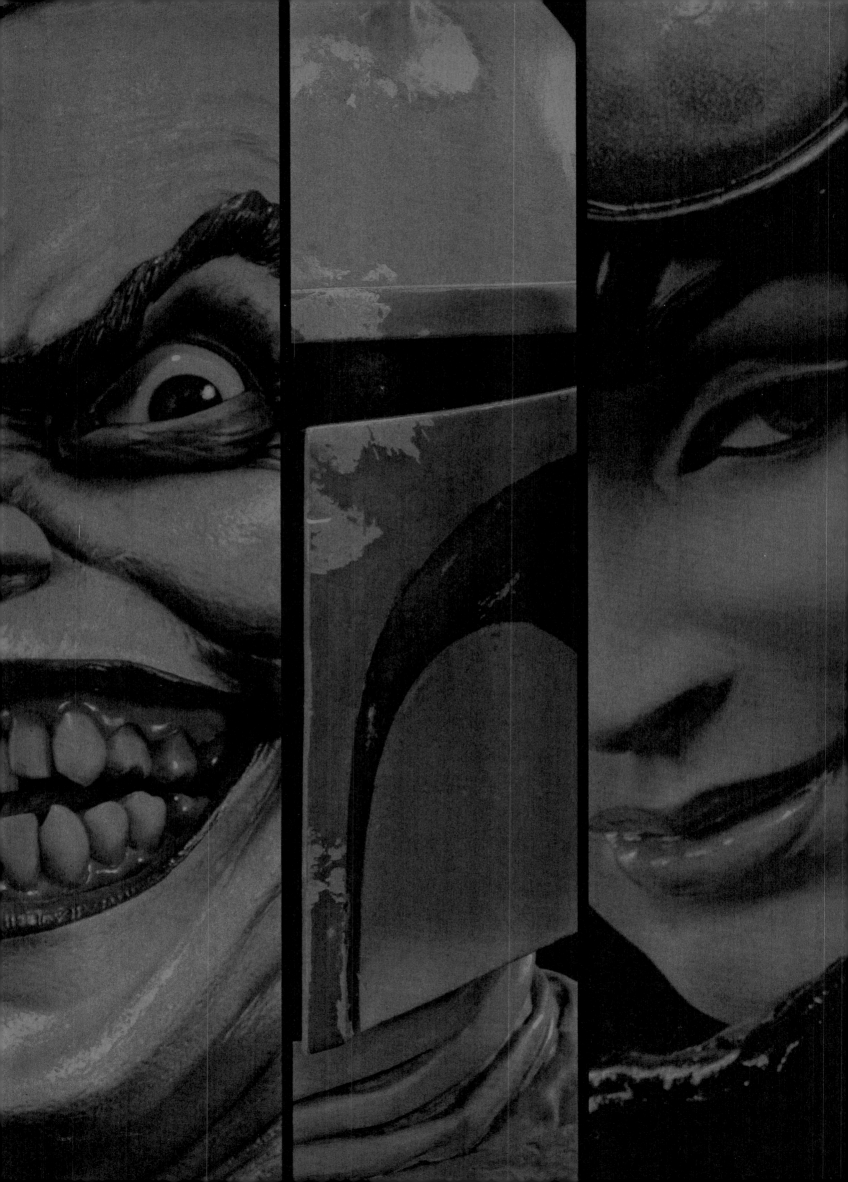